ON-THE-SPOT DRAWING

ON-THE-SPOT DRAWING

BY NICK MEGLIN

Watson-Guptill Publications, New York

*This book is affectionately dedicated to Luck—
my own special Lady.*

Paperback Edition
First Printing, 1976
Second Printing, 1978

Copyright © 1969 by Watson-Guptill Publications

First published 1969 in the United States by Watson-Guptill Publications,
a division of Billboard Publications, Inc.,
1515 Broadway, New York, N.Y., 10036

Library of Congress Catalog Card Number: 69-17667
ISBN 0-8230-3350-3
ISBN 0-8230-3551-1 pbk.

Manufactured in U.S.A.

ACKNOWLEDGMENTS

I would like to thank those who, whether directly or indirectly, helped me along the way: Susan Meyer, who started the whole thing off, Don Holden, who led the way till completion, and the other talented people at Watson-Guptill; Joyce Wessel for her encouragement in the early years, Oscar Hyman for his direction later on, and Al Meglin who taught me about "candles and flames." Thanks also go to my folks and friends—most especially Diane and Chris, who put up with me!

Special mention should be given to the School of Visual Arts for both teaching and allowing to teach some of the brighter sails on the art horizon. And, of course, I would like to thank the eleven artists whose ideas and drawings made this book possible: Tom Allen, Alan Cober, Tom Feelings, Bob Frankenberg, John Gundelfinger, Franklin McMahon, Bill Negron, Anthony Saris, Noel Sickles, Tracy Sugarman, and Bob Weaver.

FOREWORD

The war with the camera appears to be over. I use "war" for want of a better word, as this usage suggests two sides battling it out, which was never the case. The "lens" never set out to crush the "brush." The photographer merely wanted acceptance for his work as a recognized art form. That he achieved this aim there's no doubt, but in so doing, representational illustration and those involved in it paid the toll. No longer was the artist called in to cover a news event with drawings, and when an accurate, detailed picture of a "yellow-bellied nut-monger" was wanted, well, here too, the photographer was called while Audubon did cartwheels in his grave.

Personally, I can't help but feel it was the best thing that could have happened to many areas of the art world. It emphasized once and for all that an artist was, or should be, more than just a renderer or technician. Many artists began to look into themselves to find what they as individuals could contribute above and beyond the faithful reproduction of life on a two dimensional surface.

Those who had little to offer beyond a facile hand soon realized that for all their dexterity they still couldn't match the results of a good lens in the hands of a good photographer when it came to depicting the accurate side of life. Instead of changing their approach, however, they introduced a new realism to illustration by, of all ridiculous things, *imitating photography*. Some artists went so far as to actually trace photographs or to blow them up mechanically, then render them and submit the results as if they had just completed something vital and personal. How many years they've set back American illustration we'll never know.

It was the artist with a point of view, a personality, and perhaps most important, an integrity—who was able to weather the storm. Silently, and with little fanfare, he continued to work, experiment, and grow as he had before the professional market ebbed. As tastes, sophistication, and intelligence took an upward turn—plus the simple realization that a photographer is a photographer and an artist is an artist, each with strengths and each with weaknesses—the man was finally matched with the job he could do best.

But even today, on-the-spot drawing is too often neglected. Granted, it's inconvenient, uncomfortable, and uncompromising. But what it has to offer the artist is immeasurable, and certainly demands the type of dedication so badly lacking in all aspects of the art world. This book is for and about people who believe similarly.

You may recognize the names and/or work of some of the artists appearing in this book—they stand at the top of the illustration field. Others, like myself, make little if any of their living from on-the-spot drawing. But all share a common bond—the desire to leave the comforts and habits of the studio and go out and draw for the sheer pleasure of it.

I've interviewed these artists in a rather unconventional way. There was no tape recorder to stifle spontaneity nor was there a long list of questions to challenge one to instant brilliance—a sure way to draw a blank. Instead, we talked about everything from Velazquez's influence on Lautrec's art to Ara Parsegian's influence on Notre Dame football. We looked at drawings—of course, which is both pleasurable and informative, and from time to time I'd jot down a few notes, which, if nothing else, at least gave the impression I was doing something. But what I really tried to do was carry home the feelings along with the words, the essence rather than the details. I

then attempted to recreate what was once a concept, a theory, or an emotion and put it into chapter form with the reassuring knowledge that each artist would be able to read, correct, approve, or delete whatever I had misinterpreted, misrepresented, or, at the very least, misspelled. Frequently, during the course of the discussion, one of the wives appeared, offering freshly brewed coffee along with an anecdote or recollection of a particular comment her husband had made at one time or another which often supplied us with even more insight into the theme of that particular chapter. I'm thankful for both the coffee and the comments.

None of the drawings in this volume has ever appeared in print before. Many are personal notations done for no purpose beyond satisfying the moment. In most cases I tried to choose work that related to a theme or certain aspect particularly important to the individual artist's personal approach. The unfortunate part here is that often these sketches offer but one side of a many–faceted talent. Worse, they may tend to "type" an artist and interfere with a reputation he's worked hard to achieve.

I can't, then, be more emphatic in stating that in every case there existed drawings far removed from what may appear on the following pages. Each chapter by no means tells the total story of the artist's contribution to illustration nor does it serve as a portfolio representative of his work or interests.

I believe there are many people who like to draw but seldom take advantage of their interest. Notice, I didn't say *talent*. Quality of art work is relative. There's no accurate measurement or final judge of what's good art or bad art. For this reason, artists born "ahead of their time" have lived in poverty, only to have their work sell for monumental figures long after the money or fame could do them any good (when the critics finally caught up with their efforts). This aside isn't a sneaky way of blasting the critics, but a reiteration of the book's premise—draw for the love of drawing. If your work is well received, financially or otherwise, wonderful! But that's just the icing on the cake. The reward should be in the drawing itself. If it isn't, it's time for you to examine your values and ask yourself some questions.

Perhaps the following pages will provide you with some answers.

CONTENTS

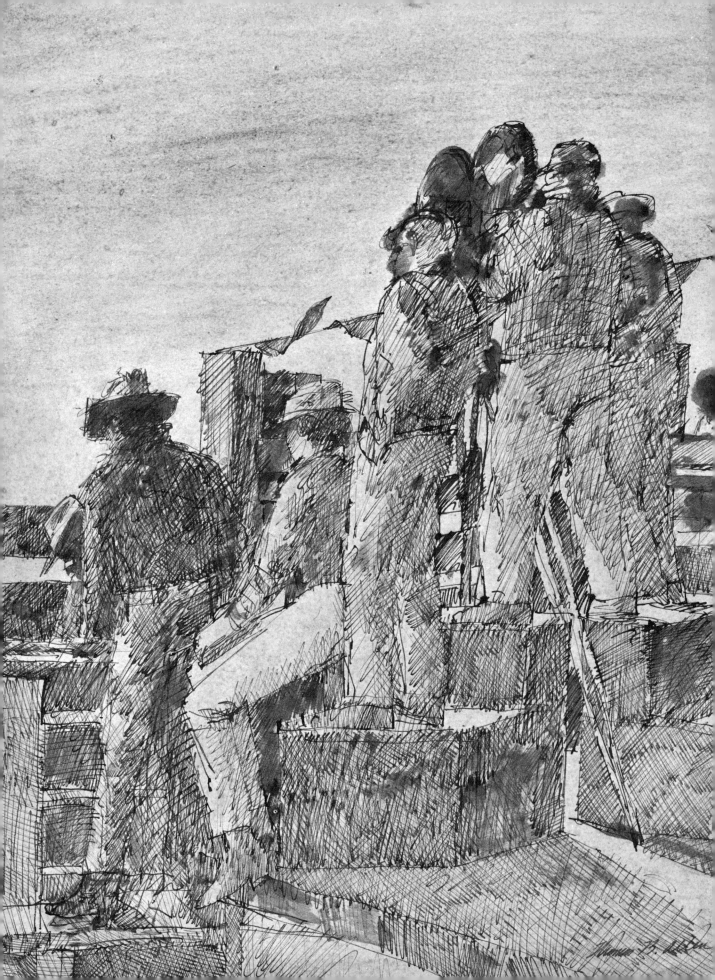

1. TOM ALLEN

A
POINT
OF
VIEW

"The only sacrosanct rule of art to me is personal involvement," states Tom Allen. "All other rules can be—and have been—successfully broken. An artist must be intensely involved with his subject in order to give to it his particular insights and convictions—his point of view. His reaction to a subject may change along with his convictions as he grows, but if his involvement remains intense, the work will be as valid and honest as before. Without total involvement there would be no art, only pictures.

"Usually, for me, involvement with a subject includes the conditions in which it exists, its environment. I consider what outside influences are present and I react to the total effect. I may react in sympathy with the subject as it appears, but more likely I will consider the possibilities of making the subject live in an environment of my choosing within the framework of my involvement."

Tom Allen's visual approach is like that of an impressionist, feasting upon that which can be seen and aware of that which can not. He's involved with his feelings about what he's drawing, and it's this subjective approach which distinguishes his work in the field of graphic arts.

Camera crew filming Montgomery Clift on the rodeo set of the film The Misfits. *"You can feel the excitement in the air" is a common expression; many say it, but how many draw it? Allen does, capturing the tense moment before the bull is released from the stall. The spotting of the darker tones directs the eye to the anxious, nose-bandaged rider, despite the fact that very little of him is actually seen. The drawing was done in a loose crosshatch, with subtle oil washes applied over foreground and sky to keep the focus on the main figures while establishing the hot, dry atmosphere of the dust-filled arena.*

The elements of interest

"There may be several aspects of a scene that stimulate my interest," Allen continues. "Sometimes the stimulating factor is the mood, or an emotional response, or sometimes it's the activity in a scene. More often it's the elements of design in a scene that stimulates me. I look for shapes and compositions formed either by things and people, or by light and dark. I use these elements as a starting point from which to build the composition, giving it the mood that seems fitting. Oddly enough, some of the things that may have interested me when I began the drawing get changed or lost by the time the drawing is completed. The drawing evolves from what's there and how I *feel* about what's there. By that I don't mean only that which can be seen. Very often I will use *air* as the main compositional element and place areas of light where I choose to attain drama. I'll alter a scene in any way necessary to accomplish my personal vision."

The air between

To Allen, the "air between" has always been a consideration, something not only acknowledged but utilized to its fullest extent. In our early years we learned that if we hold out our thumb at arms length it is the same size as a building in the distance. The eye learns about relative sizes and distances through similar experiences and accepts the disproportion without question. But if you were to *draw* the thumb and the building without regard for the air between, the building would appear as an appendage of the thumb rather than a separate object existing at a point in space beyond the thumb.

To most of us, this relationship remains a problem in perspective, solved by vanishing points, overlapping of forms, graying down objects according to their relative distance, etc. With Allen, it becomes a means for further expressing his interests in mood and emotion. As he explains:

"The air around a subject and the air between 'here and there' is very important to the life of the subject. Add the quality of light and very dramatic results are possible. For instance, take a very mundane object like a child's block. If I make a very careful drawing of it without regard to its environment, I'll have just that—a very good reproduction of a child's block. A decoration. Then, by using subtle tonation, I give the block an environment of air and it can come to life. It can become mysterious or even evil . . . whatever feeling I want to project. The air could dominate it, veil it, buoy it or be part of it. The possibilities are infinite and each variation gives the block a different character and mood."

The quality of light

Light is another factor that Allen is constantly involved with. Not satisfied with obvious delineations of light and shade, he studies the *quality* of light, (the kind of light it is and the properties it may contain), and once again using tone and value, creates the desired effect.

"It's not just the light itself but the *feeling* that it brings to the subject being touched by it that is important. A summer sun at midday is harsh and hot; a late sun . . . soft and warm; twilight . . . soft and cool. These are generalities. The subtle variations are infinite, depending on the subject, on conditions, and on things that effect the light by shading, screening, or reflecting . . . whether the light source is natural or artificial."

Working towards the end result

It's been said of Tom Allen that "he can paint with a pencil," the description applying to the extraordinary range of tonal variations he achieves with a simple soft lead. His interest in light and shade, atmosphere, and mood necessitate a tonal approach in most cases, and pencil (usually a 2B or 3B) lends itself nicely to these demands.

It's also been said of Tom Allen that "he'd rather fish than draw," and though this is a broad exaggeration (his wife says it isn't!) it's well-known that Allen is quite a sportsman. Many of his assignments for *Sports Illustrated* attest to his first-hand knowledge of a great range of sports. In such assignments Allen

prefers to work on-the-spot whenever he can, using color washes with pen or pencil outline or a complete watercolor palette if full color is desirable.

"Sometimes I'll scrub, scrape, and practically destroy the paper; it doesn't matter whether the result is successful. When drawing on-the-spot—after I've reacted to the subject emotionally, made all the necessary decisions and summoned the courage to begin —I'm never careful. Consequently some drawings are failures. Some reach the brink of failure and are 'saved' by this fatalistic attitude. So, sometimes what's *not* there is accomplished by struggle and accident rather than by design. And it *is* a struggle. Drawing isn't a pastime if you care about your vision, it's work. You struggle for a beginning, you struggle for the desired end and if that end doesn't come one way, you struggle along another course."

Allen uses the paper as more than just a surface on which to draw. Whether it be toned or stark white, he utilizes it to its full potential as he depicts the play of light on an object. He makes the subtlest value transitions, the highlights of certain subjects blending into the white of the paper, shadow areas losing their outlines and form as they merge into larger patterns of darks.

Needless to say, pencil tonation is not the speediest of techniques. When limited time is a factor, Allen will use wash to achieve his tonality, whether sepia ink (see page 18) or thinly applied oil color (see page 21).

The paper itself is usually "whatever is handy," but Allen will attempt to use a smooth finish when working with pen. The pen work itself reveals the same tonal concern, but here minute pen lines and crosshatch are employed to achieve the effect. For this, Allen prefers the Hunt Extra-fine point, delicate but not very flexible, because a flowing, variable thick and thin line is not his objective. The point's stiffness is perfect for the quick linear notations that make up the dark patterned areas as the strokes can go in any direction, back and forth, with a minimum of paper grab. A crowquill, as well as other kinds of flexible points, tends to dig into the surface, picking it up and often splattering the ink as well.

Drawing from imagination

Much of Allen's professional work is drawn from imagination. Having always been interested in mood and atmosphere, Allen is able to recall feelings and impressions he has had in the past and weave them into his artistic sense, thereby creating pictures that are realistic but which have an illusionary quality about them, much like a film by Fellini, if a comparison might be drawn. This approach is more eas-

ily attained when working from memory, but Allen considers his on-the-spot drawing essential to its success as with all his studio work.

"I may approach on-the-spot drawing from one of several different attitudes. If the drawings are for a specific assignment, then I must consider them as a means of expression. The drawings must be a complete expression of the subject within my capabilities and I must become totally involved to that end.

"Another attitude of approach is that of rejuvenation. From time to time it becomes necessary for me to refurbish my visual vocabulary by drawing from life rather than from imagination. The imagination can go so far on certain stimuli before it begins to repeat and bore; then it must be stimulated again. Drawing on-the-spot is the best way of acquiring that stimulation. You *find* shapes and compositions rather than invent them. The shapes may be positive forms or negative spaces, or areas of shadow or light. By making studies of these abstract shapes, I begin to *really* see what previously my eye has merely scanned.

"The third attitude is that of pure therapy—to relieve my mind of other projects with which I may have become so involved that I've lost my objectivity —or to simply record something for the sake of recording it as a part of a personal visual diary without emotional commitment."

Allen's words are graphically illustrated by the accompanying drawings, randomly picked from a generous supply of his on-the-spot work. When the interest was emotional, *feelings*, not the subject, dominate the picture. You sense the stillness as the fisherman, alone and silent, works his reel; the tension of the rodeo, despite the fact that the focus is on the sidelines and not on the activity of the rodeo performance.

And if it's the design elements that first elicited his attention, then Allen responds in kind with exciting contrasts—light and dark used almost abstractly in depicting a CBS film crew at work both indoors and outdoors, or the textures of man-made objects against natural objects to depict the struggle of the engineer and nature in a pipe-laying construction site in Fort Lauderdale. Allen begins with an angle of vision and ends with a point of view.

The value of being there

"It's rare that a subject presents itself as a perfect picture. If it does, it will usually take a lot of looking from a lot of angles to find it. This could mean walking around a room or trudging for miles through mud, depending upon the subject. You have to *be there,* experience being there, and react.

"It's difficult to feel strongly one way or another about something you know little about. On one hand, I could do certain political drawings with conviction and emotional impact without personal contact with the subject. On the other hand, a place, a situation, an event, a performance—these have to be experienced and not merely seen in a photograph or read about in a book. Living through the experience gives you the necessary insight into the subject to enable you to approach the drawing with an emotional concept as well as a visual concept.

"Some of my location assignments are such that I deem it more important to observe and participate than to draw on-the-spot. In such cases I'm gathering material and ideas to tell a story rather than to record a scene. Becoming involved in drawing might cause me to be less involved with the subject, thus possibly losing some important insights. What drawing I do is fragmentary, like taking notes. The final concept is formulated objectively in retrospect, and based on my reactions—intellectual and emotional. The visual material gathered serves mostly as a reminder of the physical characteristics of the subject."

Tom Allen is sensitive, his work obviously an extension of that sensitivity. There are no short-cuts for this type of approach. Whether a quick sketch or large painting, the work is consistently thoughtful, well-drawn, and perhaps most important, highly individual in a field bent on imitation.

The mood, atmosphere, drama, and imagination evident in every drawing he does is a signature to his work, as recognizable as the 'Thomas B. Allen' he affixes to it upon completion.

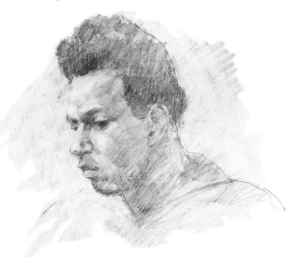

Native fishing guide, Central America. Allen, a fine outdoorsman, pauses on one of his yearly fishing trips to do a pencil study of the guide. Perhaps a tug on the line prevented further work on the shoulders and chest, which are barely indicated in rough outline. The tonality is sensitive, but not overworked, maintaining a spontaneous feeling.

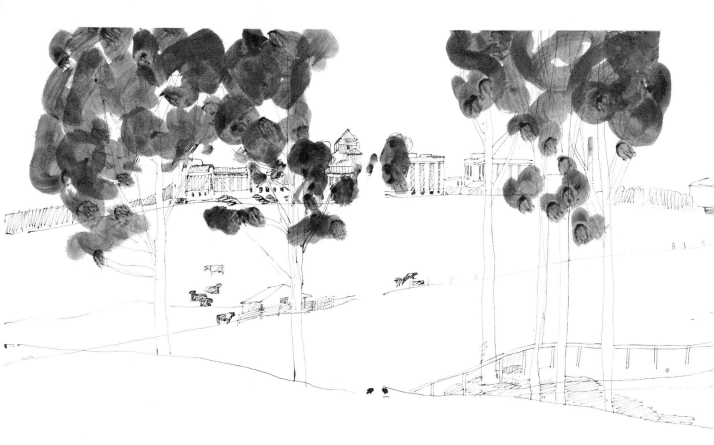

U.S. Government Narcotics Hospital, Lexington, Kentucky. *The hospital proper is to the left; the farm, barnyard, abatoir, etc., are to the right. They serve as part of the therapy program available to those serving terms and undergoing treatment there.*
This panorama extends over four pages—two double-page spreads of a large sketchbook. As this was to serve mainly as a preparatory study for a larger work in oils commissioned by Abbot Laboratories, it was of no concern to Allen that the edges didn't match up accurately. The gap caused by the binding is evident in the center of both spreads, as is the non-matching of the fence in the foreground where the spreads were taped together to form the whole. Allen never

stops exploring the dramatic possibilities of a scene: the infinite variations of light on form; the forms themselves; the natural shapes—contours and designs that cannot be invented; and the abstracts that can. All of these qualities give a drawing that extra dimension which often spells the difference between a successful or an unsuccessful attempt. "I often alter the scene to fit my needs," says Allen. "That's what the role of the artist is all about—to communicate an idea as best he can. To show it only as it exists is to show only a small part of it. In drawing a specific place for a predetermined reason, however, the liberties you can take when drawing for yourself, or in doing a highly personal illustration, are not as available to you. A certain degree

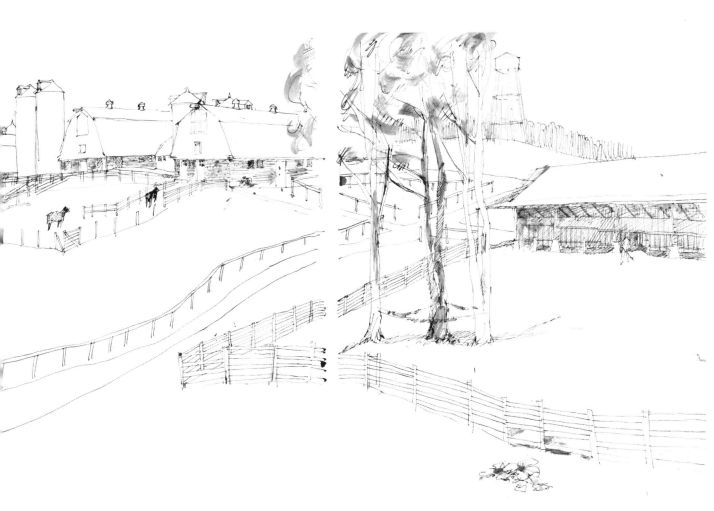

of accuracy is desired and expected. What I try to do then is to show what it is about the scene that I feel the most.

"In the case of the hospital in Lexington, the atmosphere of the place and the attitude of the people trying to help the inmates was one of peacefulness. A calmness prevailed, and I tried to capture that calmness in my work by eliminating superfluous detail and letting the long, uninterrupted lines of the landscape, buildings, and fences dominate the scene."

The foliage in the foreground can serve as a good example of keeping the drawing's emphasis where the artist wishes. Had Allen handled it in pen as he did the rest of the drawing, the intricate pen strokes would have drawn unwanted attention to that area. Instead, he brushed in sepia wash with

quick, round strokes, almost abstractly, which accents the broad, white areas even further.

Allen chooses the Hunt Extra-fine point for most of his on-the-spot pen work, carrying a holder and several extra points with him. He also carries a bottle of Pelican Sepia ink which he prefers over the regular black India for both pen work and wash. For this latter process, he also carries several water-color brushes, a sponge, and a water container. He works directly in pen and ink, laying down no preliminary pencil guidelines first. For this drawing he had no size or time limitations, and so it was completed when the last piece of information necessary was recorded.

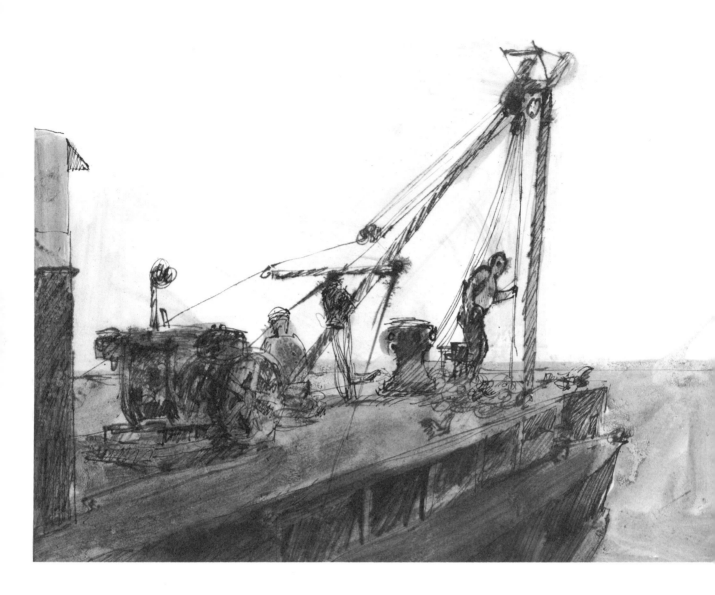

A salvage operation episode of CBS Television's Aquanauts.
*Allen, squatting on the deck of the camera boat, sketched
the barge and its operations as it was being filmed off the
Pacific Coast. The pen work was done quickly and sparingly,
allowing for the wash to carry the interest of the scene. The
angle of the barge, the crane with its lines and pulleys, and
even the crewman working on deck, directs the eye to the for-
ward thrust of the design. The sky is little more than the
white of the paper itself, left to be formed by the contrast
of the rich tones of the foreground. The water is handled in a
like manner; Allen used the actual surf for his wash. As for
cleaning out brushes, what better way then to reach down and
have a fresh wave of the Pacific do it for you!*

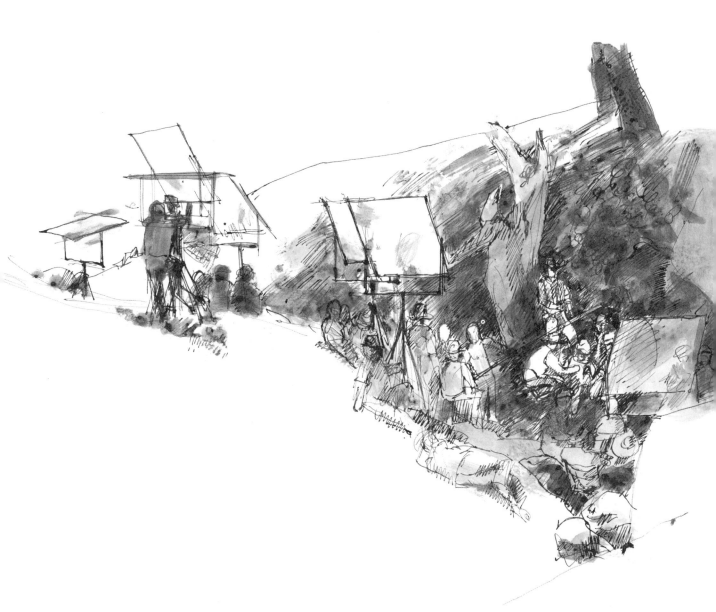

On location in California with the CBS camera crew for a
Rawhide *episode. Allen utilizes elements of the composition
to the best advantage, stating: "You've got to be there to be
able to make your variances. I study a scene carefully before
I draw it, to familiarize myself with everything about it. I
usually start my drawings with natural compositions—those
that are especially unique to the subject I'm doing. This
also helps to avoid sameness, which is an easy thing to do if
a particular approach has proven to be successful in the
past." Here Allen combines pen, brush, and wash to contrast
the shapes and forms so that his focal point is achieved, which
in this case (despite the arrow-like flow to the left) centers
around the group of actors to the right being filmed on the
outdoor set.*

Construction site, Fort Lauderdale, Florida. While on location for another assignment, Allen came across workers laying pipeline. He became interested in the contrasts between the light and the dark; the man-made and the natural; the rough and the smooth, etc.; and so he took time out from one relaxing drawing assignment to relax with another. Starting with a pen drawing, Allen applied thin coats of oil color diluted with turpentine while still on-the-spot.

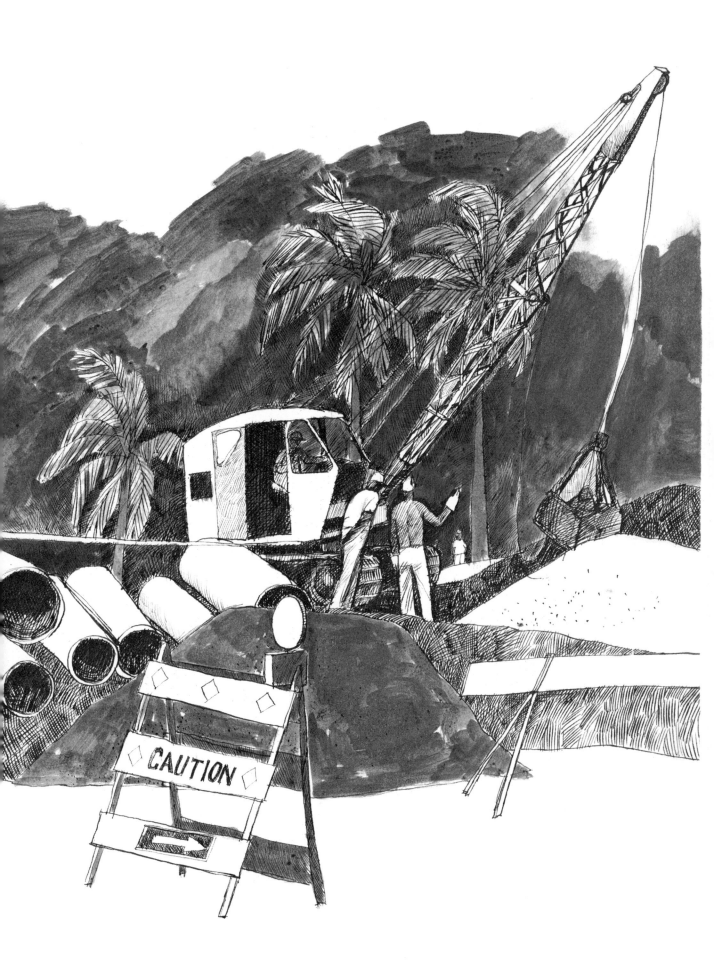

Indoor set at the CBS Television Studios in Hollywood. While on location for this network to produce all the on-the-spot drawings for an annual publication, Allen approached each one in a manner the scene suggested to him rather than trying to keep them similar in every aspect of execution. In this one, he chose to dampen the heavy stock sketch pad page with a damp sponge. Not waiting for it to dry completely, Allen began his drawing directly with pen on the damp page. The pen no longer produced crisp outlines and chiseled edges, but soft, difused strokes which blended easily with the wash. This latter stage was also applied while the page was still moist. The end result balanced the work more effectively than if the high contrast between the starkly lit set and the darkened studio were separated by only a hard outline. The experiment in drawing proved successful, but the show being filmed didn't experience so fortunate a fate—it was dropped from the schedule soon after.

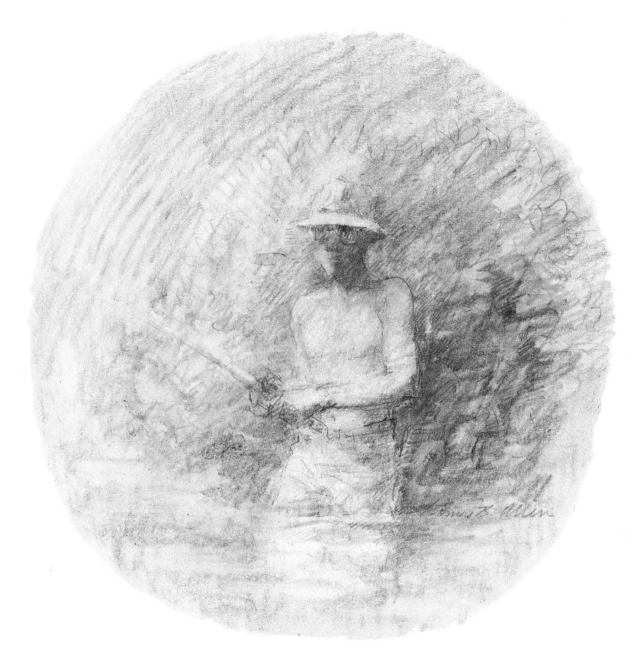

Fishing in Nicaragua. Each year Allen and some of his fishing cohorts take a trip to some little-known fishing paradise. They have fished in the Yucatan in Mexico, British Honduras, The Bahamas, Costa Rica, and other Central American countries. Along with his fishing gear, Allen makes sure to also pack his drawing gear which has proven itself to be both enjoyable and lucrative—many of the drawings and watercolors produced on these jaunts have later been sold as special features to Sports Illustrated.

In this drawing, Allen concentrated on the stillness of the early morning scene. It was a gray day, so, with little fear of sunburn, the fisherman wades out slowly and quietly sans *shirt. Allen, ever aware of mood and atmosphere, utilizes the wide range of tonality available with a 3B pencil to capture the quiet scene with its still water and gray morning light. The circular, or "cameo" shape also adds to the effectiveness of the work.*

Florence, Italy. This drawing was one of several Cober made for the Committee for the Restoration of Italian Art following the tragic flood of 1966. It's basically a pen sketch, with dry-brushed black India ink on the rough-surfaced watercolor paper for additional lighting and texture. With dry-brush, the "peaks" of the paper come in contact with the ink; the "valleys" don't. The pen used in most of his location work is either the Mont Blanc or the Osmiroid. Both have extra-fine points, and Cober fills them with Artone Fountain Pen Black. Despite the water-soluble nature of the ink, Cober doesn't hesitate to use wash over the pen work, feeling the blending of the two enhances rather than detracts from on-the-spot work.

2. ALAN E. COBER

THE
MIND'S
EYE

"A drawing should have a life of its own," says Alan Cober. "Why inhibit it by the limitation of the eye? The eye can see and the hand is capable of recording that vision, but it's the mind that can expand that vision into a personal and significant statement. That's what makes drawing such a ball. There's no one standing over your shoulder giving orders! You're on your own, a hero with a pencil and a blank sheet of paper!"

Freedom is one of the most important factors in Cober's drawings. He writes—or better—he *draws* his own rules. But freedom for the sake of freedom is not unlike distortion for the sake of distortion. If that's its only justification, I question the necessity for it. If it's not a sincere, deep-felt emotion, then it becomes sham. Many artists who lack natural freedom try to force freedom into their work, which is contradictory at the very least. And the work, of course, shows it. Many who distort do so because they have no alternative. Distortion, then, becomes a blanket to hide the artist's inability to produce an honest, accurate study beneath.

Cober is not of this genre. He draws beautifully, accurately, and honestly. His freedom stems from his confidence, and his confidence from countless hours of on-the-spot drawing. He enjoys working with a variety of drawing implements, but no implement is fused to one technique. A Cober pencil study can be sensitive or bold, a pen sketch forceful or meticulously etched on paper. He's in control and not controlled by his tools.

Good drawing is never dated

Cober is a good draftsman, and good draftsmanship is not of an age or a "school." It can never be dated. There always has been, and always will be, a place for it in the art world. What do become dated are thought processes and boundaries set up by tastes, opinions, styles, techniques, and the "acceptable" art of a particular era. Those artists strong enough to buck (or totally ignore) the trends and invest their time and interests in solid craftsmanship are insuring their place in the total, long-haul picture, for draftsmanship in the hands of any inventive individual has always been an asset, never a hindrance.

Most of the impressionists serve as an obvious case in point; many were superb draftsmen who utilized this ability with a freedom of expression that opened the gateway to better art. If Degas couldn't have drawn and painted the figure with the solidity of his salon contemporaries, or if Monet couldn't have rendered the flowers in a still life as well as the still life masters of his day, their work would have been brushed aside as sour grapes attempts. It was the very strength of their draftsmanship that commanded a second look.

By the same token, certain techniques—while usually attributed to a certain period or school—need not be something to avoid at all costs for fear of being dated. For example, the crosshatch, one of the most effective shading devices available to line-cut reproduction, has been used sparingly in contemporary illustration. I can see why. Once again, it's a matter of control. Does the technique dictate the scope of the drawing, or does the artist use it merely as a means to an end? Cober frequently employs crosshatch in his pen work without concern that the technique might be considered passé. With Cober, any technique is relegated to the role of a bit player. In his drawings, imagination gets top billing...

The power of imagination

"I am very moved by good draftsmanship and as a result make demands on myself that do limit freedom to some extent," Cober admits. "But I try to counter this by reminding myself that my drawing is not some kind of legal document and that I'm not doing a definitive study of the scene. Thus reminded, I'm free to chop up, paste over, and play around with the elements in any way that I believe will add to the total picture."

A good example of Cober's imaginative approach can be seen in his "extended period" works. Unlike most artists, his drawings don't end when the person he's sketching gets up and leaves or if a huge truck parks in front of the house he's doing a study of and blocks his view. He'll superimpose the one on the other without a second thought. The result is that he catches the passing parade—you witness time passing before your eyes rather than an isolated moment preserved on paper. These drawings are, in effect, compilations in that they're several varied thoughts in one total effort.

"As long as I'm still interested, still involved, why should I stop?" Cober asks. "If I'm drawing several figures and for some reason have to put the pad down, I continue later although the locale or background has changed, or even if the figures themselves change. If a heavy-set man now sits where a thin man sat, I blend one into the other."

"And if a man takes the place of a woman?"

"Ever see a man-nun?" he asks, picking out one sketchbook from a long line in his bookcase. He flips the pages rapidly, finally stopping at one which he hands to me for inspection. Sure enough, he had been drawing a nun in a dentist's waiting room when she was called in for her appointment. A few moments later a man walked in and sat precisely where the nun had been sitting. Cober continued his drawing as though no change had taken place, utilizing what he could from the two (though completely opposite) subjects.

Drawing is habit-forming

He is a compulsive artist who'll draw anything, anywhere, as the stacks of drawings that crowd his studio will testify. I have no doubts that he would be sketching the surgeon while being operated on. What makes an artist compulsive? In the case of Cober, his own words describe it best . . .

"I always loved drawing, but I was discouraged by relatives from going to art school. I ended up wasting, well, it wasn't really a waste—I guess I broadened my outlook somewhat—anyway, I *spent* several years in college without doing any drawing at all, as it interfered greatly with all the other work I was responsible for. It was a very difficult and unsatisfying period of my life until I attended a life class one day and knew I had to draw. It was just too important a part of me to suppress. I left college to attend the School of Visual Arts in New York and started drawing again, this time with the knowlege that it would be my life's work.

"I guess that's when the compulsive side of me came through, for I started drawing like I never drew before, probably in an attempt to make up for the time I had lost. Like a man who had been stranded on a desert—years after, he's still drinking a lot more water than he really needs. My sketchbooks, naturally, are the result of my compulsiveness. They are more than an exercise as I do get very much involved in them. Most of my work is of my family—they're available and they're so used to me following them around with a pad and pencil that they forget I'm there. That's the best way to draw people—when they're relaxed and unaware of your presence or unconcerned with what you're trying to do. I often wish I were like a chameleon so I could blend into the background."

Cober prefers the hard-cover, sewn-binding sketchbook rather than the spiral bound variety, since the former usually contains a better quality paper and the binding offers more permanent as well as easily storable properties. These are important considerations for one who regards his sketchbooks so highly. Through them, Cober can guage moods and levels he passes through as well as his own development. A few, isolated examples of work can not serve as an accurate, chronological perspective as can a collection of sketchbooks.

In Cober's case, the sketchbooks also serve as a "reference library," as he refers to them often, applying the whole or part of a drawing he feels particularly strong about to a professional assignment rather than working from photographs.

"My imagination then takes *two* steps rather than one. When working from reference or live models, your drawing constitutes one step, but when working from another drawing you're one step removed. Your imagination can run free and you're bound to be looser and more receptive to new ideas than you were initially."

The value of compulsive drawing

But compulsiveness is a psychological measure rather than an artistic one, and I doubt that someone could "become" a compulsive artist simply because he wanted to if it were not an inherent trait in his personality already. If it is, however, it is especially

valuable to an artist and should be exploited to its fullest extent. What continuous drawing can do for eye-to-hand coordination is obvious. But think of the other advantages. For one, a compulsive artist *must* draw and thus becomes involved with whatever is around him at the time. This enables him to draw subjects that aren't necessarily his preference, a pitfall for many talented people. He's not limited to his "specialty"—he does not get "typed" so that only certain assignments are offered to him.

Then, too, think of the confidence that is attained through incessant drawing. Having drawn "everything," one might feel very secure in his ability to succeed in any project he undertakes, be it an assignment or a self-imposed problem. But why labor on the subject of confidence! We all know its importance in *all* phases of life without exploring its importance in art any further. What should be looked into is means of *gaining* confidence, and here too we can learn from Cober. When his search for a convenient live model proves fruitless (the kids are at school, the wife is out shopping, and the neighbors have drawn the blinds pretending not to be at home), Cober resorts to the mirror.

"This gives me the confidence and momentum I sometimes need to solve a drawing problem," he explains. "Since the face I'm drawing is my own, naturally I know it well and find it an easy subject. Thus fortified by a successful study, I go back to the problem armed with self-assurance and new approaches to solving it. In essence, I psych myself." Here, too, Cober can be counted upon to provide the unusual, drawing with his left hand should he become interested in a pose that involves his drawing hand.

Maintaining a fresh point of view

Because he does not begin his on-the-spot drawings with pre-conceived ideas, "normal" situations and procedures never get in the way of his imaginative approach. For instance, he will often draw several views of a person on the same sheet, tying the composition together with a common background, the result looking very much like a coffee klotch or bridge game with a cast of *one*.

"When I get an assignment for location drawings, I am more limited due to the very nature of the assignment. My objectives are obvious—I do the best I can to depict the area so it comes across as that particular place. But I always keep an eye out for ways of making the drawings more interesting and exciting and not just a facsimile of the real thing.

"When I am drawing for 'myself,' the objectives are more ambiguous, they are not as clearly defined.

Growth as an artist is always a concern, so I'm sure there's a desire for improvement going on even though I may be drawing for the sheer pleasure of it at the time. It stands to reason that the more you do, the better you're going to get.

"Then, too, I'll use drawings I've made for myself and apply them to professional assignments. So, in effect, you never know when *whatever* you're drawing will be utilized."

As we talked, Cober, probably feeling that his drawing hand had been idle for too long a time, began to sketch me. It was not yet completed when I departed, but, remembering his "man-nun" drawing, I knew it would probably be finished one day—perhaps a combination of his wife's lovely eyes and my own black beard.

Random pages from his sketchbooks were chosen for this chapter, none of which has ever been reproduced before. They depict family and friends, places and objects—all with the interest, intensity, draftsmanship and imagination one has grown to expect from a drawing signed *Cober*.

Silvermine College, Connecticut. Teaching drawing can be an interesting and educational experience, but watching others draw and not being able to lose himself in his own work was, at times, difficult for the compulsive Cober. One afternoon, a student came to him after class with a particular problem. As she talked, Cober sketched, making a composite drawing of the two quick pencil studies. His own problem (the need to draw) thus solved, he was then able to be of greater aid to the student.

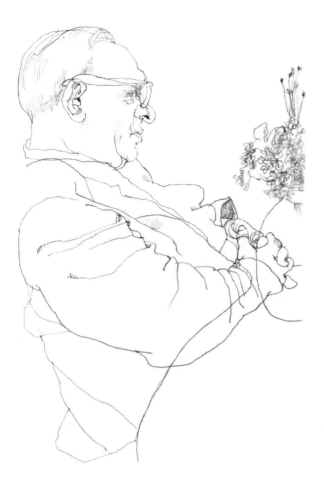

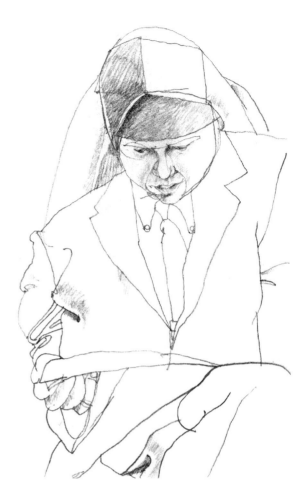

Cober's father. The artist made this sensitive pencil drawing as his father intermittently dozed while watching a television program. Sleeping figures generally make good models: there's a minimum amount of movement; the body is completely natural and relaxed; and there's none of the stiff posing many well-intentioned subjects feel you expect from them. His father's hands were partially hidden by the flower vase, as was part of the right arm as it rested on the gentleman's lap, so Cober, after having sketched that which he could see, quietly moved the table for a more complete study. The table isn't transparent, nor is the vase made of clear glass—what you see is simply a drawing by Cober, typically free and unhampered by rules and restrictions. Cober has no particular preferences in pencils, other than their intensity, choosing a 2B or 3B in most cases. The pad used for both these drawings measures 5" x 7".

The man-nun. A Cober drawing seldom ends because the subject has left the scene. As long as he's still involved with the drawing, Cober will continue, despite the fact that someone else has taken the place of the original subject. He proceeds as if no change had taken place, blending the one into the other regardless of physical appearances or clothing discrepancies. In the above pencil study, for instance, Cober began sketching a nun sitting across from him in a dentist's waiting room. After the nun departed, a man entered and sat in the same seat, and, as if according to plan, picked up the same magazine the nun had just put down. Cober continued working, and the resulting sketch depicts an interesting, albeit highly unlikely, man-nun. Interesting, too, is the difference in the handling of the nun's headpiece (tonal) and the man's clothing (linear): two distinctly different pencil techniques.

A neighbor's son, Riverdale, N.Y. Through his sketchbooks, Cober can keep a chronological account of his changes in visual interests as well as his progress. The above was drawn in 1964 and it's obvious by the crisp, exacting pencil line that the emphasis at this time was on faithful delineation of his subject, as well as careful attention to proportion. The drawings which follow were chosen from a sketchbook dated August, 1968, and while they still display Cober's fine draftsmanship, the emphasis has shifted from an exacting line to a more expressive one. Like the stages in the development of many artists, once the foundation of solid ability is realized, he is able to loosen up and create new challenges for himself which demand equally new solutions. While much can be said for Cober's earlier work, it is his later, more imaginative work that has brought Cober the success he enjoys today.

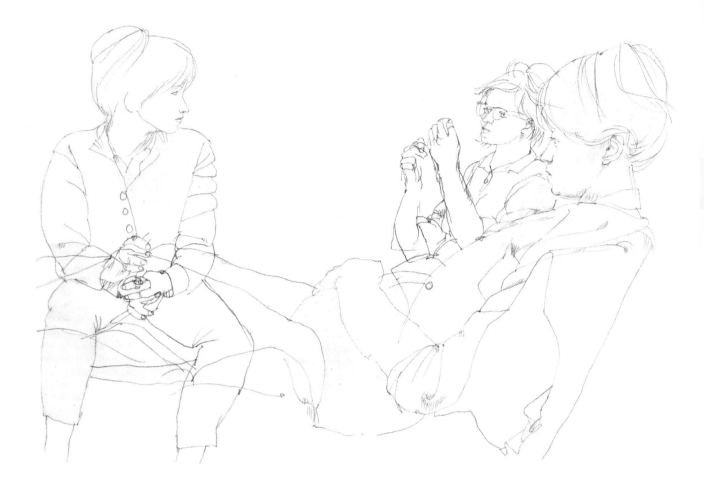

Ellen Cober, a friend, and Ellen Cober again. Cober's wife, like all others that dare enter the premises, is constantly being drawn by the pad-bearing artist who haunts the place. In this, one of his "extended period" works, Cober had sketched his wife while she chatted with a friend one afternoon. Leaving the room momentarily, Mrs. Cober took a different seat upon her return. Cober treated this new situation as though a third party (Cober is, by this time, ignored completely and doesn't figure in the tally) had entered the scene. This procedure is not uncommon to him, as many drawings of this nature can be found while thumbing through his extensive collection of sketchbooks. In some, one person appears four or five times, each time in a different spot or position in the composition, as if Cober had quintuplets posing for him. Note the two sets of hands in the drawing of the figure on the left: Cober draws hands with special interest, capturing both the character and attitude of the subject in them.

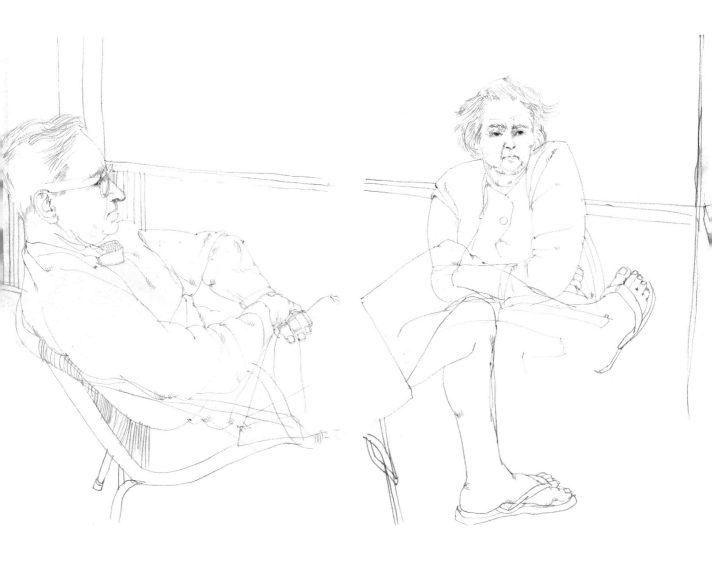

Relaxing figures. When people aren't working they try to relax, as is the case with Cober's in-laws pictured above. Cober, on the other hand, is more relaxed working, and so a Sunday afternoon visit provides the subjects, while the back porch becomes a studio. This, by the way, is an obvious advantage of any on-the-spot artist—his "studio" is where he is as long as he carries pad and pencil. In this drawing, like the one on page 28, the forms behind are as visible as those that block them: in this case, the man's legs and the woman's arms. This pencil study was chosen from one of the 1964 sketchbooks, although Cober would have preferred showing more recent examples of his work. While the latter would, in truth, show Cober's highly imaginative approach to better advantage, I felt the student can also gain insights by observing the intense study and hard work that must precede flights of fantasy before they can be considered, in any meaningful way, genuine and sincere artistic efforts.

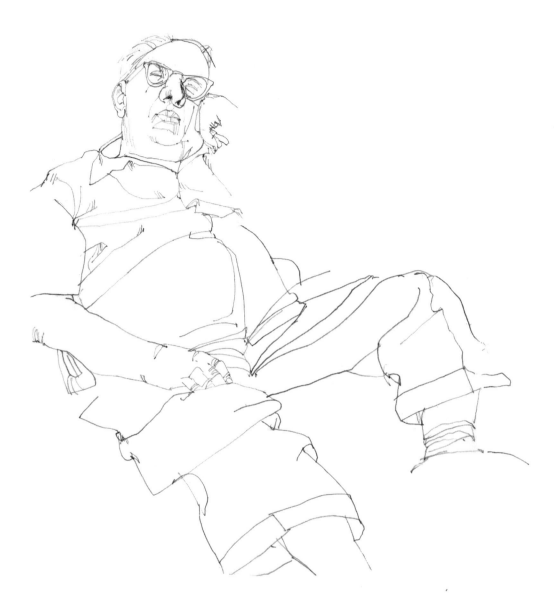

*Sleeping figure. His father is one of Cober's favorite
models. He will always continue whatever he was doing when
he sees "his son, the artist," coming around with pad and
pencil. He knows that he's most helpful when natural and
unposed. He's also conditioned to his son's compulsive draw-
ing habits and sometimes, as in the above study, his patience
reaches classic proportions. As Cober sketched, a voice,
almost sepulcheral in quality, emerged from his "sleeping"
father. "Are you finished yet, Alan?" Cober, recovering from
his start, answered, "Another minute, Dad," finished up
quickly, and retreated, astonished, as his father changed to a
more comfortable position, never once opening his eyes.*

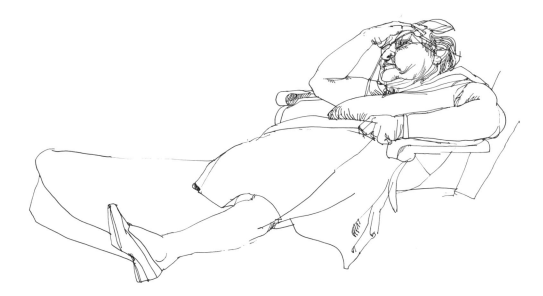

Pen and ink drawing. Cober doesn't cater to the special properties of a particular drawing instrument, nor does he bow to its expected technique. In this drawing of his wife's grandmother, he uses the pen to follow the outlines of the form in the same manner as he would with a pencil. The lines are smooth, flowing, and confident in this medium where each hesitation or mistake is as obvious as the successful passages. The drawing was executed with a nib and holder of no particular number or design, but the nib was strong and not too flexible. The ink is sepia and of the permanent variety.

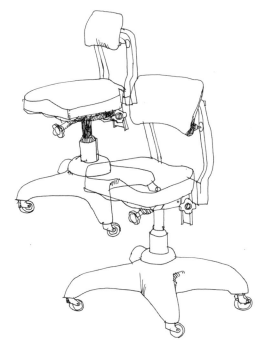

Office chair. Waiting time is invariably drawing time for Cober, another reason for never being without his sketchbook. When a client was detained in his office, Cober began a fountain pen sketch of the office chair that stood before him. Finishing that, he moved himself back a bit and started another of the same chair, drawing through the first one rather than stopping at its perimeter, and so distance is suggested not through the usual method of overlapping forms, but through use of relative sizes. The tops of both chairs are roughly two-thirds the vertical distance of the chair bottoms, creating a "going back in space" effect. The untimely appearance of the client prevented a chorusline of chairs from being drawn.

33

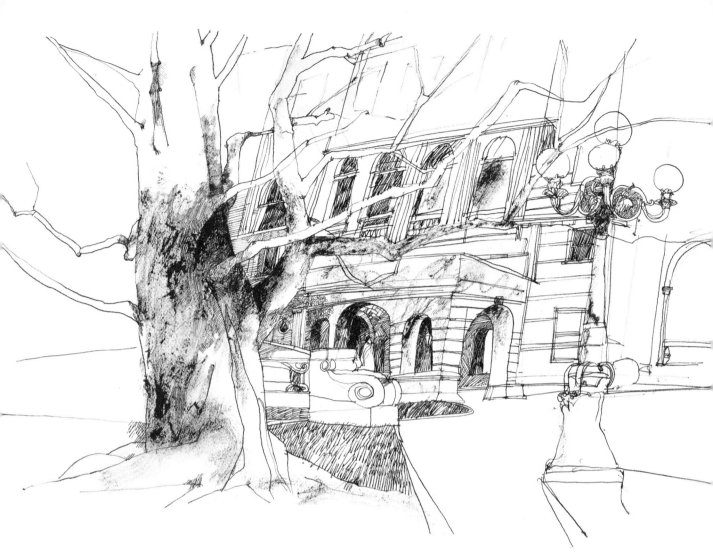

"The Breakers," Newport, R.I. In much the same manner as this chapter's opening drawing, Cober worked directly in pen (one of the "dipping" variety) for most of the drawing, scumbling in the dry-brush (while still on-the-spot) with a watercolor brush to enhance the over-all design with additional "color" and texture. The beautiful mansion "The Breakers" (so named by its owners, the Vanderbilts) is one of the most noted landmarks in this picturesque town. This study was one of many done on location by Cober for a Venture Magazine assignment. This drawing was not included in the printed portfolio for that publication, so it's in keeping with this edition's requirement of "work never in print before." The massive tree in the foreground contributes greatly to the composition, suggesting the age, stateliness, and tradition of the building, while framing the drawing in such a way that the entrance-way becomes the picture's focal point. Drawn with permanent black India ink on heavy, rough-surfaced watercolor paper.

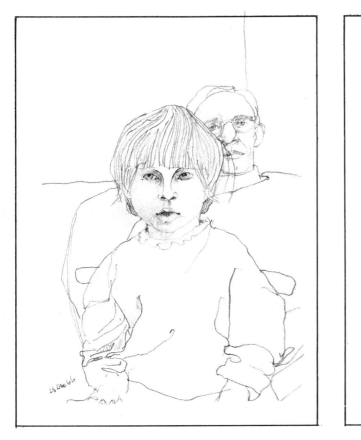

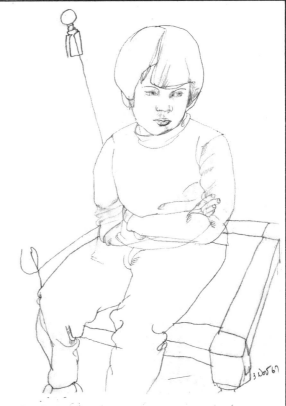

Two studies of Leslie Cober. Here, Cober's daughter appears in separate pencil drawings of contrasting mood and design. In the one on the left, Cober focused his attention on linear detail, exploring the intricacies of the design in the folds of the child's clothing as she and her mother's grandfather stare at a point to the floor-squatting artist's left—perhaps at a television screen. Similar attention is paid to the child's hair: it's clear to see the direction in which it grows and the way it falls as it follows the form of the head beneath. The second pencil study finds the same child absorbed in thought, while her father is absorbed in perimeters. Form is suggested by minimal indication of folds, but it's the masses which Cober emphasizes by careful delineation of the outlines. Even the hair becomes a solid mass rather than a blanket of detail. In keeping with the over-all pensive effect, Cober also refrained from getting involved with the ornate details of the chair, suggesting only a few lines of its basic construction. He leaves the bric-a-brac and handiwork to feast upon in an inevitable future drawing.

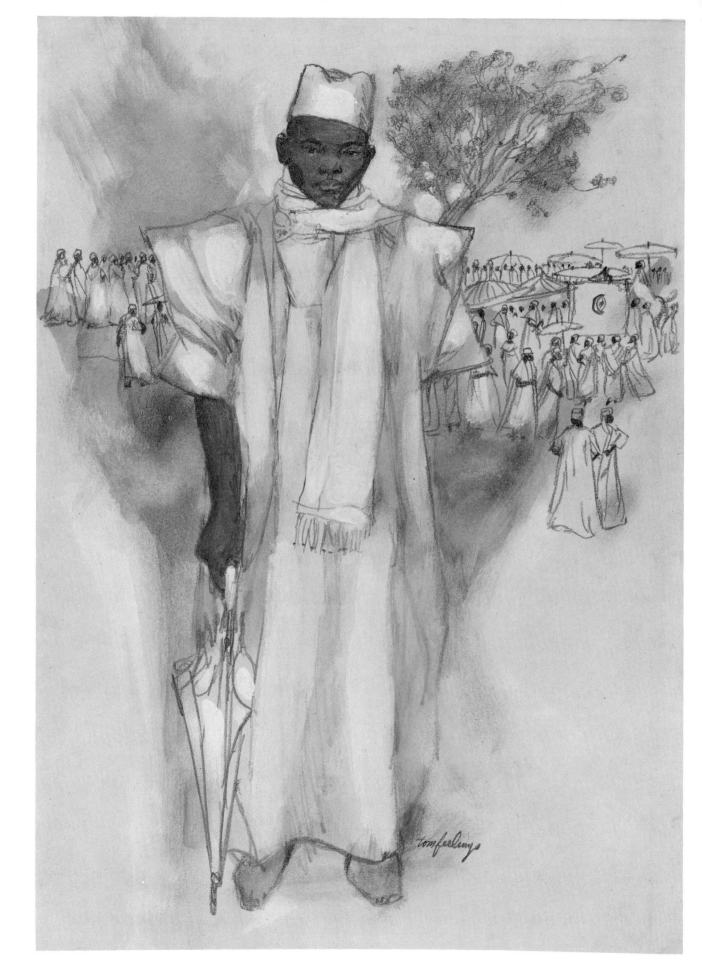

3. TOM FEELINGS

THE PERSONAL STATEMENT

"It's hard for me to separate my art into different classifications," says Tom Feelings. "It's a total thing, an entity. It's so wrapped up in my life and thoughts that I wouldn't know where to begin. With me, it's not 'art for art's sake,' but art for *my* sake. I'm not too concerned with the accuracy of the drawing. If the arm is a little too short or the foot a little too big, so what? Did I capture the mood? Did I capture the flavor? Did I capture the pain or the joy? Did I *say what I want to say*? If I did, then I got myself a good drawing. If I didn't, then the best drawn anatomy in the world isn't going to save it."

In representational drawing, what inspires an artist to do a particular picture is a mystery. "Because I felt it" is not really an answer, although it's the one most readily accepted despite the fact that *why* he felt it raises a million other questions. A man's whole life, every aspect of his complex intellectual and psychological make-up, determines his tastes, values, and needs. No single, terse statement, then, can really offer much in the way of an explanation.

Young man dressed for Ramadan celebration, Ghana. Following the ninth month of the Mohammedan year, during which strict fasting is practiced, a large celebration takes place in the Muslim community. At this time, the people put on festive robes for the occasion, and many carry umbrellas as added protection against the mid-afternoon sun. This youth (a friend and co-worker of Feelings when the latter spent two years in Ghana doing drawings for African Revue Magazine), takes time out from the festivities to pose for his artist friend against a procession of similarly robed figures. The drawing was done with an inexpensive black graphite marking pencil, and the artist used a thin wash, sparingly brushed on, to soften some edges and tie the composition together more effectively.

But what about the artist who's *motivated* more than inspired? Tom Feelings is such an artist. When he sets pencil to paper, his reasons *are* clear, and they rarely border on the esthetic. He's compelled to express himself socially more than just artistically.

The message dictates the drawing

Feelings has no particular theme or preconceived message in mind when he sets out on a personal sketching trip. The actual scenes he comes across carry their own message, and the message, in turn, dictates the drawing. For example, the drawing reproduced on page 44 shows an establishment with apparatus designed to straighten hair. Negro men sit under the machines, patiently undergoing the treatment in a weekly ritual. A lot can be said for the natural design of the scene, but it was not artistic elements alone that elicited his drawing response. What he saw were the distorted values of his fellow blacks resorting to artifical means to "improve their appearance" by imitating white standards. Feelings doesn't judge them, he draws them. The impact, of course, is greater this way. The drawing carries a stronger statement about the emasculated Negro than anything staged, posed, or constructed could. As Feelings puts it:

"It's important for an artist to depict the things he feels strongly. Growing up in a black community in Brooklyn and yet not seeing enough drawings and paintings that say enough about the people and places right outside my door—the things I see and feel everyday—convinced me of the need to portray this contemporary scene. I deeply feel that this direction is extremely important for the black artist, for his own development and search for originality. All

the rich material is right there in the Afro-American community. Through study and hard work the artist must force himself to look at it and bring it out in his own way through sensitive art."

On-the-spot for realism

With Feelings, the art is less important than the subject. He draws not so much for the love of drawing as for the need to express his thoughts. He considers realism a necessity rather than a preference, and on-the-spot drawing is the truest way to achieve his realism.

"Nothing can match the real thing," he says. "I can hire a model, dress him up, pose him, and get him to make all kinds of expressions. I can throw a dramatic light across his face, put carefully chosen props all around him, and render it to death. And what do I have? People will look at it and know at a glance the whole thing's a phoney, a set-up. But you can get the same thing right there on the street. The *real* thing, the original. It's all around you—you don't have to look for it. You never have to fake it. You trip right over it every step you take.

"I'm not trying to be subtle when I tell a story. I'll hit you over the head with it if I can. And the best way of doing it is by going out there and showing it like it is."

Matching the subject with the technique

Feelings prefers to work in the medium the subject seems to suggest. When the subject is "soft," like children (his favorite subject), Feelings utilizes the delicate tonal qualities of a thick, round pencil. He maintains a rather broad point so that he can lay in broad tonal areas quickly, especially in larger drawings. The top edge formed by the planed-down lead is sharp enough to produce thin outlines as well as pick out details.

The pencil is the most versatile drawing instrument in common use, which explains its preference by most on-the-spot artists. It can be used in a linear fashion like the pen, while offering gradations of value in the line itself from very light (as achieved by a hard graphite, 3H or so) to intense dark (a soft Wolff carbon pencil or litho crayon). The pencil also can be used strictly as a tonal medium, offering the kind of variety as achieved in wash, without any of the mess, bother, and preparation—an important consideration for location work.

Feelings' pencil work is especially effective. He uses the tone potential to the fullest, producing subtle passages and delicate blends that weave in and out to soften the contrast of the white paper and well-defined outlines which serve as the foundation to most of his drawings. This is particularly evident in the African studies. The decorative clothing and flowing robes lend themselves nicely to Feelings' sensitive treatment.

In drawings where only line work is desired, Feelings uses an Osmiroid Pen with an extra fine point, which he fills with Pelikan Fount India Ink, a water soluble, deep black ink designed for fountain pen use. To guarantee a smooth, constant flow he'll often add water to the ink to thin it out somewhat.

His line is plain, following the contour accurately with little attempt made for thick and thin, cross-hatch, or other line variations. Its purpose is to tell a story; Feelings makes no other demands.

The water soluble nature of the ink doesn't lend itself easily to mixed media as the line will bleed or pick up when any wet medium is applied. Therefore, subsequent gray or color washes must be avoided if the pen line is to be maintained.

Having satisfied the emotional factors of the drawing while on location, Feelings considers the artistic factors back in the studio. Pen drawings, for the most part, remain just that, while pencil studies will sometimes be "pulled together" with gray washes and opaque whites. He's found through experience that a slightly toothed, spiral bound sketchbook satisfies both the pen or the pencil approach equally well; the paper's finish is perfect for pencil and wash, and, with watered-down ink in his pen, the point glides over the surface with minimal resistence.

A search for personal significance

Both writers and artists are advised by their teachers to "do what you know." Feelings is black and his world is black and he does what he knows, but because he aspired to enter the predominantly white art profession, he was advised to create a separate portfolio to show when looking for work. This contradiction forced him to a decision. He had long since dropped art history courses because he couldn't identify with what was being taught and he would not readily imitate the current trends and styles in the illustration field as they "spoke a foreign language" to him. To find something more significant, Feelings had turned inward, in a process of re-discovery, to "see what was there." Now he could look outward again, but not as before, not as a spectator. He could leave his insular environment for a broader look.

Assignments from *Look* and *Reporter* magazines dealing with problems in the South enabled him to trace the steps of his parents and grandparents along the slavery trail in their background. As he puts it:

"I had to see for myself what the black man's life is all about. I had seen the New York ghettoes—I had lived in them all my life. In the South I saw some beautiful countryside, but I found the faces were the same as the ones right outside my door. Especially the kids' faces. Their eyes usually tell the story. A child reflects life better than adults who have learned to conceal, push down, give up, or sell out.

"After my trip down South I decided to look into some faces in Africa. In the United States there's a tendency to think that the history of the black man began the day he stepped foot on this soil. Well, we know differently, don't we? It's just that you don't see too much written about it. Since I was discouraged from doing black subject matter (it wasn't *in* yet—but I knew I *had* to), I decided to satisfy a long-time ambition by going to the land of my ancestry to live and work in a country controlled by blacks. There I could draw what I wanted without hearing "Why are you drawing black people?" In a black country, black imagery would be expected, *necessary* in fact, and not just the whim of an 'over-sensitive Negro' as I'd been called so often. I spent two of the most inspired and productive years of my life in Ghana, teaching and drawing.

"I would look at the drawings I had done that day and see a marked difference. I kept asking myself, 'Am I seeing happiness in the children's faces because it's there or because I want to see it?' Well, people I met there—white and black—saw it too. It comes from security in the family, national identity, and a feeling of importance. They don't question their belonging; it's a feeling they're born with. Pride. Heritage. If you've never felt insignificant, you don't have to search for your significance as I did. I returned to the States with the need to express myself as a man through my art."

A matter of influence

The influence of blacks on art has been profound despite the lack of information on the subject. A CBS television series, "Of Black America," has made available to the general public some little-publicized facts, such as the African influence on art of Picasso, Matisse, and Modigliani. Programs of this nature are certainly a step forward, but we must not lose sight that it is but a small step and very late in coming. To a great extent the damage has already been done. It's obvious that the art world benefits from all the great art that has been produced, but how can we measure the loss of art that never was allowed to be?

Learning, in general, is an imitative process. Through exposure, we can assimilate the thoughts and ideas of others. And we choose our heroes very early in life. When our eyes begin to see beyond the heroes in our immediate surroundings, (members of the family in most cases), we focus on the "greats" of the new interests we're acquiring. A young Negro with athletic interests could identify with greatness easily—he had only to turn to most sports to find a black champion. Likewise with those with musical interests. But with the exception of sports and certain entertainment areas, there have been relatively few blacks elevated to a level that an impressionable black child could look up to and hope to emulate.

For this reason more than any other, Tom Feelings consented to appear in this book. I knew only the signature affixed to drawings I had seen published in various magazines, and since they had that on-the-spot look and feel to them, I decided to contact Feelings through the services of the Society of Illustrators and question him further. Our first meeting was a fiasco. I was armed with "art questions" concerning his work which he couldn't care less about, and he, in turn, was interested in participating more as a black than as an artist, which I was totally unprepared for.

"I'm not the best artist who ever lived," Feelings said, "but I work hard at it and I'm good enough to make a living drawing. You saw some of my work. You liked it. You didn't know I was black or white or green. But it doesn't make much difference to me if you like my work or not, really. There's a black kid somewhere out there that I'm hoping to reach. Maybe he'll see my work and maybe he'll like it. Maybe he won't. That doesn't matter. What *does* matter is he'll say—'Hey, this Feelings cat is *black*!' Then maybe he'll pick up a pencil and draw his life and what's around him. If that happens, then maybe I will have done something."

Feelings' work follows...

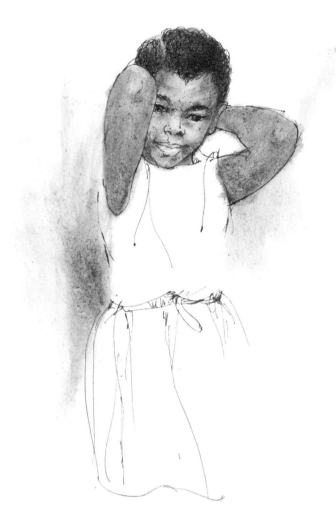

(Above) *Young girl, Ghana. Here, in a schoolyard in Accra, Ghana's capital, Feelings would relax with his sketchbook, observing and drawing children at play. Young people have always been of special interest to Feelings, and he devotes much of his on-the-spot work to drawing them. They're usually curious and cooperative subjects, but grow impatient quickly. Engaging them in idle chatter often helps to hold their attention for a more involved study, but it would serve the artist more to concentrate on quickening his drawing speed rather than improving his conversational abilities. This drawing was done on a medium-surfaced sketch pad, with an Osmiroid pen filled with black Pelican Fount ink. The wash was brushed in on-the-spot using the same ink and a #3 Winsor-Newton watercolor brush.*

(Right) *Women at a bus stop, Senegal. While he waited for a bus in Dakar (the Senegalese capital and western-most point of the African continent), Feelings sketched two native women in* bubas, *their everyday wear. He worked with a thick round pencil of deep black intensity, and used the edge of the blunt point to pick out details in the faces, as well as certain outlines. The structure of the drawing set, Feelings began to brush subtle washes over the entire drawing, keeping the standing figure's* buba *and the seated women's headwrap the lightest in value. Once completed, the artist felt he had created more interest than he wished in the center of the drawing: the light areas were too stark against the surrounding darks. To offset this, Feelings used opaque white to silhouette the figures and signpost.*

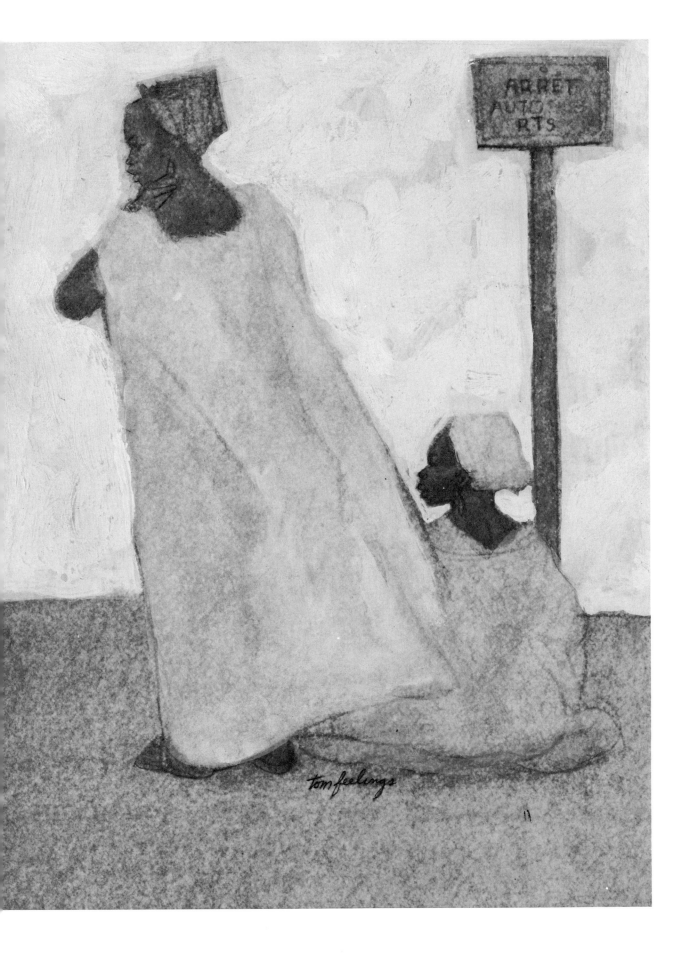

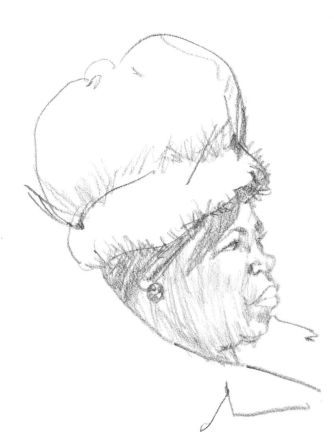

Woman with headwrap, Brooklyn, N.Y. Feelings is very much aware of the racial pride growing throughout this country's Afro-American community. Here, while riding in the subway, he sketched a woman wearing a wrap similar to those he saw in Africa. "The influence of African culture is more evident now than ever before," states Feelings. "The pride we blacks feel in our heritage is quickly becoming a part of our everyday lives. It is reflected in our customs, fashions, and more important, in our feelings of racial importance. I look for this when choosing subjects to draw, as cultural pride is extremely important and I want to express it in my art."

Considering the problems in subway drawing (discussed more fully in Chapter Seven), Feelings' pencil portrait is not far removed from those he has drawn when time and conditions were not as restricting—a fact which is indicative of his ability to draw well under adverse situations. The pencil in this case was of the mechanical variety, housing a soft 4B lead. The sketchbook was inexpensive and spiral bound.

(Above Center) Young student, Senegal. Feelings could speak neither Wolof nor French, the two most widely spoken languages of this country, but found young subjects quite responsive to the language of the pencil. A little sign language also helped, and before long close to seventy-five children had gathered, each waiting for his turn to be drawn. The drawings helped to make his one-man show (the reason for going to Senegal) a success: he had planned showing only drawings compiled in the States, but these recent works added interesting contrasts.

(Right) Afro-American youth, New York City. Prior to his African sojourn, Feelings attended a Muslim bazaar in Manhattan where Malcolm X was invited as guest speaker. Many young people came to the convention hall sporting African dress and accouterments, and Feelings came prepared to graphically record the event. He carried varied equipment so that he could match the subject with the technique it seemed to call for, handling the soft, billowing young man's robe with sensitive, almost diaphanous penciling. Ebony pencil, slightly toothed paper.

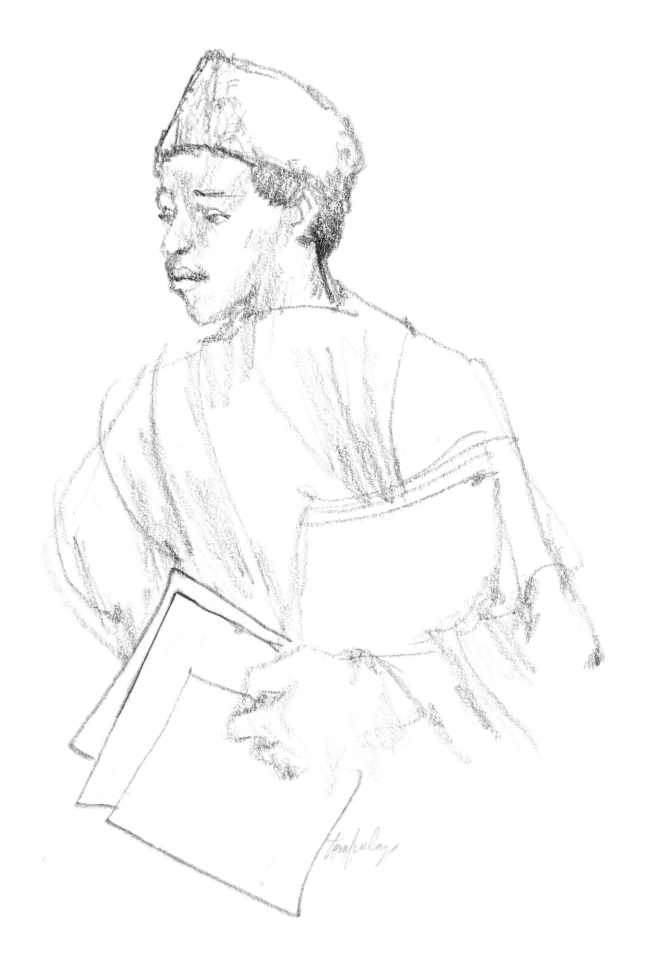

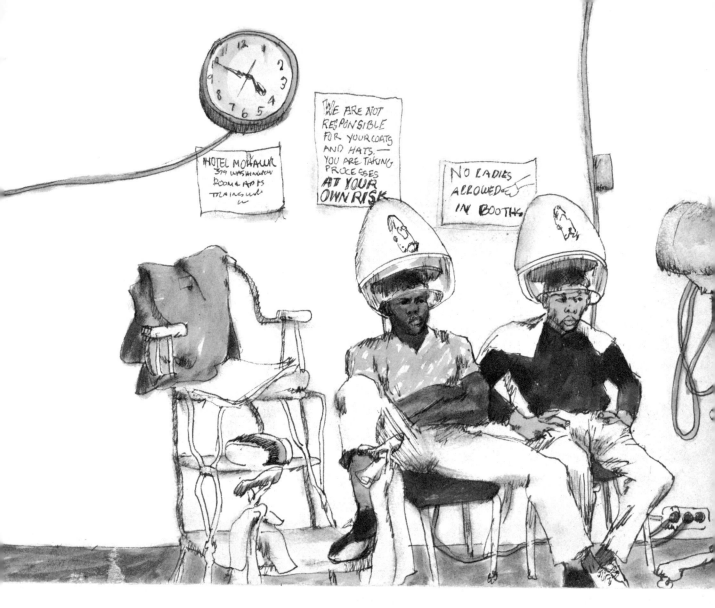

(Above) *Hair straightening, Brooklyn, N.Y. In this sensitive line and wash drawing,* Feelings *reported rather than editorialized. Showing something as it really exists can, in most cases, do more than artistic contrivances to get the message across. In this ghetto establishment, young men undergo a weekly ritual of having their hair straightened. Their thinking has been conditioned by many years of exposure to white standards, tastes, and advertising. "The whiter you look, the better your chances" is a philosophy that was, unfortuantely, believed by* both *factions. It is especially ironic that one of the two subjects pictured in this drawing is a successful boxer who had gained prominence in the neighborhood through his own effort and hard work in an occupation that "allowed" black achievement. Working with an Osmiroid pen filled with slightly diluted (for easier flowing) Pelican Fount ink, the artist concentrated on the outlines, knowing, if time would not permit, he could apply wash later to further the impact of the design.*

(Right) *Shoeshine boy, Senegal. Another example of linking subject with technique is apparent on this double spread: the drawing above was made for impact—the elements are hard, the contrasts powerful; whereas this friendly Senegalese youth (who used to follow* Feelings *around to watch him draw) elicited a gentle response from the artist and was drawn accordingly. The pencil line is confident, not searching or hesitant; and it's light, almost fragile, moving to darker values where* Feelings *wishes to accent. The boy's shirt and trousers, drawn in equal line tonation, are interestingly contrasted by the angular quality and square cut of the shirt, as opposed to the rounder and softer handling of the trousers. The paper is sketchbook stock, of medium surface and weight, spiral bound for drawing convenience. The pencil is once again* Feelings' *favorite—round, dark, and inexpensive.*

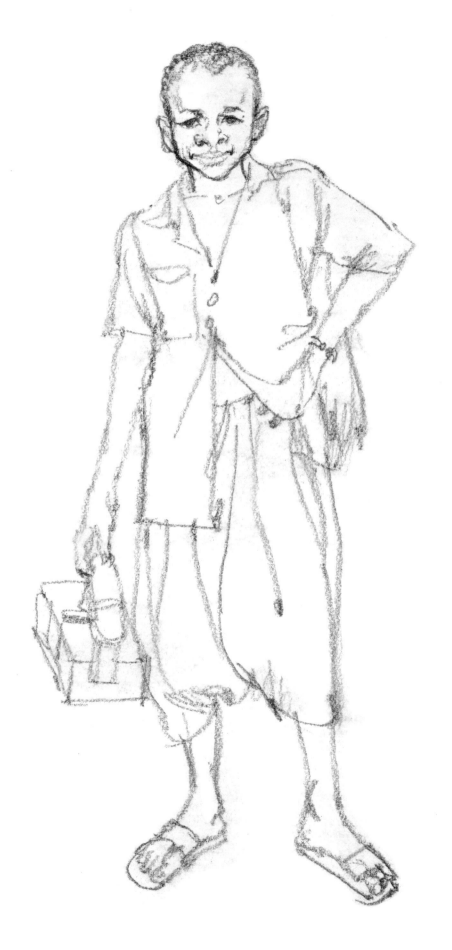

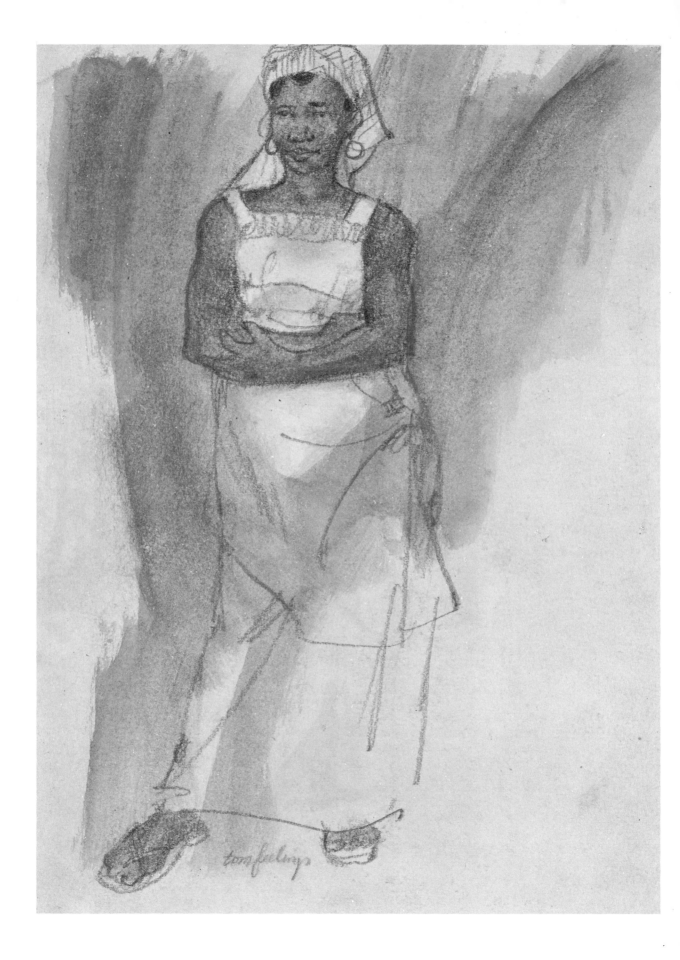

(Left) *Young woman, Ghana. "There was something about this girl, a glow about her, that fascinated me as I drew her," Feelings recalls."The rich tones of her skin against the white dress made her a beautiful subject to begin with, but her face had something special about it." Being rather shy, Feelings inquired about the girl later and was informed by a friend that the girl was married and indeed had a special glow in her face, a glow the artist was to witness again a few years later when his own wife, Muriel, became pregnant.*

(Above) *A booth at the Muslim bazaar, N.Y.C. Another interesting contrast can be made by comparing the above drawing with the one on page 43. Both were drawn the same evening and in the same locale, but each elicited a completely different response from the artist (which of course resulted in different approaches). In the drawing above, the hard lines of the counter, sign, and wall posters, together with the angular qualities of the figure, are more easily and effectively achieved with pen.*

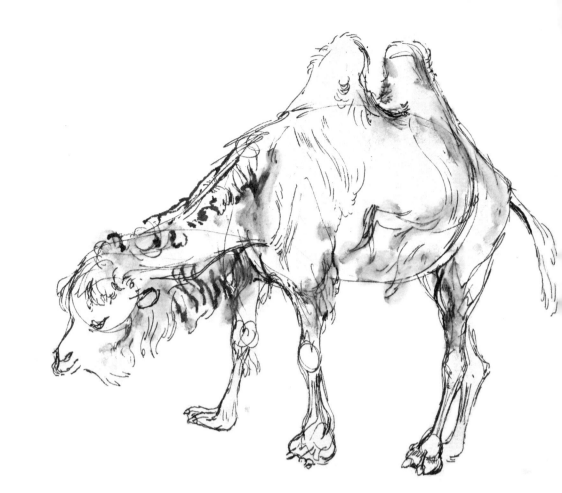

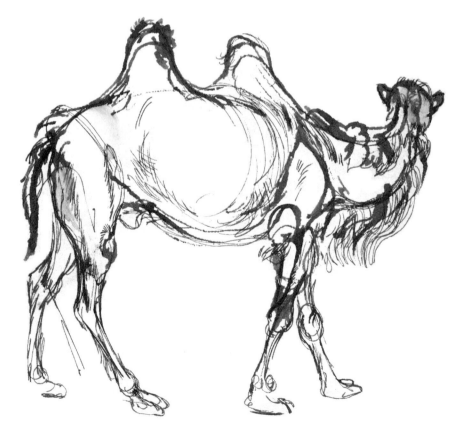

Camels, Central Park Zoo, New York City. The drawings in this chapter were not done for assignment, publication, or samples, nor were they drawn with reproduction in mind. They were simply drawn by Frankenberg for Frankenberg, as information to further his knowledge of animals (one of his strong personal interests). Or perhaps he did them as a rejuvinating pause from another project or assignment, something he frequently does. In the top sketch, the artist concentrated on the hair patterns in the spring shedding period; in the lower drawing his interest was on the leg movement and balance of the walking animal.

4. ROBERT FRANKENBERG

ANIMALS
DON'T
POSE

"I often draw animals," begins Bob Frankenberg, "because it offers me the opportunity to involve myself with the two areas of art that I'm most interested in—discovery and movement. By discovery, I mean the act of learning while executing, allowing things to happen in the picture which you didn't plan or anticipate. This process is inherent in animal drawing, as animals are in a constant state of change. They never quite do what they've done just a moment before; and because *they* are not predictable, your drawings cannot be predictable."

Many artists are more concerned with presenting their subject, be it animals or anything else, as people expect them to look and not as they really are. We've all seen the "calendar art" variety of animal drawings or paintings with the deer, usually in profile, staring across the rushing stream (April) or the meadow covered with fresh-fallen snow (November). They are frozen solid, but not from the cold. The poor beast has been stuffed and planted in the landscape like a museum exhibit, never to twitch his nose or scratch his backside against the rough bark of a tree again.

Well, as Frankenberg has observed so often, maybe the animal *will* appear that way for a split second—"pose" for the camera, so to speak, but it will be for only a split second. Then why depict him that way? It's like painting a snow scene of the city without a footprint or tire mark. It certainly doesn't represent the norm.

"What I try to capture in my drawings," Frankenberg continues, "are the subtle nuances that are natural to the subject, however unnatural they might appear to the viewer. It's a rather Oriental approach, I guess. Animals are busy with their own needs and do only what's best for themselves.

They're not too concerned with how they appear to us."

Avoiding the cliché

Cliché thinking and execution in drawing is mostly due to having formed artistic *habits*. When work suffers from this ailment, the symptoms are obvious; they ache from "sameness." The design, composition, color, or technique approach is similar, and one drawing can practically blend into another. Worst of all, the steady climb of improvement and discovery has given way to the lateral crawl of self-satisfaction. In short, you're in a rut!

One way of breaking the artistic habits you've formed is to go out and draw something you've never drawn before. By attempting something new, something altogether different, you can't possible rely on past successes or on that which you already know; it helps you change your mind patterns.

"When I want a change," Frankenberg discloses, "I go out and draw animals. It helps me learn how to *see* again. An artist can only continue to grow if he can recognize change. He must focus his attention on new problems, then deal with them through an entirely new outlook. These discoveries make a drawing live and give it a touch of reality, rather than the accuracy or the rendering that so many artists get involved with."

Frankenberg's approach, then, is one of searching as well as presenting the natural state. He satisfies both the naturalist who views the drawings as animal studies, and the layman who delights in the artistic rendition of the subject. They are accurate despite the simplicity with which they are executed, and are not detailed to death like a textbook plate.

Techniques for sketching animals

To maintain this crisp handling, Frankenberg employs, for the most part, a common fountain pen filled with black or brown writing ink (watersoluble). His pad is of medium weight, slightly toothed paper. For tonal variations, he will often moisten his thumb or index finger on his tongue and proceed to smudge the areas where he wishes to bring out a form or indicate volume. The effect, when completed, resembles that of a conservatively applied wash over a pen drawing.

On occasion, he will actually carry a small container of water, sepia ink, and a red sable watercolor brush for "real" wash drawings. Or he may apply these same materials to brush (rather than pen) drawings. The brush stroke can be applied even more swiftly than the pen and covers a broader area, thus lending itself nicely to quick action studies. In these, the details are almost completely ignored to allow for concentration on movement.

"I am very interested in the anatomy of movement," Frankenberg emphasizes. "More than just the action or what the *subject* is doing, movement, in this case, is what the *picture* is doing. For instance, a bunch of lines scribbled across a page are meaningless, but by arranging the very same lines in certain ways we can create abstract forms. By arranging them once again in a more familiar pattern—like the shape of an animal—we can achieve *recognizable* forms and communicate a different idea entirely. By incorporating both the recognizable and abstract forms and shapes, we can create the sense of movement in a picture."

Drawing quickly

The problems involved with drawing animals are not limited to the availability of the creatures. Granted, if there's no zoo or preserve in the area, the artist is limited to whatever local wildlife is available after the supply of domestic animals is exhausted. You can take just so much of Aunt Clara's Tabby or your neighbor's Prince! But the real problem is the animals themselves. Like the man says, "Animals don't pose."

"The speed you're forced to work with is of great concern to the novice. A dog running or a horse jumping is an action that can start and finish before you've had the chance to put pencil to pad. I usually advise the beginner not to start with action drawings and limit his initial attempts to animals sleeping or at rest. Here, at least, the 'pose' is usually held long enough for you to get something down on paper. As you become more familiar with

the animal—its proportions, hair tracts, and some of its more obvious anatomy—you'll be able to say more about it in a relatively shorter time when you do start the action sketches. As I draw, I try to sense the movement of the bone structure underneath which helps make even the roughest attempt a little more convincing. Indications such as these make discernable which is the deer and which the horse."

In the beginning, patience is more than a virtue. It's an absolute necessity. You'll be off to a good start if you don't concern yourself with coming home with a gem suitable for framing the first times out, and concentrate on the new problems at hand. For a start, familiarize yourself with the animal you choose to work with. Explore the properties of various drawing materials under these new circumstances; will they hold up under rapid use and say what you want them to say when you want them to say it? Are you comfortable enough with them so that you never have to give them a second thought when you're involved with the drawing?

Observe, don't look

"There's a difference between looking and observing. We've all looked at birds in flight countless times. Unfortunately, very little learning comes from it. A test of this would be trying to draw one from memory. It's frustrating to realize how little we know about a common, everyday occurrence like this. But once you've observed, studied, made *mental* notes, and, of course, *drawn* as many notes as possible, your thinking will change. You'll begin to think of how and why the bird does what it does, and it's just this sort of thinking that makes the difference between the life-like study and the cliché we spoke about. Your sketches will begin to show more action lines than outlines, and that alone will prevent the 'stop-action camera' look that the non-observer gets caught up in.

"The learning process is just as exciting as the drawing process when you begin to see beyond the isolated action, to what happens before and what happens after. Once you know the meaning and reason for the movement, you can draw it much more convincingly."

The remembered image

There's no denying that animals are difficult to draw, but once you've reached the stage where you can observe and put down a few quick lines, you know they're not *impossible* to draw. Observation has familiarized you with some of their movement patterns in the restful state and that will aid you when

you sketch the animal in full motion. Recording the image in a pad is the goal, but recording it first in your mind will enable you to achieve that goal.

"A remembered image has a great deal of visual impact," Frankenberg sums up. "With it you can retain a lot of information for a long enough interval to draw it accurately. In reality, you're combining what you've seen, what you continue to see, and what you may see again if the animal approximates the same motion. The result is a free-moving study that's a compilation of many images. And once completed, you'll find the knowledge gained by this experience applicable to drawing other animals as you notice similarities in balance, glide, leap, take-off, or landing. The characteristics of all members of the cat family, for instance, housecat,

lion, lynx, leopard, and the rest are extremely similar, as can be observed when they curl up to sleep, drink, stretch, or wash their fur. Each subsequent drawing you make will continue to strengthen that very important remembered image."

The drawings in this chapter were chosen from the numerous on-the-spot sketchbooks Bob Frankenberg has compiled on animals. Though they're but a small part of his artistic interests, their importance and influence on the total of his work is immeasurable. They were drawn for himself without a thought that they might someday be seen by others or reproduced in any way. Because of this, they serve the reader even more, for much can be learned from the intimate, self-serving drawings of so dedicated an artist.

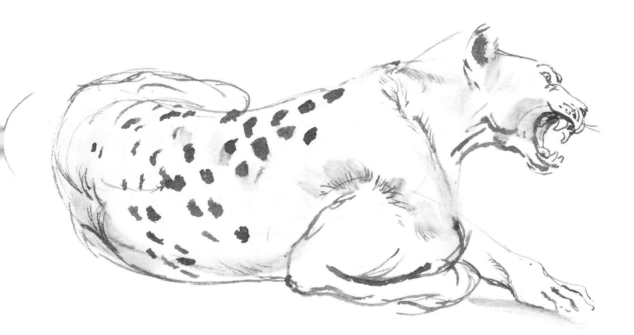

Leopard, Central Park Zoo, New York City. Sketched quickly to establish the basic structure, Frankenberg's intent here was primarily to study the form. Using a common fountain pen filled with water-soluble black ink, the artist indicated the form by light and shade (moistening a finger and smudging the ink) and by the animal's markings, drawing the spotted coat in perspective—fuller and rounder spots when viewed straight on, eliptical in shape as it recedes back. With no attempt made for a "finished" drawing, Frankenberg did not try to subdue or eliminate his guidelines—the left leg can be seen through the neck and chest area that overlaps it, and changes in position of the hind leg are noted by contradictory outlines.

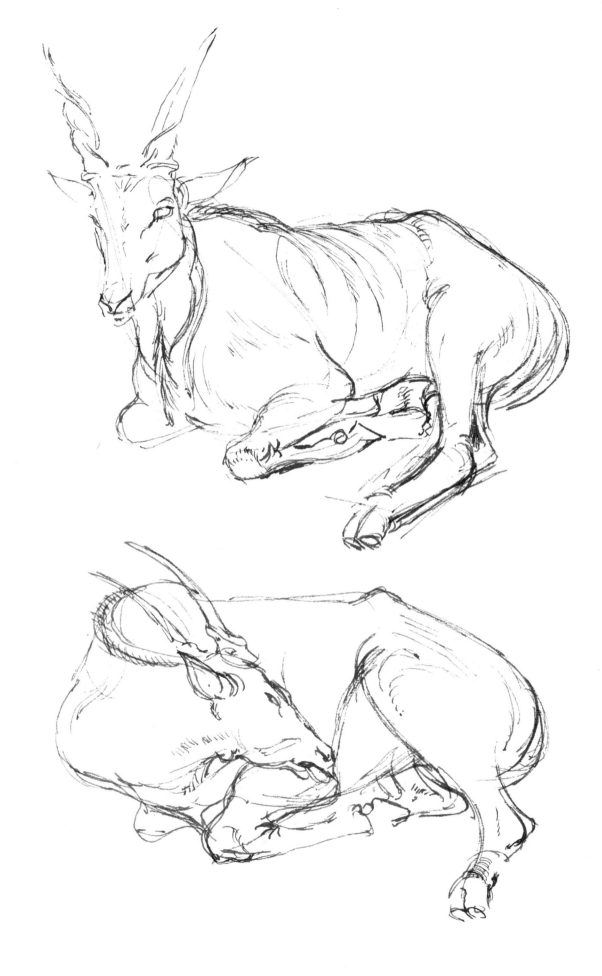

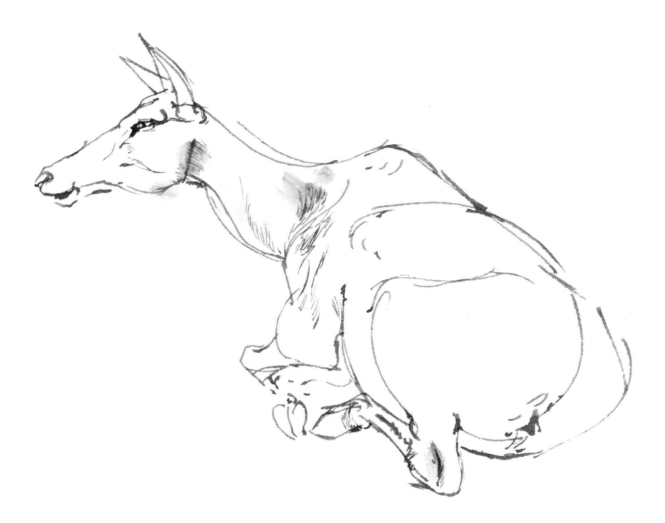

(Left) *Two studies of an eland, Central Park Zoo, New York City. Frankenberg will often draw an animal at rest and then wait for movements or shifts in body position to make further studies to compare with the first (as was the case here with the eland, an East African antelope). The several sets of lines depicting the animal's left hind leg indicate what little movement occurred while the artist made the first sketch. In the second, we see how the leg was drawn forward to meet the head for the licking action to take place, returning to a point beyond the original position after the action was completed. Not concerned with a "pretty" picture, the artist draws to learn, the drawing being a lot more effective in its personal approach and in the natural realism that results.*

(Above) *Elk, Central Park Zoo, New York City. Frankenberg will also draw families or similar types of animals in the same afternoon for further comparisons. In this drawing, the elk is observed in a resting position not far removed from that of the eland opposite, but is seen from a different angle of vision (the fence surrounding the elk area preventing study from the same vantage point). Frankenberg draws quickly; his line is the result of careful observation beforehand, sure, steady, and flowing. For him, the fountain pen offers a crisp line that is fine enough for detailed work and dark enough for clarity, resulting in drawings that are accurate, informative, simply recorded, and without pretension. He will sometimes use sepia ink instead of black, but this is more whim than anything else.*

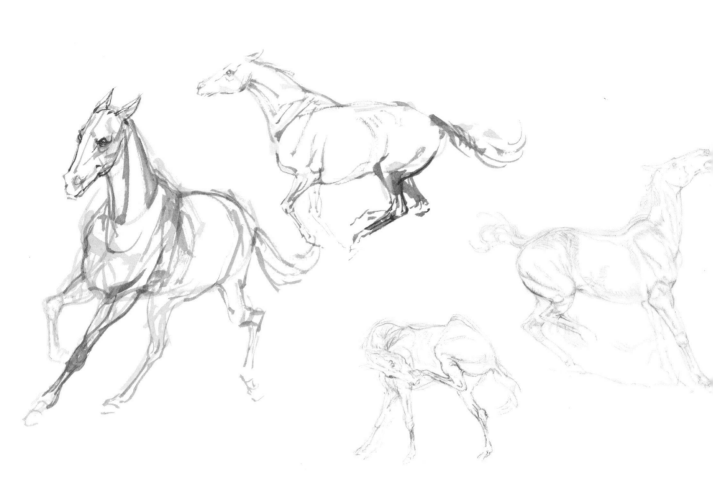

(Above) *Worksheet from a horse farm in Pennsylvania. Because his animal studies so often serve him as reference material, Frankenberg attempts to group subject matter together as much as possible. Larger worksheets with only one or two studies will often be packed along with unused paper if the artist believes there will be opportunity for further drawings of the same subject. The worksheet above is compiled of drawings made on two separate occasions at the same location. The sketches on the left were quick brush and ink studies with the artist's attention focused on the action (the neck and leg positions in particular) as the horse was being exercised. The pencil studies on the right are smaller, the emphasis this time on balance. The horse was corraled, offering more time for Frankenberg to work with greater deliberation and concern himself with details not readily available. In both cases, the "remembered image" comes into play: the artist observes, then draws what he's seen, as well as what he knows from having seen and from having drawn the same or similar things before.*

(Right) *Canada Geese, Larchmont, New York. The artist made these sketches at a protected pond inhabited by several varieties of water fowl. He concentrated primarily on the characteristic actions: the spring-like quality of the neck uncoiling to snare an insect in flight, or on the water's surface; the way the head is covered by the wings in sleep; how the water is shaken from the body and the wings inserted in a "pocket" to keep them dry for quick flight. Frankenberg was observing, in his own words, "Just birds going about being birds." He will often write pertinent notes on the worksheet to remind himself of particular idiosyncrasies or colorations, or, as in the case of the bird at the extreme right (two-thirds down the page), his notes take the form of arrows to indicate "what goes which way when." The artist considers sketches like these visual notes, observations of as many different actions as he could perceive and record in his extremely subjective approach. He even goes so far as to reconstruct actions he cannot see by piecing together information he can—as in the sketch of the dive, submerge, and recovery.*

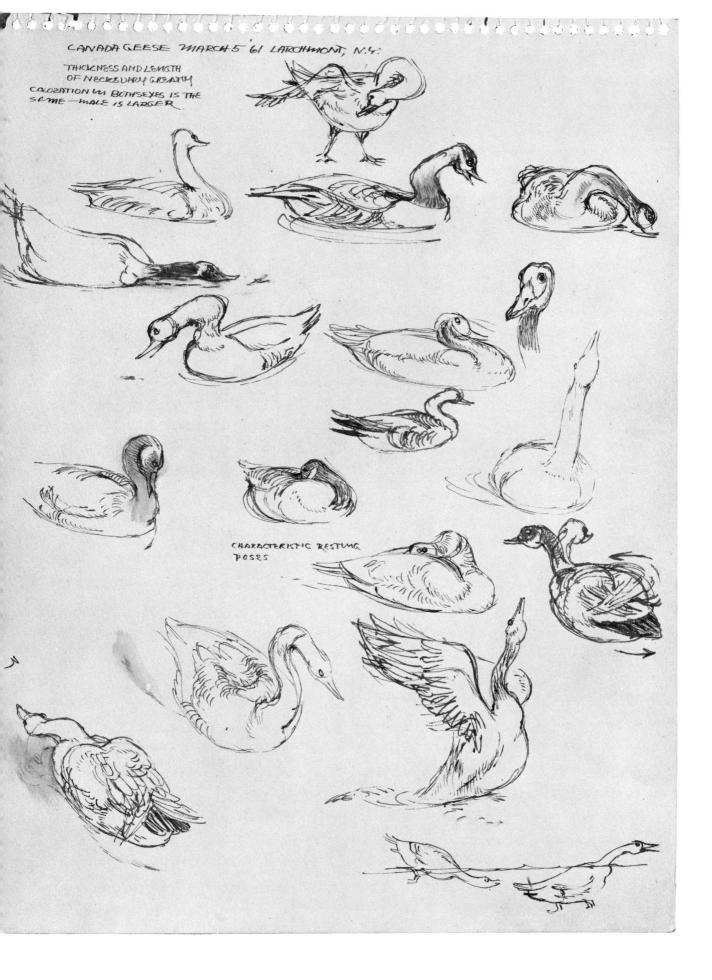

CANADA GEESE MARCH 5 '61 LARCHMONT, N.Y.

THICKNESS AND LENGTH
OF NECKS VARY GREATLY
COLORATION IN BOTH SEXES IS THE
SAME — MALE IS LARGER.

CHARACTERISTIC RESTING
POSES

Red deer, Bronx Zoo, New York City. In these quick sketches, the artist concerned himself with the constant shifts of weight and balance this gentle animal makes to complete an action. Grace and perfect coordination are inherent, it would appear, to every species but man. *Few animals ever sprain ankles, stub toes, strain shoulders, wrench backs, pull muscles, or suffer hernias! Frankenberg is always aware of the natural sense of weight distribution in animals. Erect, the deer is supported by three or all four legs directly beneath him; leaning forward to strip bark, the hind right and front left legs go forward while the hind left and front right go back—these observations are what separate the real from the "would-be" real.*

Rodeo sketch, Abilene, Texas. In small towns and outlying sections of the country, zoos and reserves are not convenient to the artist interested in doing animal studies. Neighborhood pets, farms, pet shops, kennels (even a friendly veterinarian) can provide some variety in subjects. Local fairs and 4H shows come up from time to time, and birds, of course, are everywhere. Circuses and rodeos are also good sources for animal drawing, once the artist has learned to observe carefully and draw quickly. Television nature shows and westerns can also provide material for quick sketches. In this drawing, Frankenberg indicated the action lines of the bull literally kicking up his heels at a rodeo. Many of the lines were ignored as the drawing progressed, and the "correct" lines were drawn over and darkened for clarification. The form was emphasized by dipping the pen point in an ink puddle (created by emptying some from the reserve in the pen's barrel) and then applying it with the broad, top surface of the nib.

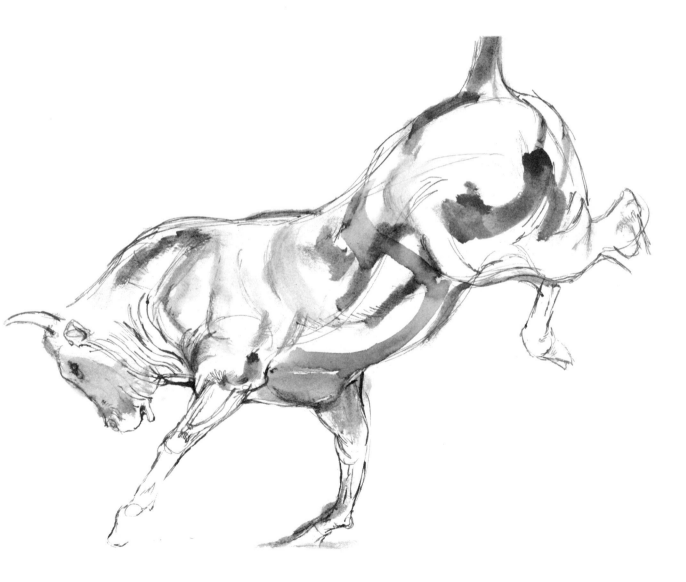

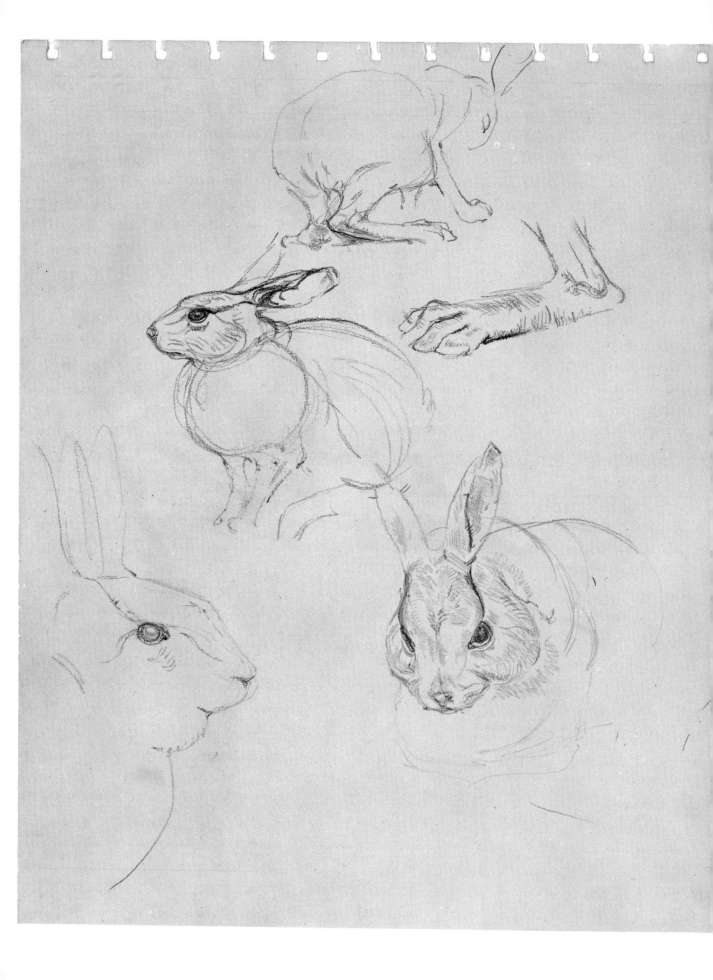

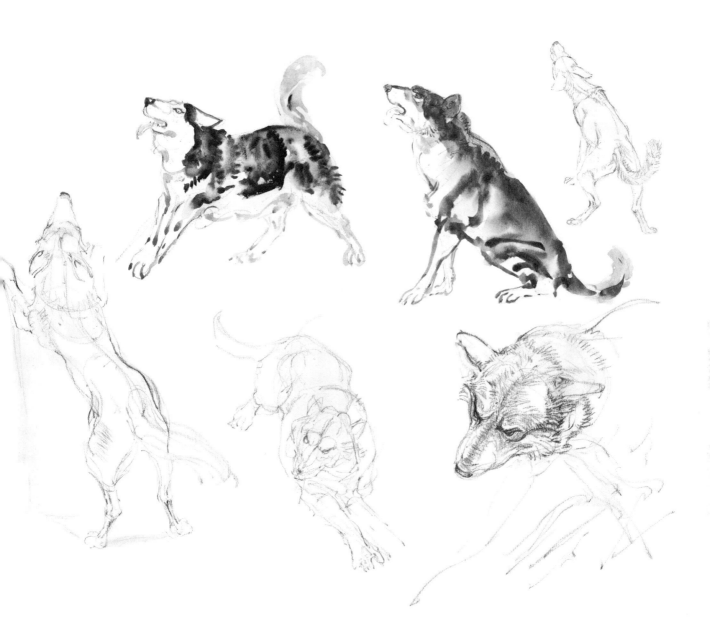

(Left) *Rabbits, Orange County Fair, Middletown, N.Y. Here the artist was able to get close to the animals displayed in a 4H Club exhibit and used the opportunity to do more detailed studies rather than the action sketches which are all time and distance usually allow. The pencil was held lightly to produce a faint outline which was then worked over in certain areas for darker delineation. A 4B pencil was used (an excellent degree for this type of treatment, due to its capabilities of producing a wide tonal range pursuant to hand pressure). The drawings are the same size as the originals, the artist's pad measuring about the same as this page.*

(Above) *Worksheet from a kennel in New Jersey. Frankenberg started these dog studies with brush and ink wash, switching over to pencil for convenience. The rows of fenced dog areas are more conducive to standing, while the brush, water container, ink bottle, and pocket-size palette for mixing the wash more or less demand a squatting or sitting position. Seeking similarities or contrasts, the artist observed the hind leg positions of one dog as it leaned forward on its front legs (upper right) comparing it with the hind leg positioning of another dog leaning with its front legs on the fence (lower left).*

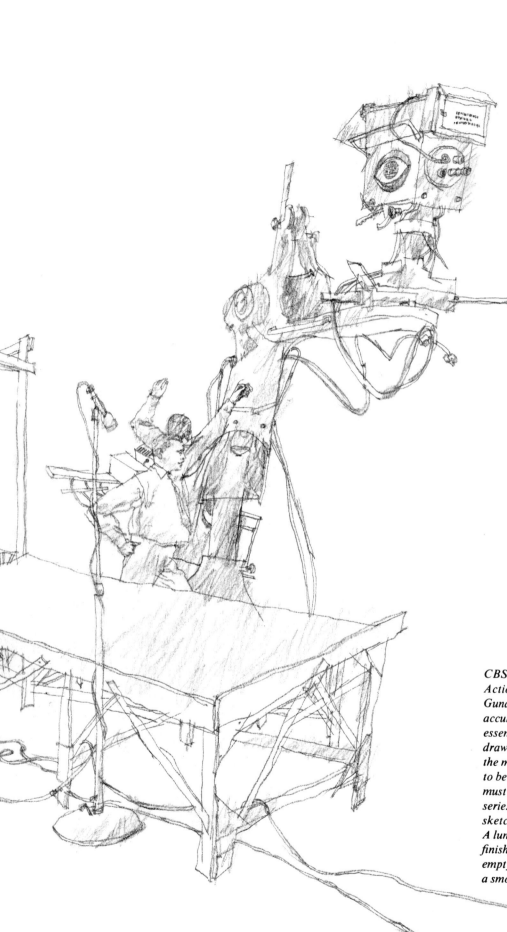

CBS Television Studios, New York City. Action studies are particular favorites of Gundelfinger. He draws swiftly and accurately, concentrating always on the essence of the action. Prior to the actual drawing stage, Gundelfinger learns about the man and the function he will perform, to better understand what his drawing must portray. In this drawing, one of a series for a self-imposed project, he sketched a camera team at work filming. A lunch break was called before he could finish, which explains the cameraman's empty chair. Drawn with ebony pencil on a smooth, spiral-bound sketch pad.

5. JOHN GUNDELFINGER

THERE'S A DRAWING EVERYWHERE

"There's no such thing as 'interesting subject matter,'" maintains John Gundelfinger. "What's interesting about any subject is what you as an individual feel about it and what you as an artist do with it. There have been interesting drawings made of what might be described as 'uninteresting subject matter' just as there have been flops with subjects that beg to be drawn. The fault is not with the subject but with the artist.

"Although I believe there's a drawing everywhere, I don't draw *everything* I see. I draw only that which moves or interests me at the time. The reasons for being stimulated perhaps can be explained psychologically later on, but it's of little concern to me. I don't question an inspirational moment; I succumb to it. The more you observe and draw, the more possibilities arise even from areas that most would consider dull (consider Van Gogh's chairs, for example). The point is to draw first and ask questions later, for if the process is reversed, there'll be too much thinking and theorizing being done and not enough drawing."

John Gundelfinger's drawings seem like "naturals," as if the picture were there and all he had to do was draw what was in front of him. But this can never be the case. You have to *see* a picture first, and the seeing is done with an educated, sensitive eye, not with a lucky one.

Reaction to subject matter

Too many of us, in our search for an artistic Eldorado—the ideal subject—look far and wide for it, and as a result ignore what is right under our collective noses. The motorcycle we curse at for taking up a beautiful parking space is the same one that Gundelfinger draws and wins a prize or award for. Sure, it was there all the while, but the artist's reaction to it makes all the difference.

I have experienced this sort of thing several times, having accompanied John on drawing trips or museum tours while interviewing him for this chapter. He stops before a tree that "gets to him" and does several studies from different angles, each drawing reflecting the change in mood brought about by the position variations; the light and shade aspects of sparkling sunlight on the upper side of the leaves against the deep shadows of the underside; the movement of the branches, twisting and turning in a hundred different directions. And so a drawing trip seldom gets past the first tree we come across.

"When confronted with the object or person I'm drawing, one graphic idea always leads to others. The ideas may be 'feelings' rather than thoughts, or a combination of both but the fact remains that each drawing lends itself to many.

"There's also a logical approach to certain subjects, one that should be considered before you begin the drawing, and that's an understanding of the action taking place. In industrial drawings, for example, I try to familiarize myself with the action or function before me so that I can depict a pertinent moment rather than one which is graphically beautiful but worthless in depicting the nature of the action. In this sense, an artist relates to the photographer. He has the ability to reproduce what he sees, but only a novice does it indiscriminately."

Learning from mistakes

"I never know what a drawing will look like until it's finished," says Gundelfinger. "Once you do—

that's security; and security is something we can all do without in drawing. It comes from working in a particular way or style that enables you to control any subject or situation you encounter, and once you're in control you've stopped learning. The nervousness and anxiety that precede a drawing are important to the end result, and certainly more of an asset to it than mannerism can ever be.

"I often learn more from drawings that *don't* work out, studying the unsuccessful attempts to see where and why I went off. I can learn more from my mistakes than from a drawing where everything fell into place easily.

"The drawings that succeed do so in some measure because of the failures I've learned from preceding it, and so certain pitfalls were unconciously ignored while drawing. Here, too, a great deal can be learned, but *conceptually*—not stylistically. It would be of little use to try and copy or imitate a good line, shading technique, or composition. Repeating a past success is no real accomplishment."

The artist as his own critic

When an artist tries to compete with nature—with all of life's depth, color, atmosphere, light, shade, and action—he's bound to come out second best. In the process of trying to duplicate all you see before you, a lot of paper will be crumpled, a lot of pencils smashed, and a lot of profanities tossed into the air. You're not there to imitate life—you're there to do what no one else in the world can do—and that is to draw *your* impressions of that which moves or interests you. This is what on-the-spot drawing is all about. As the artist, you are the observer and the reactor, a difficult enough task without taking on the job of critic as well.

This is not to suggest that an artist cannot be a good judge of his own work. It's just a question of *when*. For his own good (and possibly his sanity) he should never judge his work *while* drawing. Anyone truly involved in a drawing is just too close to it to be able to evaluate with any degree of accuracy. It's a common experience for most artists to come away with a good drawing only to be disappointed the next morning when a subsequent look discloses that it *wasn't* all that good. Of course, the reverse also holds true—the surprise of discovering a good drawing in the midst of your 'loser' file is always a pleasant experience.

The point here is that it may take hours days, weeks, or years to get far enough away from a drawing to judge it properly. As Gundelfinger puts it...

"If I stop to be a critic 'en route,' I get too involved with the drawing as 'art' and thereby miss the *essence* of what I'm drawing. And I sometimes lose the excitement that made me begin in the first place. An athlete will look back at his performance and criticize his mistakes, but if he tries too hard to alter things while in the process of doing them, instead of just doing his very best at that moment, everything, including the things he was doing well, will suffer. Drawing is similar. It's too much a physical and emotional thing to endanger the process by a halt in the proceedings while the artist becomes the critic."

It would appear, then, that one method of insuring ourselves *against* ourselves is to save everything, for a reasonable time anyway. We're each entitled to our own opinions, and those opinions usually decide what we'll show to others and what we'll keep hidden. It wouldn't hurt our reputations (or our opinions of ourselves) to keep certain personal work in a special hiding place; we can look again when our thinking won't be jaundiced by outside factors and when the memory of the subject is dimmed enough in our minds to allow the drawing to be judged *as* a drawing and not as a carbon copy of what once stood before us.

The role of the sketchbook

Gundelfinger is happiest when drawing from life, whether on assignment or for himself. His summers are devoted almost exclusively to painting, and he fills heavy-stock sketch pads with countless watercolors which, although strong enough to stand by themselves, are primarily executed in order to offer himself the chance to paint larger, more fully realized oils from them later on in the studio.

When away from the studio, he keeps busy with his omnipresent sketchbook, drawing wherever he goes. It reads like a daily appointment calendar—you can almost follow his steps through the paths of that day: from the laundromat to the barber to the diner for a cup of coffee to the grocer on the way back home.

Not one of these things has escaped his passion for drawing; none has escaped his talent for finding something interesting almost anywhere; and none has escaped his remarkable ability to put it down so accurately, with such seemingly little effort, and so personally.

Although most of Gundelfinger's drawings depict the life and the people around him, I'm particularly fond of his drawings of inanimate objects which often serve as surroundings for his life subjects. Trucks and motorcycles appear as though they were alive and quite capable of taking care of themselves —independent of their drivers. Buildings have strength

and sit solidly on their foundations, not like a Hollywood facade braced by 2 x 4's and likely to fall over with the first swift breeze.

Character and movement

"Drawing people in motion is different from most on-the-spot work in that you cannot easily maintain the flow of the over-all drawing. Construction workers or musicians move too fast for detailed portraiture and so I find myself jumping about the page —a hand here, a foot there—and you trust they'll all tie in at the end with a reasonable degree of accuracy and proportion. It's especially difficult with poor lighting, like at a jazz concert.

"Studying people for a while before you begin sketching is a good idea if time permits, as you'll be able to pick out certain patterns of movement. For instance, in a series of drawings I made at a discotheque (see the three drawings reproduced on page 66). I noticed that one singer—despite all his moving around—would intermittently return to a particular gesture, providing me with periodic opportunities to capture more accurately *his* character and movement.

"In this way, although I take the risk of coming away with nothing, the drawings avoid mannered solutions. So many artists who 'sketch' from life are merely 'looking' from life, actually working more from memory than from the subject. They can complete a drawing without endangering the result, but it's precisely this 'endangering' that will make a drawing superior in gesture, action, or feeling, rather than populated with people all having the same hands and other identical physical characteristics. One of the great thrills of observing and drawing is to capture the unique quality of an individual's hands, and why anyone would sacrifice that feeling is beyond me."

Working on trouble spots

Gundelfinger came to on-the-spot drawing by the same route most students discover it—"trouble-shooting." The difference is that once he had found on-the-spot drawing, he wouldn't let it go and still prefers it to any other method of working.

"Trouble-shooting" is the extra work an artist puts in when he comes to an area that especially gives him trouble—hands, feet, drapery, ear lobes— anything that at that particular stage of development is not up to par or as convincing as the other parts of the drawing. By practicing these trouble areas, he masters their solution.

"I still go through problems or moods—my sketchbook will suddenly contain page after page of backs of heads. How long a mood lasts depends upon when my backs of heads battery feels it has had its full charge. And I think that's the way it should be. A sketchbook should be a personal diary of what interests you and not a collection of finished drawings compiled to impress with weight and number like an old marquee announcement—*50 DRAWINGS 50*.

"A finished on-the-spot drawing is a fortunate experience and should always be thought of as such. It shouldn't be the reason you go out, for the objective is *drawing* and not *the drawing*."

The value of inexpensive paper

Most of Gundelfinger's work is done with litho crayons on lightly-toothed sketch pads, a rather difficult medium and not recommended for the beginner. He also likes to work with a soft, dark graphite pencil, applying oil color washes on-the-spot to take off the harsh black-white edge. For this method he carries a tube of raw umber, a few inexpensive bristle brushes, and a small metal container of turpentine. In all cases, the pads he uses are inexpensive.

"I always advise my students (Gundelfinger teaches Drawing at New York's School of Visual Arts) against costly drawing paper and pads. It's an added pressure to work on an expensive surface—you feel you have to create a finished, polished work—as if you owe it to the paper.

"There should also be some attempt to keep your subjects unaware that you're drawing them so that they relax and maintain their naturalness. I've found, for instance, that looking down at my pad with my eyes only, rather than nodding my head up and down as I draw, will help conceal my activity."

The old cliché that "art is 10% inspiration and 90% perspiration" has, like most clichés, a solid foundation. There is just no substitute for hard work, because this—more than anything else an artist can do—will bring him closest to the realization of his goals.

To mention that Gundelfinger works a minimum eighty-hour week and has been doing this for over ten years will teach *us* very little. Dedication of this kind can only come from within. It can't be taught, forced upon, or begged from you. Let's instead look at the *results* of dedication in the drawings of John Gundelfinger that follow...

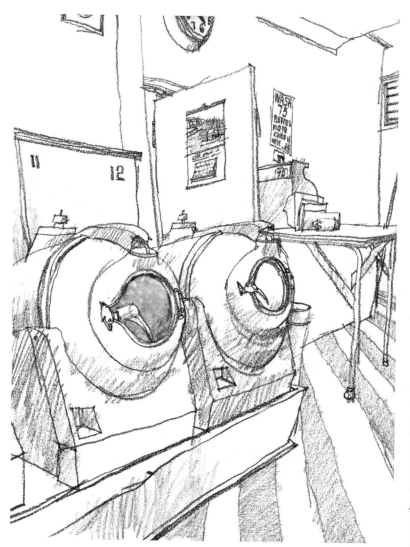

Neighborhood laundramat, New York City. In the fast pace of today's living, no one likes to waste time on such activities as waiting for a washing machine to stop churning. Gundelfinger, preferring white shirts and un-white sketchbook pages, captures the lifelessness of the scene in this room filled with rumbling machines, but void of the people who set them in motion. In this drawing, the artist uses the same tonality for indicating light and shade as he does for indicating "color" in the floor pattern. The wax base of the litho pencil is impervious to water, making it difficult for standard types of wash to be applied. One method of getting around this is to use turpentine in areas where a blending of tone is desired over the pebbled texture (as in the glass window panels of the washers). The turpentine dissolves the wax, leaving a workable, gray solution that's as easy to apply as any water-based wash.

Chess game, Washington Square Park, New York City. Litho crayon is generally not an easy medium to work in. The point doesn't remain sharp for too long a time, whether it be wood enclosed or the popular paper peel-off variety. The artist must keep rotating the pencil as he draws to pick up the new sharp edge caused by the flattening out of the old. In warm weather it becomes even more difficult: the heat effects the wax lead, making smudging almost unavoidable as it melts, however slightly. Heat was no problem in this drawing, as can be noted by the snow around the feet of the spectators and kibitzers watching one of the typical chess games in this park that never seems to notice changes of season.

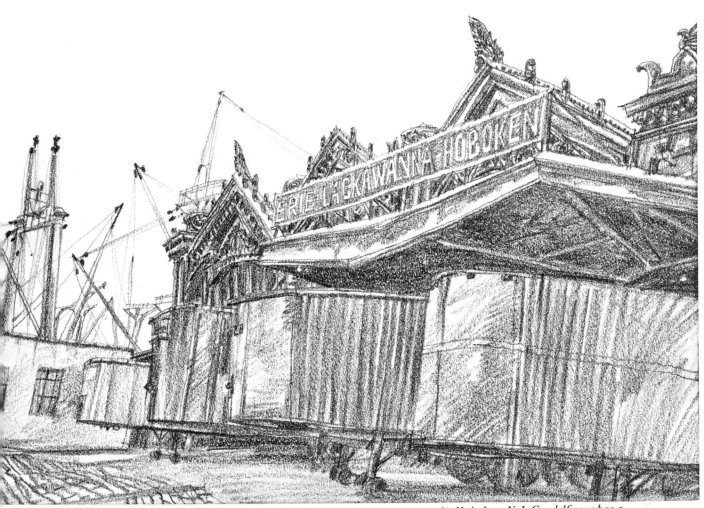

(Above) *Trainyards, Hoboken, N.J. Gundelfinger has a
great respect for craftsmanship whether it be in a drawing,
a handcarved chair, or an aging structure rich in the archi-
tecture of another era, like the Erie-Lackawanna trainyards
pictured above. Trucks and vans now occupy most of the area
left vacant by their steam-engine predecessors, and Gundel-
finger, unhappy about the razing of similar relics, draws it
while it still stands proudly. A litho crayon was used on an
inexpensive sketchbook stock.*

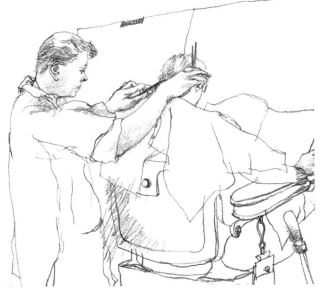

(Left) *Barber shop, New York City. An afternoon in a barber
shop can be grueling, from the dog-eared, two-year-old issues
of National Geographic Magazine to the interminable dis-
cussions about "taxes going up" and "if the Mets could only
give their pitchers a few runs to work with." Gundelfinger
ignores such impositions by trying to capture the barber at
work, his interest centered around the fast, accurate move-
ments of the hands with scissors and comb. The rest of the
drawing is built out from there, which perhaps, is why the
hands and the arm appear slightly exaggerated in proportion.*

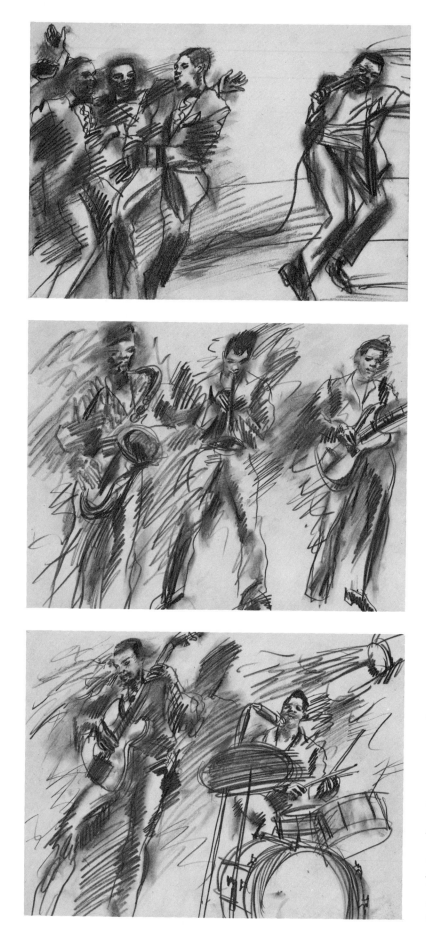

Group performing at Ondine, New York City. An assignment to design a poster for this upper East side discotheque presented Gundelfinger the opportunity to make on-the-spot drawings of singing groups and musicians in action. Fast-moving figures have always been an interesting challenge, but the artist didn't anticipate the difficulties with the available—or better—unavailable light of the establishment. Aside for some spotlights on the performers, the only other illumination was a candle burning at each table. His subject was clearly visible, but his drawing surface (8-1/2" x 11" typewriter bond on a clip-board) was not. He worked quickly (the fast action before him demanded speed), smudging the dark lines of his ebony pencil with a moistened finger for tonal notations. In order to capture the total feeling, he worked on each figure intermittently, skipping to a different one each time the gesture or the movement approximated one that he had observed moments before. Four drawings from a group of twenty were chosen for the poster, which, when completed, was accepted in the Society of Illustrators' 1968 show and subsequently printed in the annual, Illustrators 10.

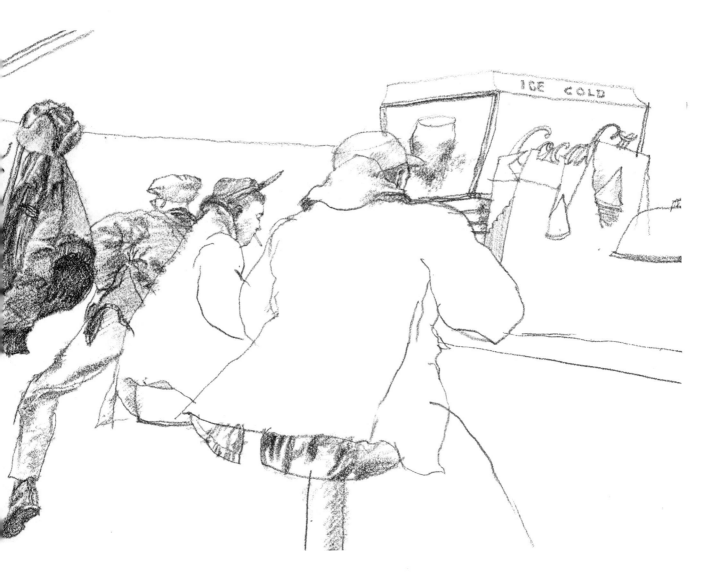

*Diner, Long Island City, New York. This particular area
in Queens is rich in industrial subject matter for the inter-
ested artist: factories housing unimaginable machinery;
auto-wrecking yards with mountains of scrap autos piled on
top of each other; trainyards with long lines of railroad cars,
rails, and power cables in a vast network of complex design.
Gundelfinger, whether for a location assignment or for him-
self, will often pack his sketch pad and take the quick ride
over from his Manhattan apartment to draw the intricate
machinery and the men operating it. Not being paid by the
hour (as most of his subjects were), Gundelfinger doesn't stop
working during coffee breaks or lunch hour; he draws hands
holding coffee mugs that minutes earlier clutched wrenches.
In this drawing, the counter, stools, and Coke machine are
details necessary to spell out "diner," but the jacket and
hat hanging to the left spell out "worker," adding still
another dimension to the scene.*

On this location assignment for a House and Gardens promotional publication, Gundelfinger traced the "history of a house," having access to every stage and level of construction of a large tract of homes under construction. The still life quality of this supply area caught his attention as he was doing an action drawing of one of the workers. The subject would intermittently leave the scene for consultation with the job supervisor, at which time Gundelfinger would turn in the opposite direction and draw the collection of materials, thereby keeping two drawings working simultaneously.

Sometimes a fast-moving figure performs a function which is repeated over and over again (unlike the movements of the singing groups, which are mannerisms or unconscious gestures), enabling the artist, despite the worker's speed, to capture the action as well as some of the related detail. In this drawing, the careful attention paid to the anatomy and to the fold patterns serves as a case in point: the artist had the opportunity to observe the worker repeat the same movements as he worked quickly across the beams in a floor-nailing operation, and was able to add to his visual notes with each row of planks.

An invaluable aid in drawing figures at work is to know what
they're going to do before they do it. Gundelfinger found
most workers helpful if not eager to explain their duties and
to describe in full the action and purpose of their function.
The artist was then able to "size up" a scene more accurately,
knowing what was going to be done, how it was going to be
done, and in what direction the action flow would be going.
The board in this man's hands, for instance, is the same
board at the bottom of the pile to his right. Learning in
advance what would transpire, Gundelfinger sketched the
man as he held that first plank, continued as it was dropped
to the floor and replaced with a second, etc. The background
is noted roughly until the action is drawn, then worked over
with more attention to accuracy and detail, and continued,
if need be, after the worker has left the scene. The drawings
for this series were all done with a litho crayon with turpen-
tine wash in some areas.

Camp Drum, New York. The Army is famous for its "hurry up and wait," but Pvt. Gundelfinger used much of his hanging around time to draw. Here, at this Reserve training camp near Watertown, he sketched trucks and jeeps as they stood parked peacefully and serenely in the cool, early morning air—the antithesis of what they were to become a few moments later as they unsympathetically jostled and bruised the bones of the uniformed passengers en route to various training areas. His drawings of vehicles in particular capture the weight and strength of the machine without sacrificing the delicate nature of some of the details and refinements that are necessary to its operation or auxilliary functions. As for the effective composition, Gundelfinger has this to say: "I seldom think about composition—it generally takes care of itself—nature or man-made structures determine it and the artist has only to draw what he sees."

Grand Central Station, New York City. Once again waiting, this time to board trains to the camp for a two-week sojourn, Gundelfinger finds both soldier and duffle bag sagging under their own respective weights as checklists are being compiled. Using a sepia-colored litho crayon for this drawing (and for the one opposite), Gundelfinger finds the medium helpful in keeping his concentration on the forms and masses rather than on the tonal variations he can achieve with the pencil. The line is direct and, to a large extent, permanent; it lends itself to a more exacting and definite approach. All his on-the-spot work is done on inexpensive sketchbook paper, the artist not wishing to attach too much importance or concern to a drawing before he makes it.

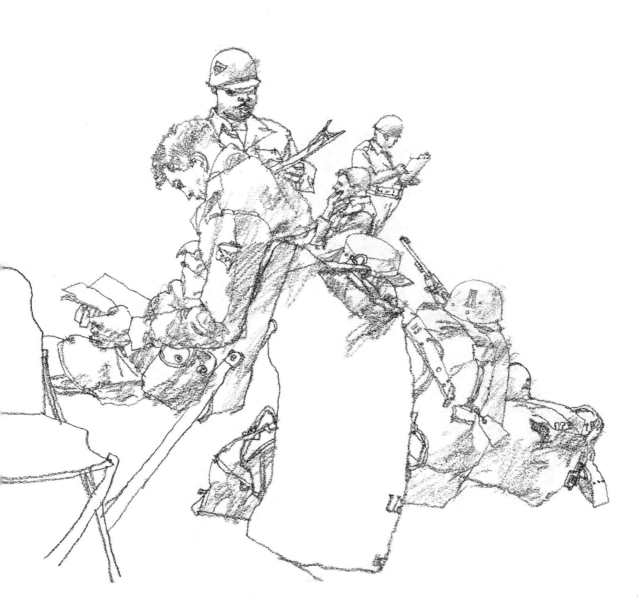

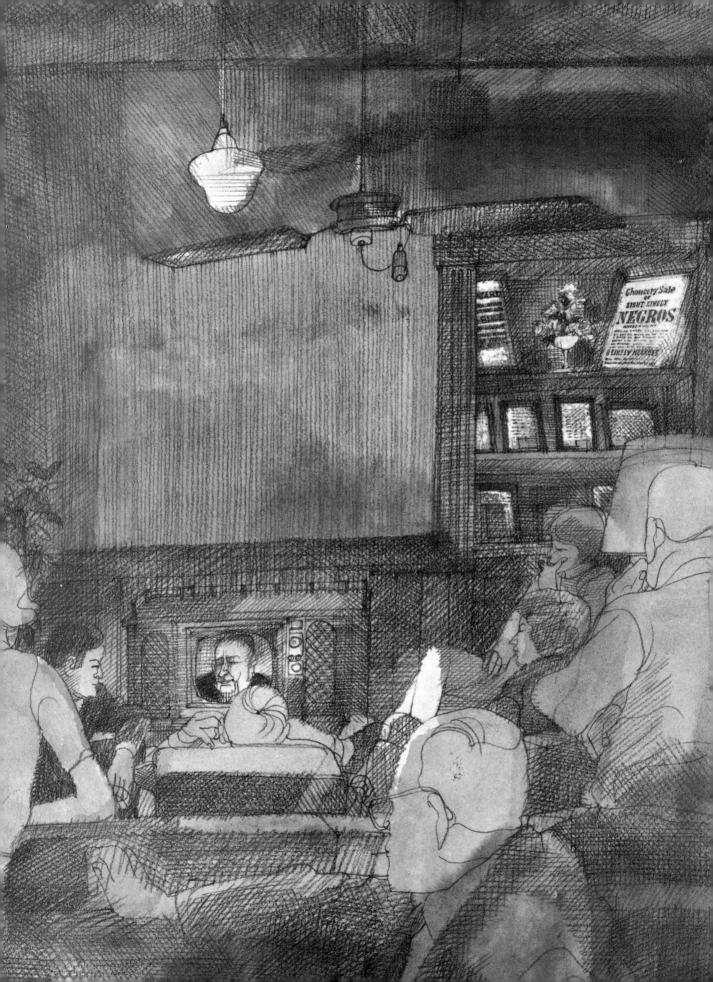

6. FRANKLIN McMAHON

LOCAL COLOR
IN BLACK
AND WHITE

"My approach to on-the-spot drawing is quite basic —I simply rely on the interaction between myself and the subject," states Frank McMahon. "I find that the drawing or painting takes on an entirely different form than what I had anticipated back in the studio, and it's this difference that gives location drawing its special value. Besides, I get choked-up when I work in the studio; I seem to get all caught up in *how* I'm doing the job rather than what it has to say. The best way to beat this is to pack up and go out on-the-spot."

Franklin McMahon is well-known for just that— packing up and going out on-the-spot, whether that spot be a few miles away from his home in Lake Forest, Illinois or a few thousand miles away in Rome, India or wherever else his assignments from major publications take him. And if there's no particular assignment at the moment, then McMahon "assigns himself."

Television room of the Albert Hotel, Selma, Alabama. This on-the-spot drawing was executed March 15, 1965, the night of the march on the Dallas County courthouse. The irony of real situations offer more impact than anything prefabricated. Here, McMahon makes note of the posters of slavery days exhibited in this room as people gather around the television set to view one of the higher points of the Johnson presidency and hear, among other things, Johnson state: "We Shall Overcome." By intricate weaving with pencil, McMahon creates an informal crosshatch that sets the tonality of the drawing and moves the eye around the drawing in a circular fashion, thereby establishing the "clustered around" feeling more effectively. Looking over the drawing later on, the artist felt certain areas still distracted from that feeling and so subdued them further by applying a loose wash. McMahon prefers the Veriblack #315 pencil on good, heavy stock.

"Much of my work is self-assigned. I go out with an idea or premise, draw it, then submit the drawings and captions to publishers who might be interested in the story. This arrangement has worked out very well for me in the long run; I'm able to publish enough of what I do this way to feed my family and pay my travel expenses. In the last couple of years I've made TV programs and three films based on my drawings and paintings, thus further utilizing work that had been done on-the-spot but never published. The films combined ideas from several sources, times and locations to form a single statement."

The before and after

On-the-spot drawing enables a type of picture coverage not ordinarily employed by photographic reportage. The cameras click *during*— seldom before or after the "decisive moment." McMahon, having covered political rallies, conventions, demonstrations for *Look, Post, McCall's, Fortune,* and other national magazines, is well aware that the picture potential preceding and following an event can often be as interesting as the event itself. He tries to arrive on the scene early to familiarize himself with the locale and to capture the feeling of the area. He observes the people preparing for what's about to happen, knowing that the event itself and the personalities involved will always offer a wealth of excitement to witness and to draw.

And afterwards, when the hoopla is ended, when the floor is littered with confetti and the broken balloons of both victors and disappointed hopefuls, and when the chairs seat coffee cups, discarded signs, and banners rather than screaming delegates, McMahon busies himself once again, knowing that

it sometimes takes more than one drawing to present the total picture.

Think in the studio, draw on-the-spot

McMahon thrives on location drawing, but that's not to say that he draws only what's in front of him. It neither begins nor ends there. He's concerned with putting more of himself into a drawing than merely a deft hand. For instance, when asked to do decorative pictures to illustrate the State Constitution of Illinois, rather than depict the action the text described, McMahon chose to draw those whom the Constitution affected— the *why* and the *how* of it. The result, of course, carried much more impact and meaning.

"Where I go, what I choose to draw, and what I'm trying to say is all part of the thinking process. I do a lot of research on the subjects I'm working on, but once I'm there I try not to allow the cerebral approach to interfere with the drawing."

The drawing mechanics

The "drawing" McMahon speaks of is more like a mural. He prefers to work very large, usually on 22 x 30 medium or heavy watercolor paper. A sturdy sheet of paper is practically a necessity considering the physical demands McMahon makes on his work. He ships his drawings from all over the world to waiting editors while he himself continues his travels on new assignments and self-imposed projects. Lightweight paper might not hold up under the strain of packing, traveling, and mailing.

The surface of a good quality stock also allows him to apply a flat wash in order to subdue or bring out a particular area of the drawing, depending upon the compositional design. He prefers to do this later on, however, unless he's on a color assignment, because it is difficult to carry around the various brushes, water cups, ink bottles, sponges, etc. McMahon likes to travel light, and aside from the large, heavy paper, he carries only a few dark black pencils (Veriblack #315), a razor to sharpen them, and a kneaded eraser.

"Too many artists are more concerned with the drawing process than what the drawing is all about. Materials take care of themselves if you use them simply as tools for carrying out your concepts. Once you start thinking about them you lose some of the intensity toward your subject, and this intensity is a lot more important to the drawing than a tricky line or shadow."

The positive statement

McMahon's line is quick and positive, much like a contour drawing in that it outlines, overlaps, and crosses over itself freely with no attempt at formality. Each notation is definite, never hesitant, for McMahon isn't searching as he draws, he's stating.

His figures are recorded with maximum speed and minimum effort. Tone is secondary, a supplement to what's basically a linear approach. He often uses a broad crosshatch as tone, shadow, or to indicate volume, and at times brushes in black India ink where he feels he needs more emphasis in his darks. This last process is usually performed later on in the studio.

McMahon's visual approach

"What first interests me about a particular scene is its natural drama and design. I don't seek out the merely 'picturesque' because everything has a way of paying off as you begin to set it down on paper, and you don't have to search for ready-made scenes. I often change my angle of vision toward the subject while I'm working, walking around *in* the picture to tell the story better. On-the-spot drawing allows you to take a kind of cubistic approach to the subject, drawing it from several angles in the same drawing, and drawing it as you *know* it to be rather than through someone else's angle of vision or emotional point of view, which is why I prefer not to use photographs.

"Working from photographs is like working through someone else's eyes. The photographer has his own point of view, entirely different than the one you'd bring to the subject, and if you use his pictures you're stuck with his views.

"Because I often do a series of drawings on a single theme, I try to avoid the same visual approach as the preceding compositions. Then too, I feel the 'dead center' view is the one we see most often— and the one most uninteresting to look at. Here, too, a walk around the subject will help, if only to give you a chance to see things from a new angle and perhaps give you ideas on new ways of approaching the problem.

"But most of all I believe the drawing, not just sketches or rough notations, but an early commitment to the actual drawing, should take place on-the-spot. This gives artist, pencil, and subject a chance to interact."

The environmental portrait

In drawings where there's great emphasis on locale, it's obvious that the background must be more than a fragmentary indication. The look and feeling of a particular place is impossible to achieve without some attempt at detail indigenous to the area. But it doesn't necessarily have to end there. Even in quick personality studies, whether the subject is a world-

famous dignitary or the neighborhood gossip, McMahon is involved in what he calls an 'environmental portrait' approach. As he explains it:

"Where and how someone lives is as important as how he looks. A man's environment will play an important role in the development of his personality. Details and surroundings are, for the most part, extensions of that personality and therefore must be included to tell us that much more about him. It should not be used only as design props or compositional devices. If a bookshelf tells you something about the person, draw it in. And if the titles of those books tell you even more, then by all means include them too."

The following pages offer further examples of McMahon's on-the-spot work, previously unpublished. The interaction between artist and scene is apparent. McMahon, responding to the visual stimulus—the action, the environment, and the "natural design of things"—has captured the drama of the passing moment, preserved for history by means of a simple, black pencil.

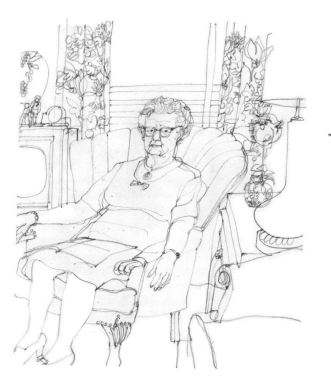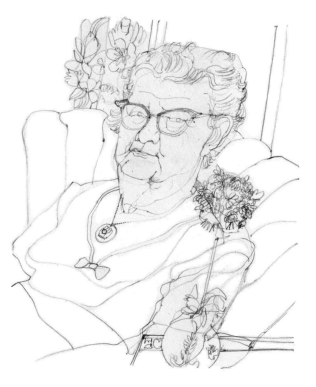

Two studies of Myrt Power, Atlanta, Georgia. In his travels, McMahon has had the opportunity to draw many people, ranging from the world-renown to the man in the street (the latter sometimes a celebrity on a lesser scale). The subject here is Myrt Power, an expert on baseball who appeared as a contestant on the ill-fated "$64,000 Question" game show many years ago. In both studies, McMahon uses the pencil in a linear fashion, foregoing the wide range of tonal variations inherent in the medium. Working in this manner, the artist does his searching with his eye and not with the lead—thus the line is, for the most part, intense, indicating a direct, confident application. This directness, aside from being highly effective, is also a time-saving factor, enabling McMahon to do two or more drawings in the time it would take to do a more tonal rendition. Having finished the full figure study (an "environmental portrait" complete with the woman's favorite chair, flowered drapes, and vase), McMahon was able to change his seat to the one appearing in the first drawing (right foreground) and do a second from a closer angle of vision. Large, smooth-surfaced sketch pad.

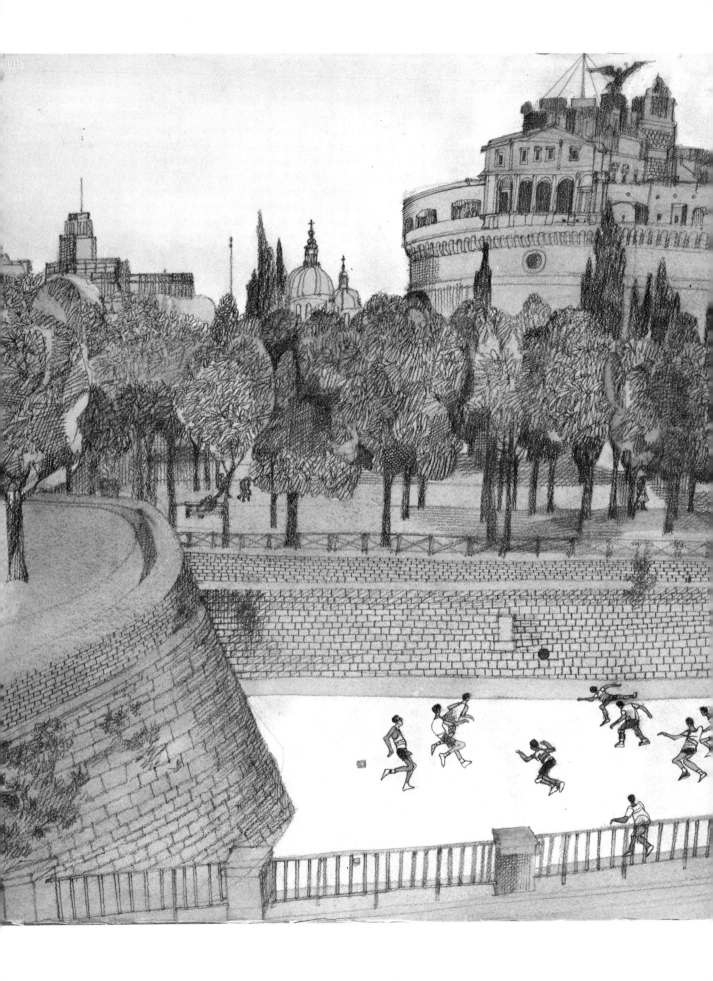

Castle St. Angelo, Rome, Italy. While the moat pro-
vides a playing field for youths engaging in a game
similar to soccer, the awesome structure looms beyond
the trees in the park area. Opera buffs will recall the
castle as the setting for Act III of Puccini's Tosca (the
hero is imprisoned and later executed here; the heroine
leaps to her death from the parapets at the final cur-
tain). McMahon makes good use of the natural ele-
ments in the drawing's design, playing the textured
areas of the stonework and trees against the starkness
of the moat and sky. The shadow areas formed by the
trees in the middle distance is handled with an almost
geometrical crosshatch to keep it closer in feeling to
the intricate textures of the foliage rather than just
solid areas of dark. It also strengthens the contrast
between the textured and nontextured areas even more.
Drawn on a large sheet of heavy watercolor paper
(22" x 30"), McMahon brushed a flat wash over all but
the sky and moat areas while still on the scene.

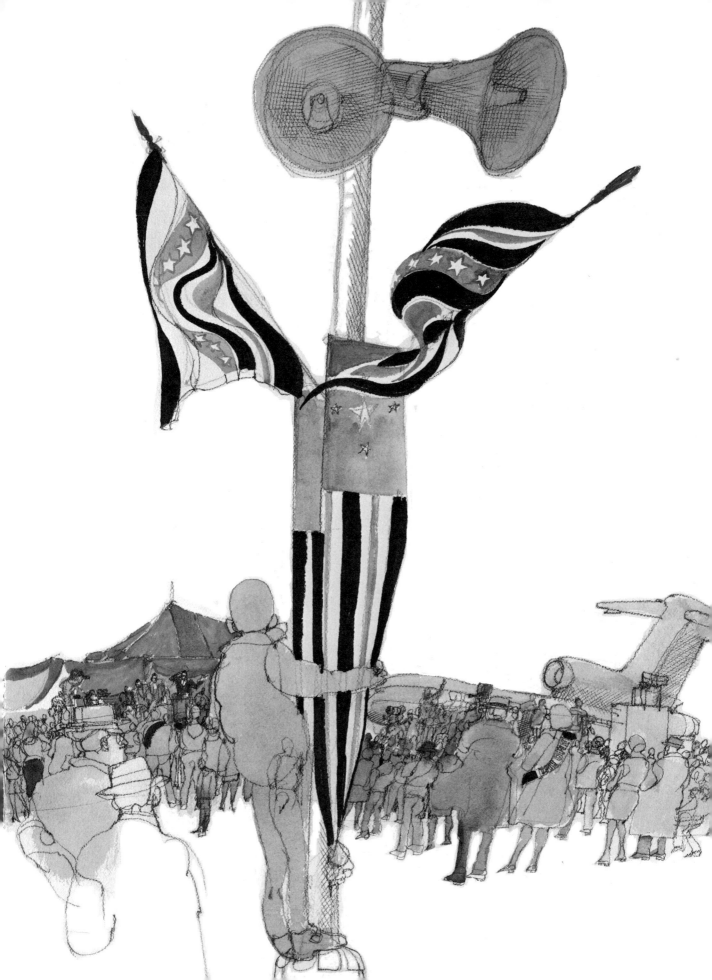

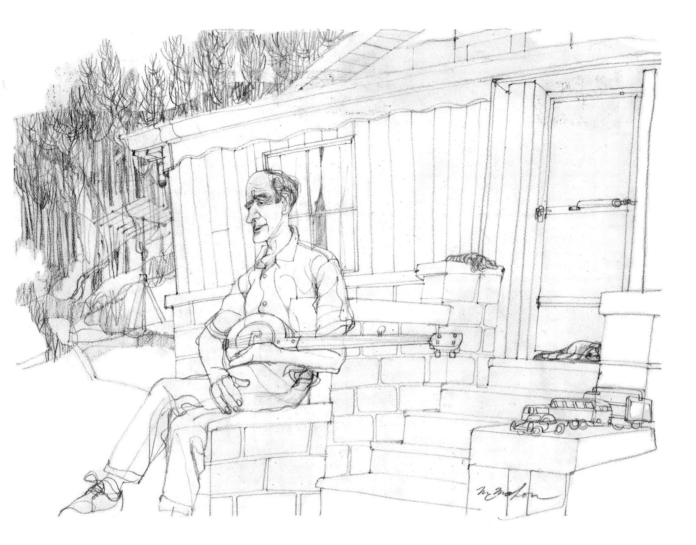

(Left) *Nixon's arrival in Peoria, Illinois. The artist covered the candidate's arrival at the airport with large, quickly drawn line and watercolor sketches. In black and white, as reproduced here, McMahon's exciting use of color is lost, but in viewing the work through a cinematographer's color-reducing viewer (color is seen only in values of gray), it became obvious that the artist's strong line, the foundation for the color washes, maintained all of it's spontaneous, free-flowing effect in gray as well. In black-and-white reproduction methods the color red is the most intense, appearing in print as a deep, rich black. This can be noted in the red, white, and blue bunting and flags attached to the speaker-laden light poles, upon which the boy in the foreground has elevated himself for a better view of the goings-on.*

(Above) *Frank Proffitt outside his home in North Carolina. Proffitt was one of America's best-known authentic folk-singers before his death in 1966. His work had a direct influence on many modern-day folksingers (and "they on him" he said to McMahon as the artist sketched him, motioning to his television antenna installed in the side yard of his house). As they chatted, the singer would occasionally strum a few chords and sing a few bars, but for the most part he sat comfortably on the stone porch, cradling the instrument that had brought himself and countless others so many moments of pleasure. McMahon, in keeping with the freedom on-the-spot drawing has to offer, doesn't concern himself with exacting horizontals or verticals, the "leaning" left side of the structure adding charm to the sketch.*

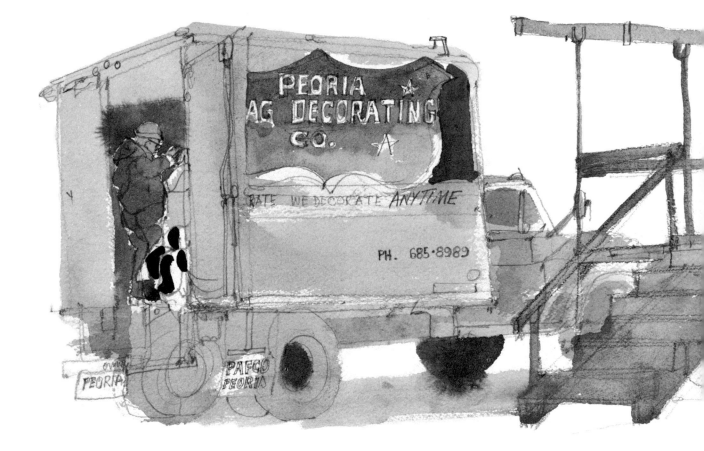

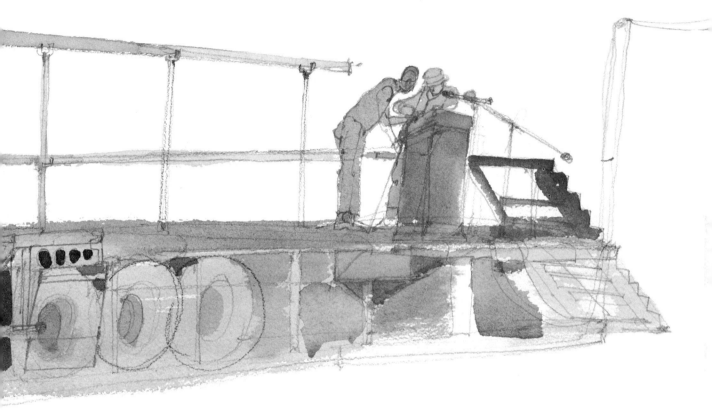

Prior to Nixon's arrival, Peoria, Illinois. Feeling that an event entails a great deal more than the incident itself, McMahon arrives early at the scene to avail himself of the opportunity to draw the before as well as the during and the after. Here the workmen prepare the platform for the candidate and his entourage scheduled for a speech at this airport the next afternoon. This drawing was, like the one appearing on page 78, executed on-the-spot with pencil and watercolor. Color is, of course, an aid in depicting a subject like this . . .brightly tinted flags, balloons, signs, decorations,

all the sights which generally accompany events of this nature, fill the view. But even when reduced to gray values, the loosely applied washes (brushed onto the moist paper so that they bleed and blend into one another) provide enough tonal variations to suggest some of the hoopla involved. McMahon's more intricate pencil work and crosshatch is seldom employed when he plans for color. Instead, he uses the pencil for laying out the preliminary sketch, outlining forms and areas which will serve as guides for the color stage of the work that follows soon after.

Lightnin' Hopkins, Houston, Texas. This noted blues singer has had, among other landmarks in his illustrious career, Carnegie Hall performances. McMahon sketched him waiting for a fellow musician to pick him up outside the rooming house on Hadley Street in Houston where the singer lives. McMahon has the ability to draw architecture quickly and convincingly without resorting to measurements and rulers to portray the proportions or solidity of the structure. Each brick or wooden shingle board is freely drawn, put together "correctly" by the viewer to form the complete entity. An over-all light gray wash was applied to the garden area and to the children playing in the foreground to insure that the focus of attention remains on Hopkins himself.

Freedom Hall, Louisville, Kentucky. McMahon, as we've already observed, believes the anticipation of an event, the before, *to be as important a subject for the artist to record as the event itself. The same belief holds true for the* after, *depicted in drawings like the one above. Here, delegates and party supporters file out slowly following their "Humphrey for President" meeting. The cluttered nature of the composition, unlike the drawing opposite, does not focus on any one person or individual detail; instead it moves the eye from glass to fork to cup to chair to table in no pre-planned direction or sequence. The mass of forms creates an over-all tone with only the dark lettering on backs of chairs and small pools of unfinished coffee to occasionally break it up.*

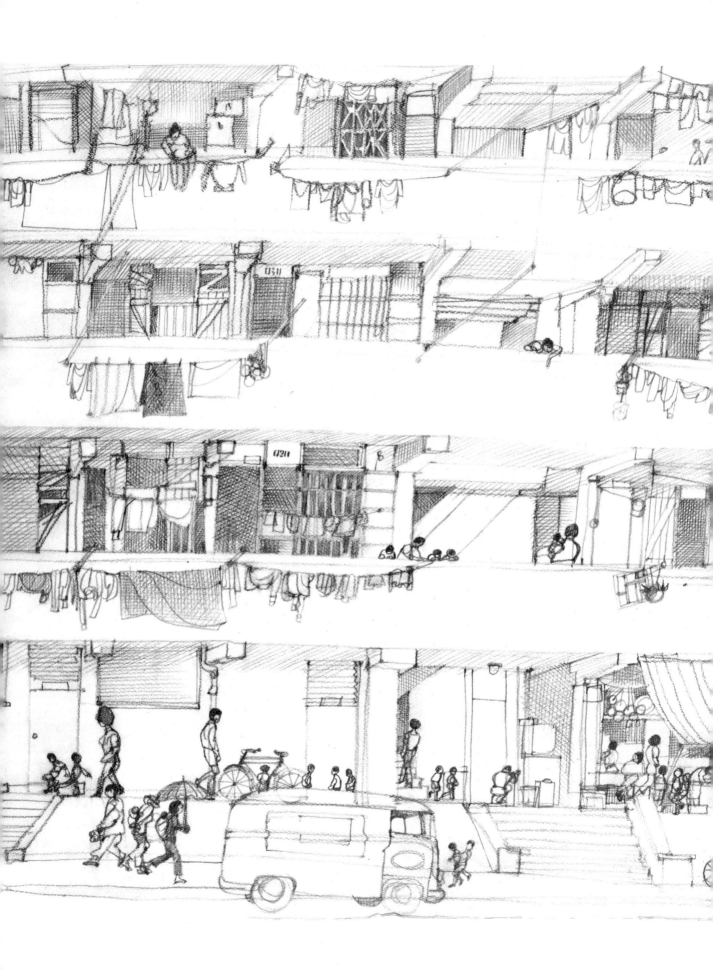

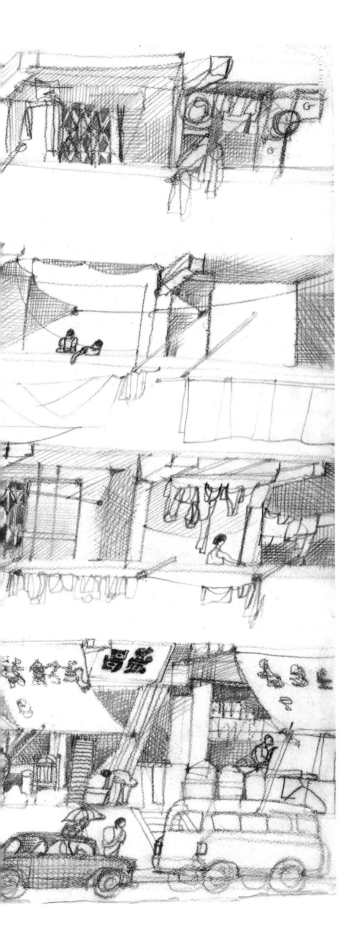

Housing project, Hong Kong. McMahon added to rather than detracted from the horizontal flow of this scene by emphasizing the shadow areas with cross-hatch patterns. The result is a "layer cake" effect where, once again, no particular focal point is established. Even the clotheslines, most of them filled to capacity, tend to move the eye down the page in the same manner one would read a typewritten page—a line at a time moving from left to right. While there are no rules as to what can be done on what size paper, I think it is safe to assume that a drawing of this nature should be attempted on larger than usual stock. McMahon uses 22" x 30" sheets of Arches paper, a handmade sheet produced in France. It is expensive, but heavy, durable, and beautiful to work on. It is imported to the United States and can be purchased in most of the larger art supply houses in various sizes, weights, and finishes. Some artists delight in drawing on a high quality paper, others freeze up, not wishing to "waste" the stuff on anything less than a monumental work. Whichever the case, every artist or student should at least once indulge himself in a fine grade drawing paper—even if only to scribble lines or test out a new technique idea.

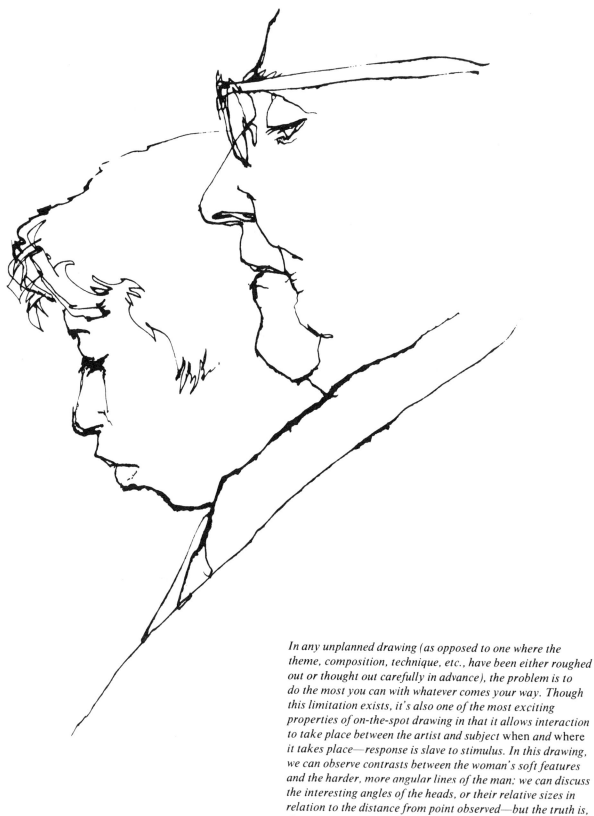

In any unplanned drawing (as opposed to one where the theme, composition, technique, etc., have been either roughed out or thought out carefully in advance), the problem is to do the most you can with whatever comes your way. Though this limitation exists, it's also one of the most exciting properties of on-the-spot drawing in that it allows interaction to take place between the artist and subject when *and* where *it takes place—response is slave to stimulus. In this drawing, we can observe contrasts between the woman's soft features and the harder, more angular lines of the man; we can discuss the interesting angles of the heads, or their relative sizes in relation to the distance from point observed—but the truth is, that I was aware of* none *of these things while working.* Artistic *instinct* prevails during the act of sketching, I'm afraid, and artistic *intelligence* comes afterward.*

7. NICK MEGLIN

SUBWAYS ARE FOR SKETCHING

I can't think of a more impossible way to draw from life than drawing on a subway. The train rumbles on, shaking, jerking, tilting as it proceeds along its serpentine course, completely indifferent to the efforts of the budding Rembrandts within. The "models," if they're aware of your constant gaze, stare back indignantly as though you were a pervert on probation, or—if they're flattered you chose them for subjects—stiffen up in a pose they feel is becoming, careful to let their good side face you. If they're unaware that you're trying to immortalize them in your sketchbook, they proceed to twitch, itch, scratch, shift their weight from leg to leg, cross their legs, turn pages—anything, it would appear, to make your work that much more difficult. Some have the unmitigated nerve to get up and leave before you're finished just because they've reached their station!

With all this, then, why bother at all?

First, you get a wide range of subjects to choose from. Every known shape, size, and variety of person boards the subway (at times you'd swear *all at once),* offering you a treasure chest of personality types and clothing styles to draw from free of charge.

Second, there's the challenge. The gambler values his winning longshots more than his wins on the favorites, and the analogy holds true with subway sketching. To come up with *any* drawing under such adverse conditions is an accomplishment. To come up with a *good* drawing is á la mode!

But above all I draw on the subway for the sheer fun of it. I can rationalize that I'm putting to good use otherwise wasted traveling time, or that this kind of limitation helps to achieve discipline as well as a quick, sure line. All true. But the *real* truth is that I have a ball, and that's the only demand I make on art— that I enjoy it.

The value of the quick sketch

My on-the-spot drawing started in Stuyvesant High School at the suggestion of Nat Werner, a famed wood sculptor who taught a class of four or five students interested in drawing in this science-oriented school. Not really equipped to handle a class of *art*-oriented students, our "Studio" was whichever room in the school wasn't in use at the time. When the warmer weather prevailed, we would hie ourselves out to a neighboring park to sketch derelicts, dog strollers, and fellow students cutting other classes. Once the sketchbook habit was formed, it naturally branched out to the subway—New York's famed underground classroom. But this was drawing with a purpose. I was drawing to learn, to practice, but not *just* to draw.

It wasn't until I studied with Bob Frankenberg at the School of Visual Arts that I was encouraged to draw for *myself.* The aspiring artist tends to think of some practical use for his efforts, and since I could see no commercial value in subway sketches, I relegated these attempts to the "of little consequence" file. Frankenberg, in looking through my sketchbook for an assignment illustration (which he hated) came across some subway attempts (which he liked), and questioned the gap between the two. My "finished work" had none of the freedom, excitement, or life that these "insignificant" drawings contained.

A re-evaluation of the relationship between effort and quality was necessary. I had to face the fact that four hours of work didn't necessarily mean that the drawing would be four times better than one drawn in an hour. In fact, sometimes exactly the opposite would hold true. The answer for me could be condensed into a single three letter word—*fun.*

Drawing for fun

Very few jobs are fun, and those that are aren't fun all of the time. Professional artists are fortunate in that the act of drawing is—or at least should be—enjoyable a good percentage of the time. But for the amateur, there's no reason why drawing shouldn't be enjoyable *all* the time. Why do it otherwise?

The fun need not come from the act of drawing itself, but from the situation surrounding it. The drawing on page 92 comes to mind, for instance. I had just completed it and was rather pleased. So was the man sitting next to me. He told me that his daughter was studying art, and he insisted I meet her. He persisted until I finally jotted down her phone number just to get him off my back. Unfortunately, I wrote it on the reverse side of the page I had been using, not realizing it would show through the lightweight paper. Attempting to subdue it later on, I pasted the drawing down on white illustration board with rubber cement. The phone number didn't show through but, in time, the *rubber cement* did. The effect was interesting, so I decided to include it here.

Another time, my train had stalled between stations and I found myself with enough time to draw several different people sitting or standing around me. I totally ignored an auxiliary policeman because he had assumed a heroic pose (believing himself to be a perfect model, I suppose), which to me was uninteresting. After the fourth sketch of others he realized I wasn't going to play Michelangelo to his David, so he decided on a direct confrontation.

"What are you doing?" he asked.

"Drawing."

"This is a public means of transportation."

My ignorance of subway law is only equal to my fear of the badge, so rather than have this irate cossack pull out some 1827 ordinance against sketching in public vehicles and fine me three gold nuggets, I did what any bright art student would do in this sort of situation—I lied.

"I'm on assignment for *Subway Commutor's Quarterly.* Can I draw you?"

"Well, if it's for *that*, I guess it's okay."

He assumed his pose. I remember sketching, but I don't remember if it turned out well or not, and I'll never know. The cossack asked for it when I was finished and I ripped it out and presented it to him gladly. He must have figured an original drawing is better than a print from a non-existent magazine.

The common fountain pen

I've found that the ideal instrument for my approach is the common, everyday fountain pen. Concerned with a gesture rather than a complete composition, I find the temptation to concentrate on wide tonal ranges (as can be achieved with pencil or charcoal) immediately overshadows the importance of the gesture. The very nature of a pen—a final notation rather than a fuzzy, noodled-up one—is perfect for the quick, definite line necessary for this kind of work.

I use either the Esterbrook or Osmiroid—both are inexpensive and durable—and I own a variety of points. All points are interchangeable—Esterbrook points work fine in Osmiroid bodies and vice versa. My favorite point is the Esterbrook #9128. It's extremely flexible and can produce a thick-thin line according to the degree of pressure placed on the paper. Holding the point broadside can produce a brush-like flow of ink that's executed even more quickly than a regular pen line (and to me, more beautifully).

I've tried the India ink pens and have found the Ultraflex (discussed more fully in the Sugarman chapter) and the Faber-Castell pens the most satisfactory, especially when used with Artone Fine Line India Ink which doesn't seem to clog as quickly as the regular dense black India inks. But since reproduction or further work in other media is not my consideration, I prefer Parker Fountain Pen Black or Artone Fountain Pen Sepia, both water soluble and non-clogging as well as smooth-flowing on most inexpensive, spiral-bound sketch pads of convenient carrying sizes.

I leave the drawings alone in most cases, the good lines with the bad. When a line, blot, or mistake detracts from an otherwise good drawing to an intolerable degree, I will attempt to erase it with a typewriter eraser or white it out with Luma White, a non-bleeding correction paint that works well over water soluble media.

For variety, I sometimes cut up smooth, gray stock into 8″ x 10″ sheets and clip them to a portable drawing surface made from the backing board of any drawing pad. Whether sepia or black ink is used, the contrast on gray stock between line and drawing surface is softer than the typical black on white effect. I have also tried to color areas with white chalk afterwards, but it seems to take away from the "fleeting moment" quality I value in this work, as if I were trying to make something more of a quick, simple sketch than it really is.

Essence drawing

In most on-the-spot work, speed is a necessity and not a goal. A drawing must stand on its own with no apologies, descriptions, or sad stories with violin

accompaniment. Most of the drawings in this chapter were done in under five minutes, but I say this with regret and not pride. I always wish I had more time to capture "a little more," especially since I seem to have mastered the art of non-retention, a dubious distinction which leaves me helpless once the subject has left the scene. The drawing ends with the 'model's' departure.

With little emphasis on detail, my interests are focused on the gesture, the mood, the personality, and the mannerisms of my subject in what I call "essence drawing," in short, an impression of the total person. I try to draw laughing eyes, not hazel eyes; or if the subject is asleep, I try to draw sleep rather than closed lids. There *is* a difference, and my interest is in capturing that difference.

I never try to think in terms of a finished piece of art in these, my subway sketches, as it's obvious from the limitations mentioned that neither I nor the subject is in one position long enough to accomplish a complete composition. The drawings are, for the most part, single figured vignettes. As each station brings forth another charging horde to obstruct the view further, one cannot expect to draw on a grander scale. Besides, drawing for pleasure means just that, so why impose pressures or goals?

Bits and pieces

I find the standing figure more interesting to draw than the sitting figure, because the subject is involved with balancing himself, finding a comfortable position, and reading a newspaper in an atmosphere that defies all three. In the seated figure, the variations in facial characteristics or expressions attract me initially. Generally speaking, the major part of my sketches are pen portraits, as by starting with the head I "set up" the drawing in relationship to the page and allow for the full figure if I'm fortunate enough to get that far. When time permits, I attempt some indication of surrounding details. As a drawing exercise, it's always interesting to start a figure from a hand or a foot, but a rumbling subway isn't the most conducive place for drawing exercises, and so I start with a hand or foot only if something about it caught my eye initially. For this reason, many of my sketchbook pages contain various assortments of feet, umbrellas, shopping bags, and the like. Since I ask nothing more from sketching than the pleasure of the moment, these drawings serve little purpose afterwards except perhaps to supply a rich legacy of bits and pieces to mystify some poor, unsuspecting psychiatrist who might someday come across them.

My sketching materials are minimal. My fountain pen clips into my pocket, my sketch pad slips into my briefcase, and my especially bad drawings can be slipped between two slices of bread and swallowed when I wish to destroy the evidence.

My approach to this facet of on-the-spot drawing, like all the others discussed in this book, is highly personal. The sketches selected for this chapter span more than a decade and were chosen not to serve as examples of my work, but because each one caught a little something of the essence drawing I described and that makes it successful to me. In the final analysis, isn't that all that really matters?

Even in quick sketches, I find it hard to remain indifferent toward my subject when drawing from life. I can start out as if I'm observing fish in a tank, studying differences in appearances and mannerisms, but I soon find myself lost in fantasy, figuring out lives and personalities . . . that man looks like a grouch, but he's not really, he's just had a hard life; that woman visits friends at hospitals and eats up all their candy; that girl is madly in love with me, which is obvious by the way she ignores me, etc. The subject of this drawing, my fantasy assured, was sensitive and bright. She was dressed neatly, hair casual, glasses studious but with a trace of flair. The sketch was one of the quickest I've ever done—the pen glided along the page so effortlessly and accurately that I surprised myself. I showed her the drawing, which is something I rarely do, but a sketch that goes so nicely is something one likes to share, and I was in the mood for praise. "That's not my nose," she said, obviously insulted by my portrayal, shattering my fantasy opinion of her into a million pieces.

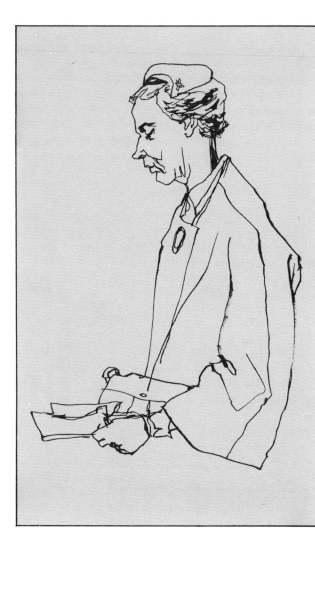

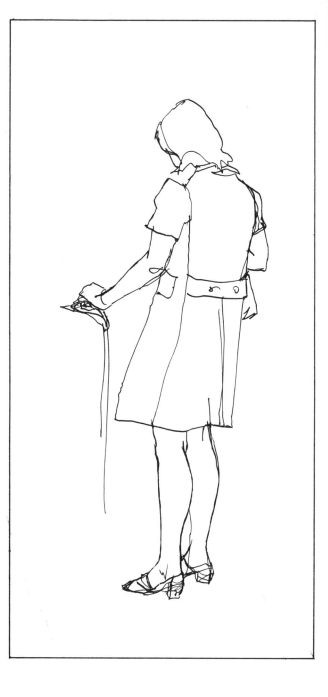

In going through sketchbooks to choose drawings for this chapter, I noticed that a larger percentage of my subjects, like the one above, face the left. In an attempt to analyze why, I became aware of an unconscious pattern that had developed over the years: because of the perpendicular seating arrangements in most of the subway cars I ride, I, being right-handed, prefer a seat with a window on my right—when I can find one—so that I can rest my arm on the ledge for additional steadiness in the shaking vehicle. Thus, many of my "models" appear in profile facing the left. This drawing was done with black fountain pen ink on an 8" x 10" smooth-finished, gray-colored stock.

I also noticed many examples of standing female figures among my sketches. I seldom, if ever, have sketched while standing in a subway car, so it must be assumed that I was sitting comfortably, entertaining myself with pen and pad, while some woman performed "the rush-hour ballet." It takes a dedicated artist to remain seated at a time like this—as well as a thick skin to ward off the dagger-like stares of female indignation. Either that, or not much gentlemanly sentiment! I wish I were sure which of these is true in my case. When working quickly, I seldom see problems that come about until it is too late, like the seam line of the girl's dress blending into the leg . . . had I seen it on time, I would have shifted one or the other.

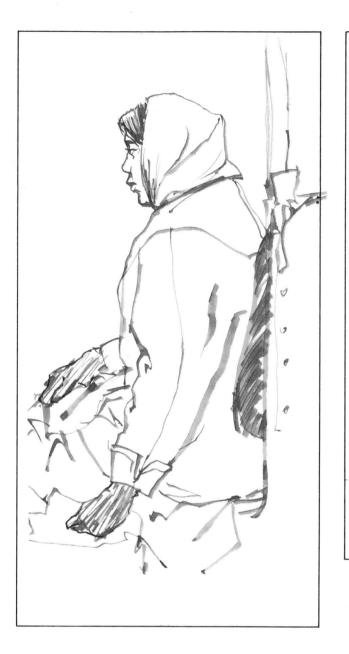

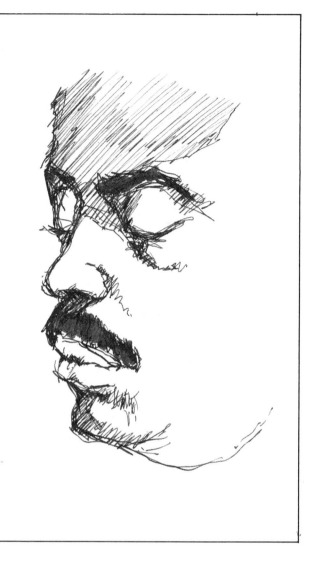

The right-angle seating of subway cars also allows for back and three-quater back views of seated and standing figures. The woman in the drawing above had just come from Christmas shopping, a large shopping bag filled with other smaller bags was propped at her side. I wish I had had more time and space for this one—from her vacant stare to the galoshes on her feeet it was a natural—but the car started to fill up to the point where I had to constantly lean over or shift from side to side in my seat to the annoyance of all around me for just a quick glimpse at her. The lower portion of the drawing shows the haste—and the ultimate giving up of the whole thing when she disappeared completely.

Sleeping figures offer the opportunity for more careful studies than is possible with awake, moving subjects, as they're unaware of your constant gaze and scanning eye. When this happens, I'll sometimes give up the free-flowing stroke I can achieve with the Esterbrook #9128 fountain pen point when held on its side or back, and use the point in the normal writing position. My goal, in these cases, is not so much the essence as the accuracy, with concentration on details and subtleties. And, as in the drawing above, I will sometimes attempt to show form through light and shade, indicating shadows with quick, single-direction strokes which, when blended together by the eye, form darker tones.

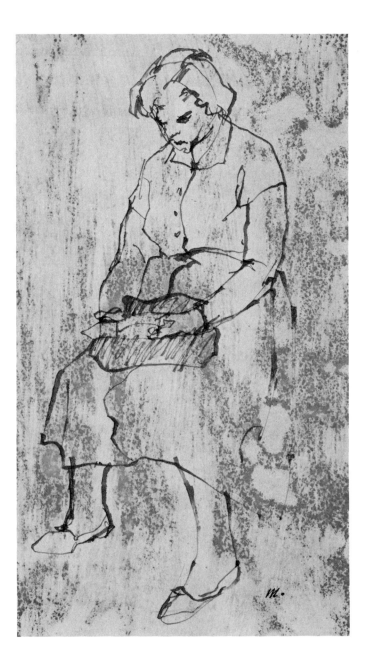

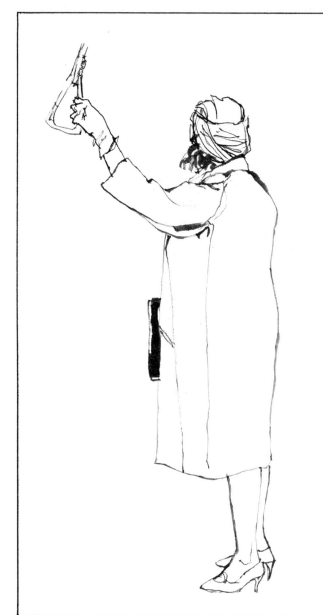

The interesting tonal effect in this drawing was achieved by sheer accident. In an attempt to eliminate a phone number written on the opposite side of the thin sketch pad paper, I pasted it down on a a white mounting board with rubber cement. I had tried a typewriter eraser on this surface before, but thin stock doesn't hold up well under certain conditons: considerable erasure breaks through to the other side; and water buckles the sheet to an unworkable degree. The writing on the opposite side was subdued to a great extent by this pasting down method, but, in time, the dried-out rubber cement started to show through. I liked the effect, and only wish more accidents would turn out as well.

Balancing oneself in the shaking subway car is no easy feat, but for the artist it presents figure situations he wouldn't see anywhere else in the world. Feet planted firmly on the floor of the car, the body will sway to and fro with the train's movement when the rider hangs onto the metal strap which is connected to a pivot above. The figure in this drawing leans slightly forward, but I have seen some forty-five degree angles achieved in my time too! The seated passengers have it a lot easier, naturally, but when the standing passenger loses that precarious balance, then they too must suffer, finding their laps suddenly filled with two hundred pounds of wildly hurtling flesh.

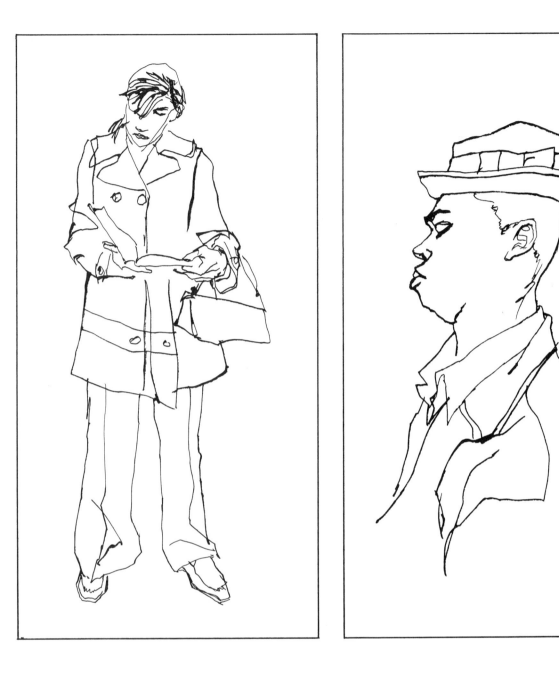

Subway "models" are not professional; the poses they assume don't have your artistic interests in mind. As the girl in this drawing read, she kept swiveling her body without moving her feet. The extent of her pivot can be measured by her jacket: the vertical edge of it has been drawn in two different places, and the bottom buttons, which were actually in a vertical line with the top set, appear shifted well over to the right. The bellbottom slacks played havoc with the feet, covering them completely as she shifted forward, exposing a section of each as she leaned back. In any case, her feet look too big in proportion to the rest of her, but how can you tell when the ever-moving bellbottoms continue to cheat the eye in that way?

The subject here was sitting directly in front of me, so close that the profile had perspective problems. His arm and shoulder appeared much larger and out of proportion with his head as I drew, posing the type of distortion that the eye accepts when seen in actuality but questions when seen in a drawing. I became amused by the problem and decided to draw it as it was without compensating for how it should look. Somehow the slope of the near shoulder exaggerated the tilt of the neck in the opposite direction, setting the head heavily into the body, and giving an even stronger impression of someone deep in sleep than I might have captured otherwise. Black fountain pen ink, 8" x 10" pad.

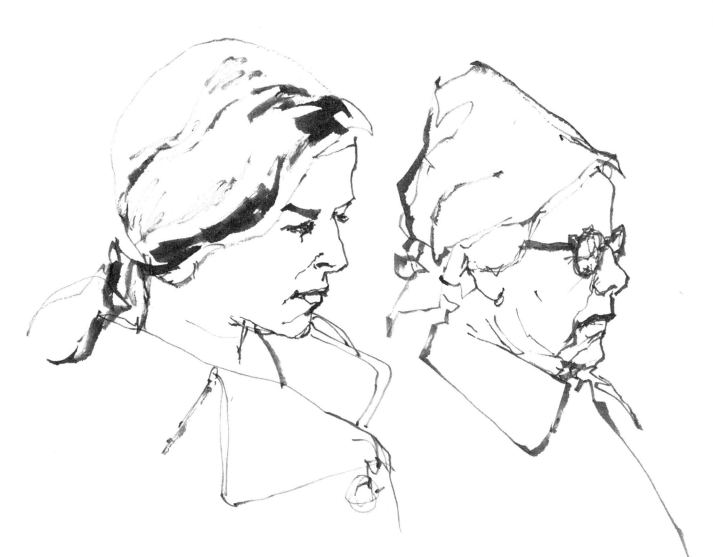

The above drawing is the result of sketching done on two separate days. I clean out my spiral-bound sketchbook every so often, segregating the work into three distinct files: winners, so-so, and losers, the latter being the waste basket. (It is surprising how the winner and so-so files exchange drawings through the years.) "Weeding-out time" had not come up yet and so the sketch of the girl was still in my pad as I turned pages looking for a clean sheet. There was a man now sitting where the girl had been sitting several weeks prior, but to his left sat an older woman whose attitude and pose was reminiscent of the younger woman. I decided to do a "granddaughter-grandmother" study using the same pen.

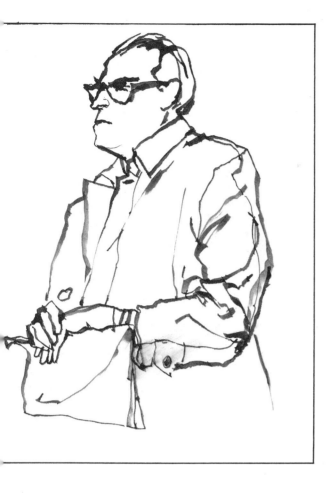

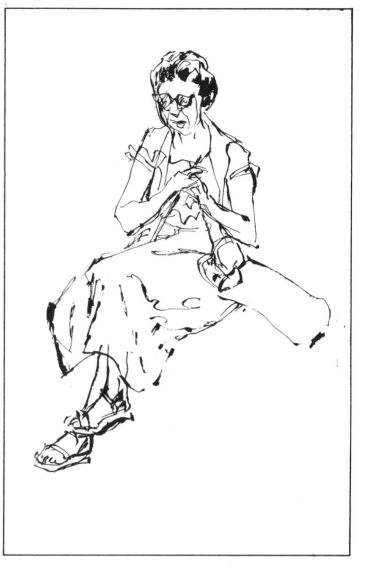

The subject for this sketch set my fantasy world in full gear. His physical appearance reminded me of that fine character actor E.G. Marshall, and, with his back straight in the seat and his hands clasped firmly around his impressive, soft leather briefcase, I was convinced he was the lawyer in the TV series The Defenders that Reginald Rose had fashioned and whom Marshall portrayed. The woman seated next to him, however, seemed to share a different opinion about the briefcase. I learned what caused her grimace a few moments later as I pased "E.G." on my way out—the aroma of well-seasoned salami emanating from the briefcase was unmistakable! Oh, well, even our "defenders" must eat!

This drawing is one of the oldest in my collection, the fashion and low hemline of the woman's dress indicative of a style long since vanished from the cosmopolitan scene. I remember only that her hands moved at a blinding rate, her knitting needles crossing as rapidly as swords in an old Errol Flynn movie, her fast-growing patch of woven wool being fed by a thin supply line emerging from a shopping bag propped on the seat next to her. I included it here because I feel the drawing still holds up, which is a somber—if not depressing—note to end my chapter with, seeing how an ancient attempt can be as effective, or worse, more effective, than recent ones. No, it's just my imagination . . .

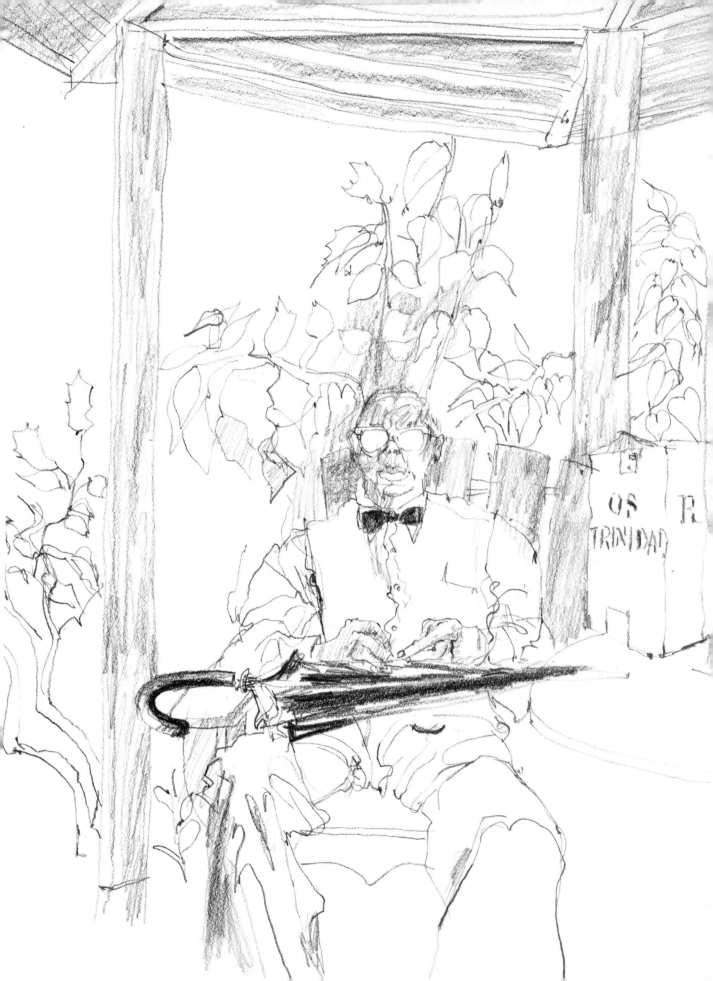

8. BILL NEGRON

SELECTIVITY

"An artist's participation in drawing has to be more than just a recording of lines, forms, and areas," states Bill Negron. "I believe drawing, on-the-spot drawing in particular, should not be passive. The need to participate, to be in the scene rather than just an indifferent passerby probably serves as my greatest source of inspiration. When I see something that I find interesting I want to communicate with it, and, as an artist, this is what I try to do.

"Perhaps I'll be walking down a street," Negron continues, "and I'll see a rooftop shingled in a particularly interesting way— or I'll catch a face— maybe deep-set eyes, maybe flattened nose; or I'll catch chairs, a mountain of them held together by a single thin rope, balanced perfectly, matter of factly, by a man carrying them like he's done it that way every day for twenty years (see the drawing on page 105). It's this sort of exchange—life and a response to life— that, to me, drawing is all about."

A language teacher, Bequia, St. Vincent. In art, one never knows beforehand if the newly-started work will be successful or not. All the artist can do is set a level of quality for himself and hope for the best. An on-the-spot artist takes it one step further in that he can't even anticipate his source of inspiration, for much of his work is unplanned. This drawing serves as an example, being the result of such a chance meeting. Taking time out from a busy schedule of drawing specific people and places for a book assignment, Negron began chatting with a gentleman seated in a gazebo in a little park across from his hotel, and as they talked, the artist began sketching for "himself." The supports and roof of the little structure, the foliage, and the high-backed chair form a regal setting for the proud subject, complete with umbrella-septre. The drawing was done with ebony pencil on a slightly toothed sketch pad paper.

And that's precisely what a Bill Negron drawing is all about: a roof, a face, chairs. Whatever "catches" him at that instant becomes the point of emphasis. Everything else becomes the structure, the framework upon which the emphasis is built. And the name of the game is *selectivity*. Not an intellectual selectivity, but an emotional one that responds to the moment; it cannot be anticipated nor can the effect be predetermined. Negron starts out at an "interesting point" and lets the drawing evolve naturally.

Pick and choose

"It doesn't make much sense to draw everything the eye can see," says Negron. "The greatest advantage an artist has over the camera is the ability to pick and choose. He can include or omit things at will, accenting that tree over there or fading out this street light over here. This ability to pick and choose, when combined with similar features that a camera *is* capable of, such as taking in the scene with a wide angle view or coming in on something with a telescopic view, gives the artist great latitude. He can bring into focus only that which interests him.

"I don't believe backgrounds should be flat, fuzzy stage sets for the action to play against. A background can set the location of a drawing and the mood of the scene immediately, as well as offer the artist innumerable areas of interest to work with; therefore, it shouldn't be relegated to the level of fuss and frills. I also see the background, especially architecture, as a means of expressing my interest in abstract and decorative experimentation. In a single afternoon I do houses in one drawing as abstract shapes, in another as detailed baroque patterns

contrasting with the simplicity of the action in the foreground."

Negron's interest in selectivity carries over to his printmaking. Whether etching, using dry point, or combining these with deep, blind embossing, Negron, through use of detail, pattern, and light and dark, used in the same manner as his on-the-spot work, beckons the eye to move about his work and follow the compositional rhythms he's created.

Negron's working procedure

For most of his location work, Negron delights in good-quality paper. He prefers heavyweight, medium-toothed handmade Fabriano paper from Italy, cut into 18" x 24" sheets which he clips onto a lightweight drawing board.

Working primarily with pencil, Negron favors the automatic variety with a chuck wide enough to house medium or thick leads in a variety of blacks. A kneaded eraser, a smudge stick, charcoal, and a sandpaper block complete his location drawing kit.

His line in any one drawing seems to combine both a searching and a stating quality rather than exclusively one or the other. It's dark and sure where he feels it, lighter and more intricate where he picks up details. The combined result offers far more interest than merely the fine draftsmanship Negron is capable of.

In most cases his drawing is completed in one sitting, Negron trying to do as much work as possible with the subject in front of him, maintaining that artist—subject relationship which is so important to his work. This method enables Negron to achieve a great deal of spontaneity. He says, by way of explanation:

"Perhaps later, when the drawing has long since passed the emotional phase and can be viewed with more objectivity, I may go back for a fresh look; a dark area might be added here, a little more detail worked up there, but only to improve the whole or to bring the areas of emphasis together in a more interesting way.

"But this 'going over' process has to be as highly selective as the initial statement was, because artistic hindsight can lead to overworking or choking the life out of a drawing that once breathed freely."

Drawing in a foreign atmosphere

Negron has done many drawings in Central and South America as well as the Caribbean, illustrating two books for noted art critic and traveler Selden Rodman (Road To Panama, The Caribbean), and is currently working on a third with the same author covering all of South America.

The problems an artist encounters in foreign lands are multiplied; there are language barriers, custom differences, and the obvious physical unfamiliarity of the facial features, garb, and architectural variances inherent in each new location. But it's these very contrasts, and the lure and challenge of the unexpected, that Negron responds to so readily.

"I'm quite comfortable when I travel," he says. "In most cases, people are friendly. They're interested in your interest in them. They'll often help you if they can, teaching you words and phrases that will help you over some rough spots while you're trekking through their country. Kids in particular like to gather around and joke—you, more often than not, being the subject of their joking.

"Because I don't like to draw as a performance, I try to get involved as quickly as possible in what I'm doing to avoid the peripheral goings-on that may interfere with my work. There's another—albeit out of the ordinary—advantage an artist has over the camera; in some of the more remote areas there's a great fear of the camera, the people believing their image or "soul" can be carried away in that little, black box. Drawing, on the other hand, is a slow process which enables them to see their image emerging on the paper. Then too, they've been involved in totems and religious drawings themselves and don't fear the moving pencil.

"Before I get to a new location I always have ideas for pictures I want to do, but, to date, I've never done one. You can't help but fantasize about what a place will be like, especially if you've read about it, seen photos etc. But a pre-planned approach is impossible. Each area speaks to you in a different way, a way you couldn't possibly anticipate. I find that all my preconceived ideas just don't measure up to what I see when I actually get there."

On-the-spot portraits

While Negron's interest in portraiture per se is not that intense, the nature of his location work has presented many portrait situations to him. In these, Negron's free and expressive approach is still apparent and not at all unlike his many-figured drawings. He bounces in and around the faces, picking up details with a light, sensitive touch which contrasts with the bold strong lines in other portions of the work. His relaxed manner allows interaction between himself and his subject, the latter becoming more at ease in the process, and the resulting drawing, of course, more natural. Negron has these comments to make on his approach to portraiture:

"Portrait subjects are generally cooperative once you've been able to get an appointment to see them.

Political subjects in particular seldom 'sit' for you—in the usual sense— they're too busy. It's then that you as an artist must gain their confidence by a professional approach, manner, and respect for their time by working quickly. If this is achieved, they soon forget you're there, enabling you to study your subject naturally, and sometimes with more time than a pose would allow.

"Whenever possible, I try and do several drawings of a subject rather than only one. It sometimes takes a while to warm up and I'd prefer not to warm up on a 'one and only'. When I had the opportunity to draw the Obin brothers (important Haitian painters), for instance, I did several drawings at the sitting despite the knowledge that I had less than an hour to work. Each drawing was successively looser and more expressive than the first, as I, naturally, became more familiar with the subjects. With each subsequent drawing I made, my chances of coming home with one I particularly cared for increased. Naturally, this procedure can only come about on-the-spot. Working from photos could not offer the freedom, the ability to observe subtle nuances, and the spontaneity of line."

These previously unpublished on-the-spot drawings combine natural drawing ability and intelligent use of design— the two most important elements in any drawing attributed to Bill Negron.

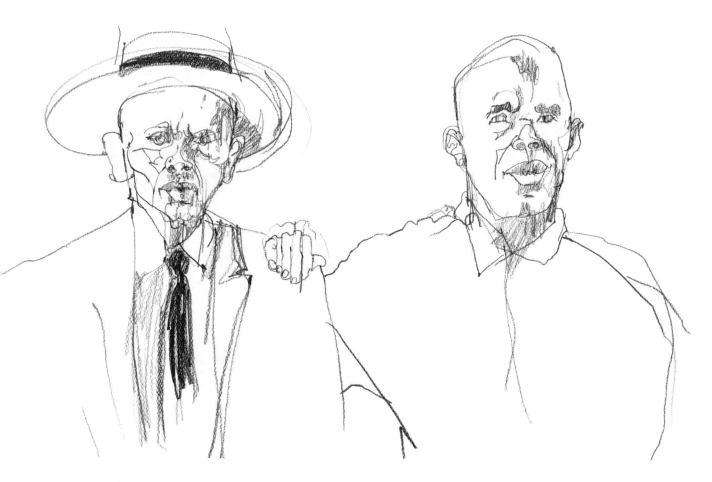

Philomé and Senêque Obin, Cape Haitian, Haiti. Brothers, these two men are among the world's foremost primitive painters. Drawing other artists might seem difficult for many, as a desire to show one's own ability often stiffens and interferes with a natural approach. Negron doesn't subscribe to this, stating: "For me, exactly the opposite holds true. Artists are aware of the difficulties, having experienced them first-hand. They're more understanding, less demanding, and generally receptive to another's work." The drawing was done on 140 lb. Fabriano Classico, a handmade paper available in varying weights and surfaces, this one being medium-toothed. Negron cuts the sheets to 18" x 24" which he then clips to a masonite panel for support. Of the automatic pencils, he prefers to use the Caran d' Ache Fixpencil, which has a rough-finish lower section which gives a better grip, loaded with 6B lead.

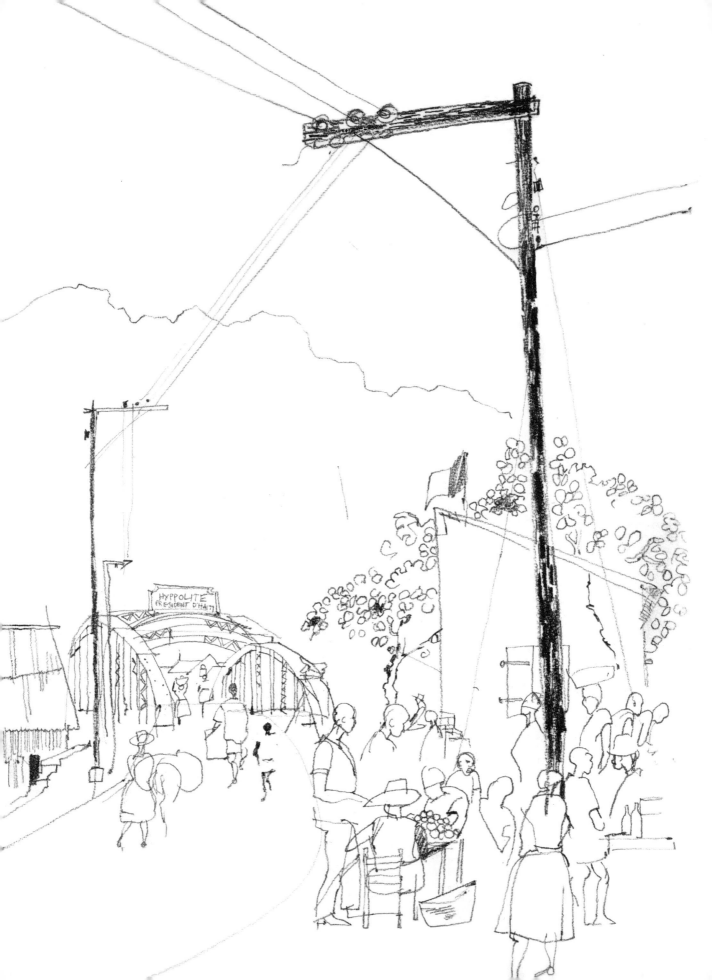

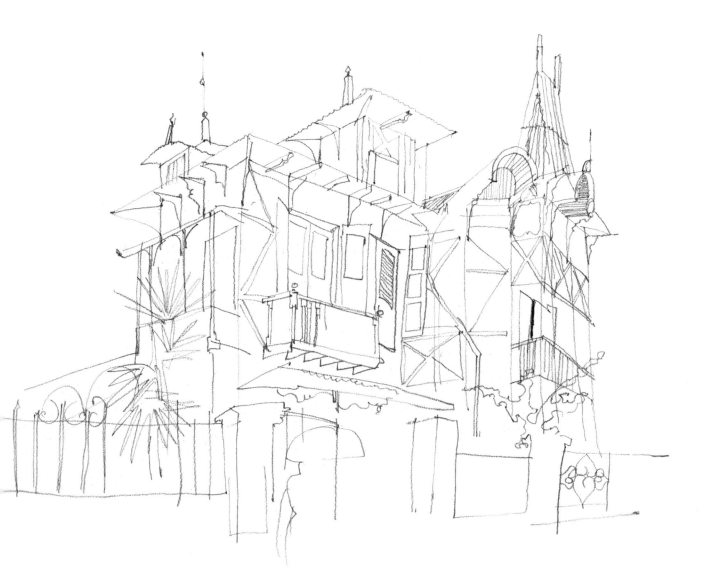

(Left) *Hyppolite Bridge, Cap Haitien, Haiti. Life funnels through this steel structure at the entrance to this old, French colonial town. Farmers send their bushels and baskets of produce—often atop the heads of their wives—to the markets and stands scattered throughout the city. Negron reduces the scene to its barest essentials, recording impressions more than details, simplifying forms to basic outlines to further the feeling of commerce (perhaps slow paced by American standards, but commerce nonetheless) being carried on. In this drawing, the artist uses tone as color rather than light and shade. He emphasizes the relationship between the power-line poles to establish perspective and permit the drawing to go back in space. The fine tooth of the Fabriano paper somewhat softened the intense black as well as the penciled ebony lines.*

(Above) *In this study of a home in Port-au-Prince, Haiti, the "gingerbread" architecture elicits an almost abstract response from the artist. Light and shade usually play an important role in establishing the form of a structure, but Negron purposely avoids its use here, maintaining a uniform tonal range throughout and allowing the various linear directions to indicate the building's planes. Though the emphasis is on the decorative qualities of the home, here too Negron utilizes his selective approach, indicating portions of the grillwork in the balcony, foreground fence, and louvered windows without feeling obliged to carry any to completion. The drawing accomplishes what it sets out to do—it identifies a specific location and supplies certain architectural information—but it is the freedom of line and imaginative approach that make it so pleasing to look at.*

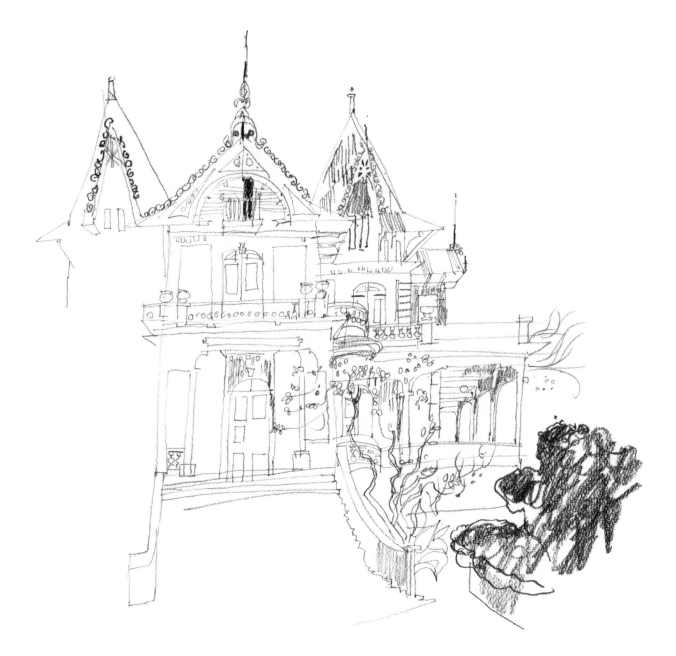

The Institute of Culture, Port-au-Prince, Haiti. Negron's pencil seems to weave in and out between the details, picking up some, starting but not finishing others in this baroque structure laced with frills and fanciful handwork. There is some indication of light and shade, but here too Negron is selective in where he chooses to indicate it and where not. The foliage of the tree nearest the building is handled in a like manner, the quick circular notations of leaves blending in with the circular patterns of the construction. On the other hand, the foreground foliage is indicated by tone, balancing the darks at the top portions of the structure as well as "easing" you into the drawing and up the front stairs. 18" x 24" Fabriano Classico paper, 6B lead in an automatic pencil.

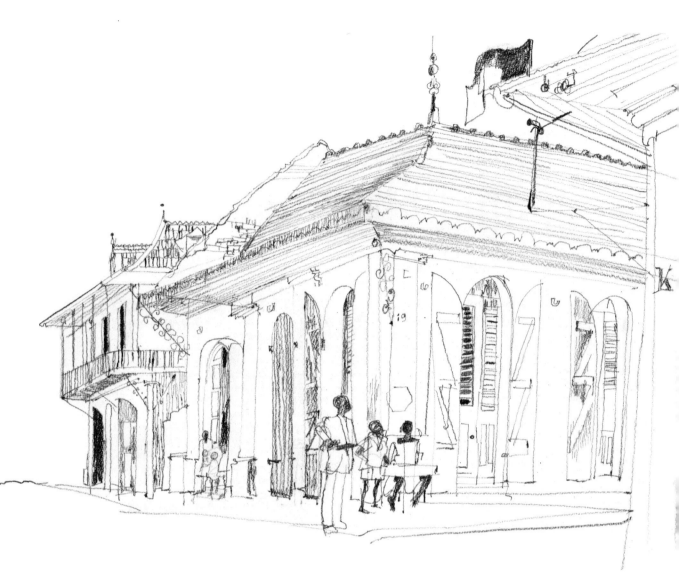

Government Building, Cap Haitien, Haiti. In contrast to the drawing opposite, this structure was more formal in design, and Negron worked accordingly. Though it's drawn with the same free approach, more care seems to have been taken in making the verticals and horizontals more exacting, giving a feeling of solidity to this official building. The roof of the building bleeding off the page at the right, the center edifice, and the home at the left all display the wide overhang common to this location, where shade from the blistering afternoon sun and protection from the torrential rains are necessities more than architectural pleasantries. Selective interpretation keeps the composition free from superfluous details and cluttered backgrounds. The artist chooses to isolate the foreground against the stark white of the paper.

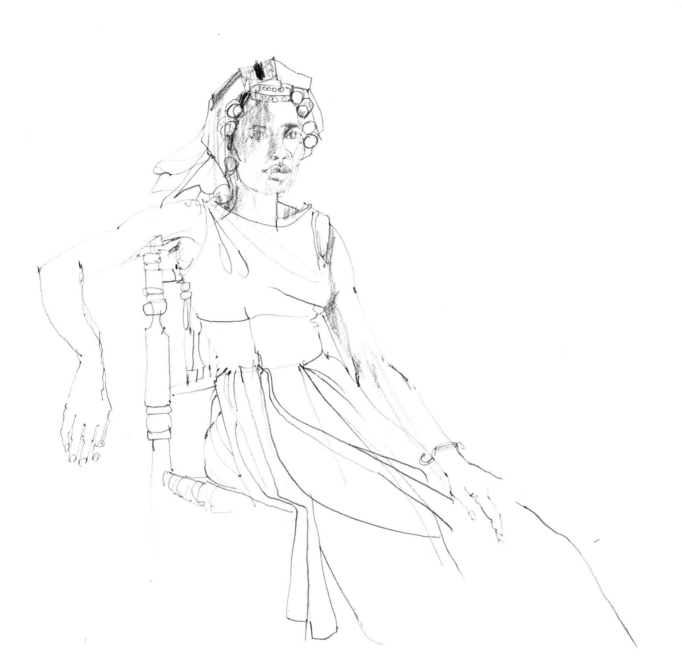

Young girl, Santo Domingo. It is no easy task trying to draw a specific stranger. The approach, "Would you pose for me?" is already suspect in this country, but in a foreign land—with language barriers—well, suffice it to say that it's difficult to get your proper intentions across. Negron had no such trouble with the subject of this portrait; the girl serving as a maid for friends was complimented by the artist's interest in drawing her. He uses tone with the same selectivity that he displays in his flowing line, shading only certain planes of the face and left arm and nowhere else.

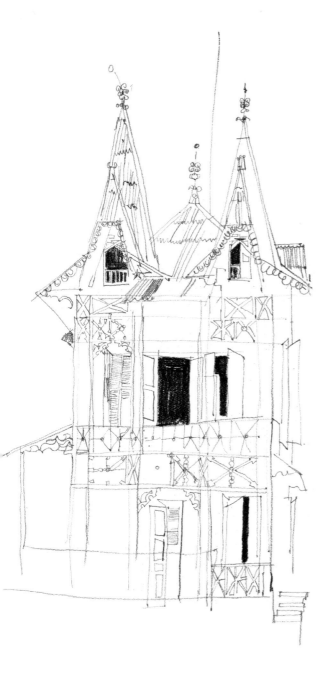

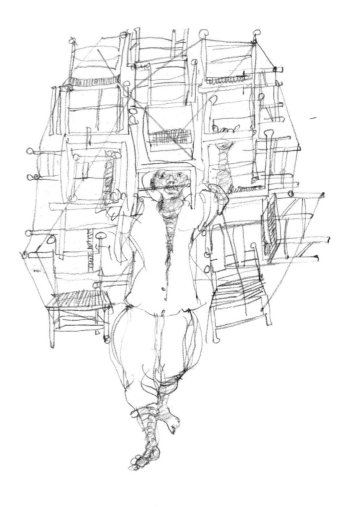

Chateau, Bois Verna, Port-au-Prince, Haiti. This rococo mansion was built in a style very popular at the turn of the century. Fine quality paper, like the Fabriano sheets Negron prefers, can aid the artist who works for the "original," and not strictly for publication (where the original is often cut up, whited out, pasted over, etc.—anything that will enhance the end result which is the printed form). A good textured stock will break up the line into easily controlled values for added interest as well as provide the tooth necessary for rich, deep, solid areas of tone that this sketch has.

Man carrying chairs, Haiti. Negron spotted this subject in the distance, but didn't put pencil to paper until he was close enough to ascertain where the chairs ended and the man began. "It wasn't so much the remarkable balance that interested me as it was the man's nonchalant attitude, wearing this mantle of chairs as I would a straw hat. They interlocked in a clever design, held together by what appeared to be a single strand of cord." The dowel connecting the legs of the chair directly over the man's head reminds me of the face guard of a football helmet. The chairs? The other team!

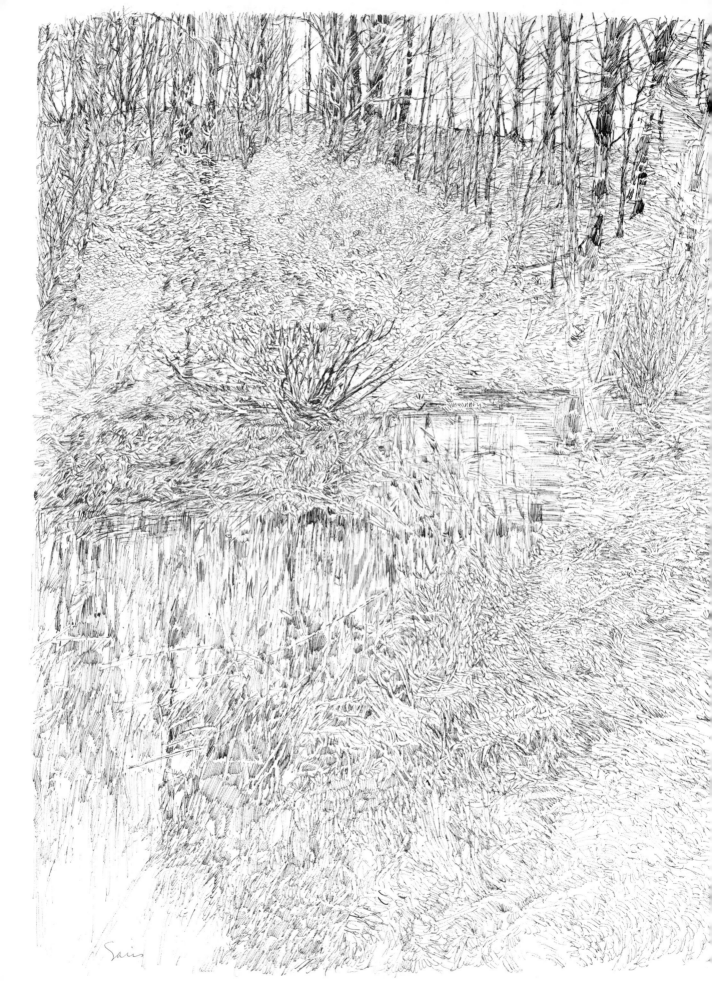

9. ANTHONY SARIS

THE
NATURAL
WAY

"To me, drawing and sketching are not the same," begins Anthony Saris. "I think of a drawing as a graphic expression achieved by means of lines and outlines; its purpose is to communicate, to express, and to satisfy the need to create. It's a deliberately planned artistic form, within which framework exists room for many avenues of approach and many possibilities of end result. The artist can approach his drawings objectively, subjectively, or experimentally; and each artist brings to his work his own technique, his chosen materials, and his individual concepts and feelings.

"A sketch, on the other hand, is much more fragmentary than a drawing. It's a preliminary notation, often serving no purpose other than that of jotting down an impression or recording visual information. The pages of an artist's sketchbook make up a graphic diary of personal thoughts, ideas, and observations; each sketch is a study, a learning process, an unfinished experiment with no predetermined use.

Glen after heavy rain, Lake George, N.Y. Saris has brought his family to this area each summer for many years. It's during this time that most of his on-the-spot sketching takes place: his drawing occupies the other fifty weeks. This sketch depicts a lower section of the forest which becomes easily flooded in a heavy downpour. The reflections in the water provide areas for sparkling contrasts which counter-balance the dark tree trunks at the top of the drawing and also help to create the feeling of distance in the central portion of the work. Saris prefers working on 2-ply Strathmore, purchasing it in full sheets and then halving or quartering them to suit his needs. Drawing solely for relaxation at these times, Saris equips himself with the barest necessities. Along with drawing paper, he carries a pen holder, a few Hunt #104 nibs, and a magazine or folded New York Times for backing.

"While my professional work challenges and satisfies my drawing needs, all of my on-the-spot work falls into the category of sketching. When I sketch, I'm not concerned with making personal statements or with producing a finished piece of work. I'm free of constraint and of the external pressure of deadlines, research, etc., which, of course, makes the work especially pleasurable and relaxing."

Those familiar with Saris' professional drawings and illustrations are aware of the extent to which he'll go in order to get the feel of his subject; he often spends more time researching a picture than in actually drawing it. Although examples of Saris' professional work aren't included on these pages, I mention it in order to make the point that his motivation for drawing is far removed from his motivation for sketching, yet both are executed with the same sensitivity and with the same dedication to accuracy.

Working with pen

Saris, having explored various techniques in his work, favors those which best enable him to make the personal statement he strives for. In most cases it's pen and ink, a medium well suited for emphasis on accuracy. The pen offers an abundance of line types to choose from to match the needs and demands of a particular problem; it can be exacting and precise, loose and varietal, or definite and final, depending upon how it's used. Also, pen work reproduces easily and faithfully—perhaps the most faithfully of all available techniques.

The pen point is a stiff, scratchy, intractable instrument when compared with the smooth fluidity of the brush, and Saris exploits its properties to the fullest.

Saris' ink drawing isn't just the inking phase (the finishing stage administered to a pencil drawing in order to make it more reproduceable), but a complete start-to-finish operation. His outline isn't clear or heavily stated, it's made up of several lines, one line, or no line at all—invisible or strong fading in or out, it expresses the form fastidiously.

Saris' line follows rather than leads the pen. It's a hesitant, pushing-pulling line, drawn as if it constantly worked against the grain, feeling its way across the page with every pause as important as every passage.

And out of this network the drawing appears, or better, *congeals*, accurately, and with great charm.

Utilizing the white space

Saris' pen, by the very nature of the back and forth quality of its movement, enlivens what could easily be a dead line, and makes important a negative area that could easily remain uninteresting. Contrasts are formed by the congealing of lines in certain areas. Likewise contrasts are formed by the absence of lines, especially when combined with judicious use of white space. In the drawing opposite, for example, you *can* see the forest for the trees, although the trees themselves aren't drawn. The bark carries no texture, the limbs no leaves—all the obvious opportunities to indicate detail are ignored. Instead, the *space between* the forms gets Saris' attention, an interesting reversal. Saris also uses negative space in a positive way by composing around a void, keeping the middle of the picture relatively empty— another departure from the more obvious solutions.

Very much at home with the vignette, Saris can confine the scanning eye to the boundaries he sets, drawing to the emphasis or focal point of the composition despite lines bleeding off the top or sides of the page.

Patterns and textures

The subject of many of Saris' sketches—and all the ones included in this chapter—is nature. Natural forms offer him an endless and readily available variety of texture and pattern. Trees, plants, and grass especially appeal to his artistic sense. These sketches are practically atonal and have a delicate, over-all composition. They're like tapestries—you're affected by the whole before you see the intricate relationship of the parts. When the individual parts of Saris' sketches are finally examined, the sensitive pen work carries the eye from passage to passage, from blade of grass to bark of tree, blending them into a total effect. As Saris puts it:

"Along with textures and natural patterns, I'm fascinated by the effects achieved by combinations of lines in line drawings. I like to break down textures into line formations, and shapes into linear tonal variations. I enjoy the challenge of trying to capture the quality of different textures— the peeling, shredding bark of the birch tree, the gnarled bark of the linden, the complex random patterns of grass."

Sketching objectively

In nature, perhaps more than in any other subject, there are so many different things going on in such a small area that the temptation to simplify, delete, or "reorganize" that which exists in front of you is always present. While there are many arguments in favor of this being the role of the artist, others maintain that accuracy and dedication to the truth is the artist's responsibility. The answer, of course, is simply a matter of personal preference.

In these sketches, Saris has maintained an objective approach. They weren't drawn for reproduction or communication, which enabled him to approach them with enjoyment as his only motivation and veracity as his goal. Blades of grass are tenaciously depicted as they are. Because his aim was not clarification, the leaves of grass sprout, wilt, twist and turn according to nature's will, not the artist's. A tree makes a gradual, almost indefinable ascent from the ground, neither erupting out of it nor having the look of having been stuck into it like a sign post. The tree blends harmoniously with the varied textures of the surface from which it emerges and the roots seem to show how, through the years, they've twisted and grown through the earth.

On-the-spot learning

An important advantage of the objective approach is the learning which takes place. What happens in nature cannot be imagined or easily imitated while sitting comfortably at the drawing board in a studio. The learning must take place where it's happening— on-the-spot.

Saris, who conducts drawing courses at the Pratt Institute in New York City, is very aware of the learning potential location drawing has to offer, and often plans class sketching trips throughout the city. He has this to say about on-the-spot drawings:

"Drawing of this kind contributes to an artist's growth. Practice and observation are necessary in order to catch pattern and movement, a fundamental

requirement of good draftsmanship. Once you've studied something, you'll be able to draw it more convincingly, and more important, you'll be able to draw it with a point of view.

"With on-the-spot drawing the artist encounters unpredictable situations. Once he becomes stimulated by what he sees, he's forced to create what he feels despite his materials. The roles of problem and material are switched in this case. The solutions aren't necessarily found by utilizing effects which he's grown accustomed to and he's often forced to work in an accustomed way, seeking new ways of approaching new problems. This is especially valuable to students who tend to be rigid. Most students also tend to be timid and attempt to solve their problems by obvious and safe means—a fine line with a fine pen point, for example. Why not a sharpened twig, grass, a feather, the edge of a knife, or pine needles?

"On-the-spot provides the necessary limitations which force you to achieve the most with the least. How different the results, how satisfying the experience and how rewarding the discovery!

"As for solving problems, let me make it clear that I don't apply my sketches to future assignments; if you try to find a place for something which you've already done, or try to include a passage that you're particularly pleased with, you become involved with ways and means of applying old solutions to new problems. It's better to seek new answers to problems as you meet them.

"Besides," Saris concludes, "the pleasure I obtain while sketching is my most important consideration; it sustains me, becomes my therapy. Once I direct the sketch towards an auxilliary use, I greatly diminish that element of relaxation, and I think, at that point, it ceases to be sketching."

One's own point of view

Most of the sketches here were executed on one ply, kid finish Strathmore paper with the Hunt #104 pen point, a very flexible nib, and Saris' favorite. But it's the hand, not the pen, that makes the difference, as is evident in the drawing on page 111, which was executed entirely with a ballpoint pen.

Saris does comparatively little on-the-spot sketching. His creative needs and artistic enjoyment are usually satisfied by his "drawing," and so his "sketching" is relegated to what he deems his relaxation. Whether you subscribe to this approach or ally yourself with the approach of others in this book who draw on-the-spot to create a finished entity, or still others who seek information to be used directly

or indirectly later on, is up to you. Decisions like this, in the final analysis, have to be made with consideration for one's own needs, personality, and point of view.

Exposure to the highest standard of work as an example of each of the approaches available can help clarify our choices as well as establish criteria that we can compare with, learn from, and strive for.

In these, the personal sketches of Anthony Saris, an exceptional standard is set.

Pine Grove. In an area dense with tall pines, the foliage grows at the higher points of the tree, leaving the lower portions laced with gnarled, dead branches. At night, these twisted limbs make excellent kindling wood for campfires; during the day they make excellent subjects for Saris' pen. Here the artist avoids exploring his usual interest in textures of foliage and bark, and concentrates on the area between the trees instead.

(Left) *Using minute pen lines, Saris lets the eye blend the strokes into a tonal effect to contrast with the calm waters of this Lake George inlet. The artist, by means of building up the intensity in certain areas, controls the viewer's attention, which, especially in a vignette, can easily wander off an edge and "get lost" if not handled properly. This concentration of tone also establishes the forms in such an exacting way that simple strokes take on meaning and form elsewhere with only minimal rendering: the sand makes a gradual descent into the water by means of a scratchy, spotty pen stroke; the outlying pebbles take form although they're simple outlines with no indication of light and shade; the water itself is non-existent, as is the sky—no pen work, no texture—and yet they are there, blending into one another at an invisible point on the horizon (which is also nothing more than a mere suggestion, started at the left and never finished).*

(Above) *In drawing non-specific plantlife, subject matter abounds. Very often Saris has only to turn a few inches in another direction after completing one drawing to find an entirely new arrangement of natural forms to challenge his interests in textures and patterns. The eye drifts immediately to the areas of greatest contrast (in this sketch, right of center, where the congealing of lines and shadow make up the drawing's darkest tones and serves as backdrop for the surface of the leaves facing the light source). The staccato-like quality of Saris' pen line effectively projects the feeling of the stems and shoots in their vertical, slightly bent ascent, as well as the rough edges that are common in many varieties of leaves and blades of grass. This is achieved with his favorite point, the Hunt #104 even more readily than with the common ball point pen which was used to execute the entire drawing above.*

"The whole is the sum of its parts" is a mathematical axiom, but it can be applied to Saris' drawings, like the one above, just as readily. An ability to adhere to the physical properties of the subject (with no attempt to simplify or "beautify") and a tenaciousness in depicting a subject sensitively and accurately are the qualities necessary to produce effective representational work—little else will suffice. Saris has these qualities, obviously. Here, the aged tree base, its twisted roots blending into the ground from which it first sprouted, is shown larger than the original drawing to offer the reader a close inspection of the kind of sensitive handling of detail work that goes into a Saris sketch.

Sitting on a log, rock, or the ground itself offers Saris a straight-on view of his subjects rather than the down view that most people have of the growth he depicts. Then, too, there's the straight up view, which, although it's a common sight, is rarely drawn, many artists preferring the more distant profile view of the tree. In the angle of vision Saris chose for the above drawing, the problems of perspective are at once obvious: the taper of the limbs, due to the natural thinning of the higher (and newer) extremeties, are exaggerated by the converging of lines to a vanishing point—even if the lines are parallel (i.e. train tracks in the distance appear to be coming from a single point instead of two). By the same token, objects in the foreground seem larger than those in the distance. Thus, a limb growing in the viewer's direction appears malformed, thicker at the tip of the limb than at the base, which, of course, cannot be the case.

In this study of the linden, Saris' interest centered around the new growth sprouting from an old wound in the tree's trunk. The surrounding bark differs from the rest in directional growth in its attempt to heal its broken limb ("scar tissue," if you will) which Saris records with typical precision. To establish the form of the tree, the artist built up the shadow side with more pen work, leaving the lighter side relatively void of detail. Then, shifting his attention to the background growth, Saris used the network of thin branches to further the effect of roundness as well as to separate the foreground from the background. Isolated from the rest, any portion of the drawing would appear fragmentary, almost indiscernible, but this "working toward the end result" approach creates effective organization of form from what appears to be essentially a mass of seemingly unrelated lines and abstract pattern effects.

Contrast was the keynote for this study: light with dark,
horizontal with vertical, clear definition with vague indica-
tion. But this is not to suggest that Saris began with a pre-
conceived approach in mind—he never does. The emphasis,
focal point, or "theme" of the drawing evolves while working
and is completely spontaneous. "My purpose," Saris clari-
fies, "is relaxation only. I actually spend more time carving
my 'yearly piece of sculpture' than I do with pen and paper,
as sketching is a rather isolated activity—you work better
alone, giving full attention to your drawing. On the other
hand, I can whittle on a hunk of wood while still being a part
of the conversation, campfire, or whatever recreational activ-
ity is being carried on by family and friends. When I do
sketch, however, I respond to the challenge before me,
becoming completely involved and enjoying the work that
much more."

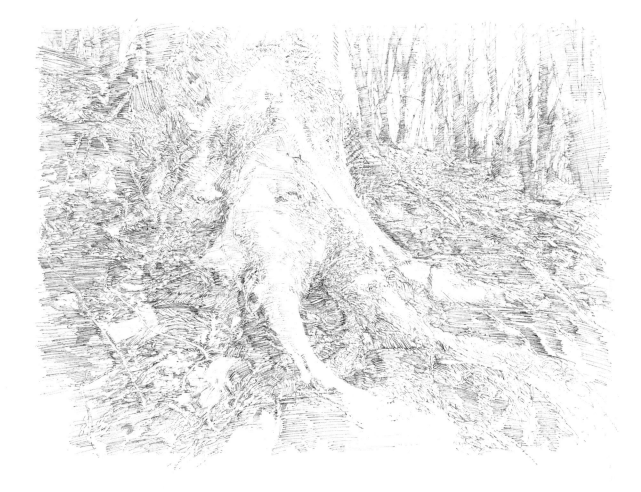

(Left) *Sometimes Saris will make a mental note of a particular area that inspires him, returning to it when he feels like "scratching his pen a little." The scene is as variable as the mood, the artist often choosing an area for weather conditions—on a hot day, the shaded forest or breezy shore; on a cooler day, an open field. Saris passed by this section of the Lake George shore late one afternoon and saw the deep shadows and quiet reflection as a subject he'd like to get involved with at some future time. He returned a few days later at approximately the same time of day, equipped with a quarter sheet of Strathmore (2-ply, kid finish stock), Hunt #104 point and holder, a bottle of black India ink, and two magazines—one to serve as backing for the drawing paper, the other to sit on. The attention of the viewer is drawn immediately to the clump of growth where the darkest tones accent the thin blades of grass that sprout out in all directions. The long reflection lines help to blend the calm water with the high background growth.*

(Above) *The approach for this drawing is the opposite of the approach to the one appearing on the pages 116–117 spread. Here the ground, not the trunk and roots of the tree, elicited Saris' response, a reverse contrast in which the tree is given minimal treatment by the artist's pen, taking its form by the offsetting of the darker, more delineated areas of ground. Short, parallel lines make up much of the tone around which the forms of twigs, rocks, and leaves can be observed. The same tonality continues in the distance: the thickly wooded section of the forest is suggested rather than carefully defined. In the denser parts of the forest, leaves, small branches, and last year's growth are, to a great extent, trapped, undergoing physical and chemical changes as they collect, returning nutrients to the soil in nature's endless cycle. Saris takes no shortcuts in his attempt to depict what he observes, indicating each form he comes to, regardless of how small or "unimportant," knowing they all add up to his sensitive, total "sketch."*

Frankfurt, Germany. The rebuilding of bombed-out ruins is the subject for this on-the-spot drawing by Noel Sickles, which, like countless others before it, was made to satisfy his need to record art as history. Accenting strong light and dark contrasts, the artist silhouettes the scaffolding used in the restoration dramatically against the white Strathmore watercolor paper, using a General Charcoal pencil (smudged with his finger for softer middle tones in certain areas).

10. NOEL SICKLES

YESTERDAY
AND
TODAY

"Styles change. Tastes change. Opinions change. Fashions and architecture change constantly. And as advances are made in chemistry, the materials themselves change, offering new and variable techniques which are far removed from those available to artists of preceding years. But the drawings themselves, as well as the approaches to them, are timeless; timeless in that they express, very directly, the mobility of life and nature. It's difficult, and often impossible, for other pictorial media to capture this feeling of mobility. The immediacy of a direct drawing or sketch seldom breaks through in the more static nature of other forms of art."

So says Noel Sickles, one of the best-known names in the field of illustration. Older illustrators were contemporaries of this "bright young man with new ideas," and today the younger ones are influenced by this same "bright young man with new ideas." As an innovator, Sickles has bridged the span of several decades with his freshness, and that's why his work is in as much demand now as it has always been.

Invent rather than imitate

Never seeking a "style" or a "method," Sickles has stayed on top of time rather than being crushed under it as have so many others who, having perfected their own private formula for drawing, couldn't rise above it when "their thing" became dated. In effect, they were immobile in a field that demands mobility.

Having forced change all along with new approaches and a great natural sense of design, Sickles has had no changing to do himself. He simply goes his merry way, trying new things and applying new materials to his work long before they were in popular use. He chose to invent rather than to imitate, and the result is that his work has something new and exciting to say in a field which is too often busy repeating itself. There's no catching up to do when you're leading the race.

The sketch as finished work

It wasn't that long ago that on-the-spot drawing was not readily acceptable in the professional field as a valid expression on its own. Throughout the 30s, 40s, and early 50s a great deal of emphasis was put on rendering, technique, and style—the "completed" look—so that location sketching was relegated to private art, something done to satisfy the artist's personal needs. It's interesting to note that the approach Sickles once employed for these personal studies (a strong, confident line in pen work or a tonal drawing leaning heavily on light and shade contrasts), he now uses for his "finished" work.

This probably reflects the changes in attitude towards on-the-spot work as not only an acceptable art form, but a highly desirable one. Sickles speaks of the growing importance of on-the-spot drawing in the world today:

"Imaginative art directors and editors are aware of the qualities which on-the-spot has to offer—the life, the immediacy, the spontaneity—none of which can be duplicated in the studio. The craftsmanship and technique may not be the same, but as public awareness increases, the demand for the true picture, the natural picture, has become the important thing. We're quickly aware of the difference between the naturally witty person and the comedian who tells jokes; the extemporaneous and the prepared speech; or the live versus the taped television broadcast

(though each can be effective). It's a felt difference, as is a drawing done in the middle of the action, and a drawing that is contrived from second-hand means.

"In the past I would draw on location for primarily one purpose, information. I found that if I drew something from life I'd never forget it. I have better recall of something once I've put it down on paper. So my drawings were mostly observations, details, compositions, ideas, and just plain visual notes to myself . . . a wagon wheel looks like this . . . an oak tree looks like that.

"You'd go to an editor with your drawings and he'd say— 'Yes, fine. This is what we wanted. Now go home and do me a *finished* one.'

"Today he says—'Yes, fine. This is what we wanted.' Then he reaches over and rips it out of your sketchbook and prints it, charcoal smudges and all. It's a wonderful feeling."

On-the-spot drawing as communication

With this widening demand for on-the-spot drawing, many facets of the work overlap. For instance, a reportorial artist is sent to a Civil War battlefield to draw the area as it appears today, while a location artist who specializes in landscapes is sent to cover a political convention to "get the feel of Chicago." It would appear, at first impression, that both artists would be more comfortable if they were able to switch assignments. But this is not the case. Both are qualified to handle their respective assignments on the basis of the mobility Sickles refers to. By examining the assignments more closely, we find they share a common goal—to tell the story. But hasn't that always been the role of the artist? What is the objective of "objective art" if *not* to tell the story?

Sickles continues: "My approach to drawing has always been to communicate. That's my chief concern. I will reduce things to basics or arrange them in a particular way, anything that will enable me to achieve that goal. An artist has the freedom to do this, his major advantage over the camera in the past and certainly in the present. Since I work rather representationally, I have to take into account all these factors. I enjoy the challenge of location drawing, and my responsibility to that challenge is to be there, on-the-spot, with all faculties alert. If the artist's eyes are focused only through a camera lens he won't be aware of what is taking place *all around* him, which is often of equal importance to that taking place directly in front of him.

"On-the-spot drawing is limited only by the character and skill of the artist. While reflecting the changes in viewpoint and techniques of its time, it generally keeps its own place in the vast herb-bed of art."

The elements remain the same

The basics of location drawing have not changed very much through the years. The same limitations exist now as they have in the past. If anything, these basic elements have been limited further by the omnipresent time pressures of today's living. But in the hands of a competent artist the pencil retains its original properties and can be relied upon to deliver the full extent of its potential.

The drawing opposite serves as example. The elements of drawing are still valid—good composition, confident line, and interesting use of blacks as design emphasis. The subject matter is the only reminder that the drawing was executed many years ago. A substitution of late model cars and fashions would produce a drawing acceptable by any contemporary standards.

In the case of personal or scenic art, there are various approaches open to the preference or mood of the artist. In reportorial work, however, demands of factual representation and a high degree of identification present an altogether different list of essentials. As Sickles puts it:

"For reportorial drawing one needs a draftsman, an artist who goes beyond a literal rendering and who interprets and selects. He can often make the slightest sketch significant and can bring life, meaning, and vitality to a drawing as well as the imprint of a personal style. When I was asked to draw public figures at work in the New York State Senate in Albany (Sickles drawings appeared in three installments of *Lithopinion* Magazine, a beautifully designed publication devoted to the photo-engraving trade), my sketches had to be just what was expected of me as an on-the-spot reporter— the Senate Hall had to look like the Senate Hall, and if a particular senator was up there on the dais addressing the assembly, then the drawings had damn well better show who that senator was. Any artist worth his salt doesn't want to depend on a caption underneath to bail him out of a bad likeness."

Art as history

The drawings appearing in this chapter cover a span of many years. They were drawn primarily because the scenes interested the artist. An artist's interest, history has shown, is an invaluable commodity. It has enabled men to see life as it existed in the past

and to record aspects of our society that at the time had seemingly no historical significance. We cannot judge in the present what will be of historical value in the future. It's up to the artists of today to record their interests for posterity.

Perhaps it was only the crisp lines of taut ropes playing compositional games with the billowing roundness of the 'big top' it held in place that first caught Sickles attention. Perhaps it was the contrast between the bright sunlight and the dark shadows which it created under protecting canvas lean-to's.

Or perhaps he picked up his pencil to make a note of the construction, or a particular style of fence edging a meadow— information to be referred to at some future time for some future project. Whatever the motivation, the result is drawings like these—documents of a time when circus trains wandered from town to town and circus performers lived in tents and there was parking space available anywhere for the old "buggy." Time cannot be reproduced. Fortunately drawings, like these by Noel Sickles, can.

Courthouse Square, Hillsboro, Ohio. In this early work, the artist thought the locale would make an interesting background for some future drawing, and so sketched the scene with particular stress on certain details. Sickles has always believed that an artist's own sketches are one of the best sources of reference available to him, so although it was *obvious from the large number of sketches accumulating that many (like the above) would never take form in another work, the love for working on-the-spot prevailed. Sickles is, to this day, a sketch pad carrier. A carbon pencil supplied the thick and thin outlines, as well as the deep black window and store areas.*

SHARECROPPER FAMILY
MISSISSIPPI

(Left) *Sharecroppers, Mississippi. This drawing, and the one above, are the most recently drawn in this chapter. They show the same fine draftsmanship that a Sickles drawing is known for, as well as the artist's interest in recording detail and simplifying form in order to communicate more effectively. The major difference between these two drawings and the Sickles' drawings that follow is his approach. In the past, the artist considered an on-the-spot study as a recording, accurately drawn and historically significant, whereas a "drawing"—on-the-spot or otherwise—could go in any direction the artist chose (ignoring the detail completely, abstract, impressionistic, et cetera). Today, Sickles enjoys the fusion of approaches once separate and apart. While he's still faithful in recording existing detail, there's more freedom displayed and greater selectivity exercised in doing so. The trees and hills in the background, for instance, are ignored on purpose to let the figures and the house stand alone instead of being enveloped by superfluous line and tone.*

Yorktown, Virginia. Sickles is often commissioned for historical assignments, whether Civil War paintings for a Life Magazine *essay on that period or a portfolio of important moments in the lives of former United States presidents for* This Week *Sunday supplement. His interest in historical subject matter goes beyond the artistic (as membership in organizations like The Company of Military Historians will attest), and his drawing ability is an asset in recording visual notes to further these interests. Whether on a "research trip" or on a vacation, Sickles manages to compile graphic information, be it a cross-section of a cannon barrel or an 18" x 24" drawing of an old Yorktown home as pictured above. He uses a General 4B Charcoal pencil, sharpening the point with a pocketknife when necessary, maintaining a linear approach and not using the blending properties of the medium. The stock is a thin watercolor paper, the drawing sprayed with Krylon Crystal Clear upon completion to prevent accidental smudging.*

Train storage yards, Chillicothe, Ohio. As a child Sickles
and his friends would play on these old trains stored by the
Baltimore and Ohio Railroad for scrap, some of the engines
and cars dating as far back as the Civil War. Later on, as
a young man just out of his teens and with both artistic and
historical interests fully rooted, Sickles would often return
to this scene to sketch, producing work like the above. He
recalls the wonderful un-coated magazine stock that the
paper mill in the area produced for magazine publishers
which would be bound in small pads (for their own office
use) but which the artist could purchase inexpensively. The
paper was strong and durable despite its thinness, and had
just the right tooth to produce the flat, even tones applied
with a 7B pencil—another near-extinct product that most
companies have stopped making, ending their soft lead
graduations at 6B.

Country road, Chillicothe, Ohio. Strong tonal contrasts have always been a Sickles trademark. A late afternoon sun provides the bright background lighting the young artist silhouetted the trees and fence against in this drawing of one of his hometown roads. As in the drawing opposite, a 7B pencil was used on a thin, uncoated paper, the likes of which Sickles has never come across since. Today's standards insist on a better grade of paper from manufacturers, but the finish, especially on smooth bond, for some reason picks up the impurities in the graphite, preventing the application of a quick, even tone—flat and grit-free.

Hagenbeck Wallace Circus. Sickles made these three draw-
ings (and the two that follow) during his freshman year in
college. His interest in the circus as subject matter centered
around the activity on the outside, most especially the wagons
and trucks, rather than on the acts performed under the can-
vas itself. In Chillicothe, Ohio, the artist's hometown, the
circus was an annual summer event, alternating each year
between the Hagenbeck Wallace troupe (the subject of this
series) and that of The Ringling Brothers, both famous for
their town-to-town ventures. Sickles arrived at the fair-
grounds at 3 A.M. the morning the circus trains were
expected, so that he could be on hand with pad and pencil
to record every stage of the setting-up process. The light
plant (pictured above) was the company's power source and
was one of the first areas put in working order. The power
was generated by gas engines housed in the wagons. The
huge lights, which would later serve to illuminate the
entrance area for each night's performances, supplied the
light necessary for work to continue through the pre-dawn
hours. By morning, most of the canvas shelters and storage
tents were erected (as this drawing shows). The "big top"
itself (upper right) was saved for daylight, because the opera-
tion was too involved to be attempted in semidarkness. By
noon (notice the short shadows which any Boy Scout would
observe as an indication that the sun was directly overhead
and therefore noon, as compared with the long shadows and
completely shaded planes in the drawing above which would
indicate sunrise or sunset) the huge main tent was up and
in place, the crew resting and chatting during their lunch
break. When the horse-drawn wagons (lower right) needed
more than horse power to move them through the fair
grounds' muddy sections, another crew, that worked for pea-
nuts, (forgive me!) came to help.

Stringer Wagon

NS

CIRCUS

Canvas Wagons Hagenbeck Wallace Chillicothe 193

The whole circus city was made of canvas, ropes, and poles.
Wagons were designated for each material: canvas wagons,
like the one pictured above, carried the folded tents for the
side show, menagerie, cooking and eating lean-tos, quarters,
and, of course, the big top itself; stringer wagons (pictured
in the top drawing on page 127) held the poles, ropes, and
pegs. How things work always interested Sickles. He would
often interrupt his drawing to ask questions of one of the
workers, their answers providing him with insights and infor-
mation that increased his knowledge of the subject as well as
inspired new ideas for pictures. The artist still remembers
how to make particular knots used in securing the guy-lines
that he learned from some of the circus hands on the day
that these sketches were made.

The motor age fast descended upon the circus world, heavy Mack trucks like these replacing the draft horses (which for so many years were as much a part of the circus as the sword-swallower) pulling the floats through the town square to announce the show's arrival. But even these mechanical monsters often proved no match for fairground mud-holes, which meant the elephants would have to perform their off-stage feats of strength once more. The trucks and wagons also served as shelter: canvas was attached to the roof and pulled taut by pegged rope. The resulting lean-to at least offered protection from rain for those who slept in cots or on the ground beneath it. Kerosene stoves sometimes provided some heat, campfires proving too dangerous on the sawdust ground or near the trucks themselves.

IN GOD
WE TRUST

Tracy Sugarman

11. TRACY SUGARMAN

WHERE
THE CAMERA
CANNOT GO

"To me, the most significant aspect of on-the-spot drawing is the ability to get closer to man and the world he's made," says Tracy Sugarman. "You become more than an observer; you become a part of the picture emotionally. You find yourself giving up assumptions, generalizations, and beliefs once you've been exposed to the real thing. It's a learning process, one that never fails to alter preconceived ideas if you maintain an open mind. You can begin to see some good in what you once thought totally bad and some fault in what you once believed to be faultless. In this way the reportorial illustrator is fortunate to have the chance to touch life in a manner that few people have the opportunity to know.

"The experiences I've had, the pleasures I've derived, and the feeling of having done something that has meaning—of having made a contribution, if you will—is immeasurable.

Federal Court House, Foley Square, N.Y.C. The jury has been dismissed momentarily while the lawyers and judge determine the admissibility of certain evidence. Sugarman, responding to the drama of the situation, uses what he has learned about picture-making to maintain that drama, neither adding to it by contrivances nor taking away from it by focusing his attention elsewhere. For example, his angle of vision from the press section where he was seated was close enough for him to have concentrated on the group of figures only; but only a caption or description accompanying the drawing would have communicated the idea that the jury was not allowed to hear this discussion (so that they would not be influenced by evidence which might not be admissible). By the very nature of the empty seats of the jury box in the foreground, a great deal more information is offered pictorially, and with a lot more impact, than had they not been included. Pen and ink with ink wash.

"Working only in a studio may increase an artist's knowledge of technique, but not of the world. When you're on-the-spot, you meet people, you talk, you trade ideas and opinions. Hopefully, you grow. But most important you learn about yourself, sometimes more than you learn about your subject."

There may be only one chance

In reportorial illustration, the artist must deal with one specific pressure that does not exist in most of the on-the-spot approaches we've talked about, and that pressure is, of course, the "one shot at it" facet of the work. While there always exist certain limitations in location drawings, most can be circumvented. Even on a professional assignment, several studies can be made of a particular scene, or another popular practice of late, the artist can carry along a camera. Then, should he have to stop abruptly before he can finish, photographs of the exact spot he was sketching can be made as references from which he can work later on. Neither of these alternatives was available to Sugarman when he executed the drawings in this chapter.

"There are few dramas in contemporary life that are as arresting as a murder trial. Even as you watch the accused and the accusers, measuring responses and evasions, you have to remind yourself that the stakes are years of a man's life and the actors are real. I was never certain when a witness would be dismissed or if a defendant would be recalled. Consequently, there was an unrelenting urgency in making my graphic statement before the moment vanished. For the weeks of the trial—before, during, and after the court was in season—I filled the pages of my sketchbook with the images of the drama. Some-

times I would sketch the architecture of the court before the entrance of the presiding judge and then populate the picture with spectators, attendants, and principals of the trial as the day wore on. Since the outcome of the trial could not be foreseen, each witness had the same potential of becoming central to the deliberations. I felt my job was to try and isolate his particular quality and style. In a trial one could struggle to capture the fact and spirit of the moment. But the *meaning* of that moment might not be known until the jury would return with a verdict. Therefore, the total trial, the sum of all those moments and personalities, was the canvas I had to fill."

Background for the trial

The "canvas" in this case was the complete pictorial coverage of the trial of the suspected killers of Malcolm X. Sugarman was an obvious choice for the assignment, his own book, *Stranger at the Gates,* being a brilliantly written and illustrated account of that historic summer of 1964, when students from all over the country met in Mississippi to help Negroes secure the vote and share the freedoms and rights given to them by law of the country, while denied them by racial pressures and bigotry. (The drawings by Sugarman would be of interest to any "on-the-spotter" and the book, published by Hill and Wang in both hard and soft cover editions, is well worth picking up for your library).

The Saturday Evening Post secured permission for Sugarman to cover the trial for a proposed illustrated feature as there was a "no photographs" restriction on the trial. Despite Sugarman's efforts, the article for editorial reasons never materialized. These drawings would have probably never seen print had Sugarman not mentioned them in one of our discussions of reportorial illustration for this book.

"I knew the importance of Malcolm X's assassination and the impact it would have on the black community," the artist explained. "Malcolm's death was the death of a folk-hero to countless black youngsters newly conscious of racial pride and a sense of personal value. His murder was the beginning of a legend that has continued to grow. When *The Post* offered me the opportunity and credentials necessary to cover the trial, naturally I grabbed at the chance.

"The courtroom was filled with tension and anxiety. Several of the spectators, noticing that I'd been sketching them, expressed hostility, as if their being included in a drawing of the court scene compromised them in some way. But after a few days, no one paid me any special notice and I just went about my business of drawing pictures."

Working directly in permanent ink

All the drawings reproduced here were executed entirely with an India ink fountain pen in a large, heavy-stock sketch pad. Sugarman also carries a No. 6 red sable watercolor brush for wash, a small container of water, and an ample supply of blotters. He's quick to exalt the virtues of his Ultra-flex pen, a natural for this sort of work. The pen is fashioned after the old Waterman drawing pen, which is unobtainable today. It features a retractable point which remains submerged in the ink reservoir, thereby preventing the ink from drying on the point and keeping both point and feed lines free of the clogging properties of the India ink.

The point is flexible, responding to hand pressure for the variable thickness in line that might be desired. Sugarman has found that he can also produce a very fine line, much like that of the crowquill point, by turning the pen on its side and sketching with the back edge of the point.

The ink reserve is also an obvious benefit. No bottle of ink to carry around and find leaking in your pocket; no flat, stable surface required to keep the bottle handy and steady while you're working; and best of all—for both the fast and the lazy—no constant pen dipping.

Even with the numerous advantages of the India ink fountain pen, why work with India ink at all? Admittedly, all on-the-spot work presents problems and limitations not usually encountered in the comfortable, well-equipped studio, but to further these limitations by using as constrictive a medium as direct pen drawing on location may seem senseless. The answer, of course, must lie with the individual artist's needs, approach, and personality. Sugarman explains his choice:

"The ink line is exciting, final and sensitive, while at the same time a bold commitment to the paper. It is permanent, thereby offering the opportunity of working over the initial drawing with color or washes. It especially lends itself to my particular approach, which is linear rather than tonal. I generally use gray washes as design factors, as decorative forms and shapes, or even as suggestions of color. In every case, the foundation of the drawing is a permanent structure, a constant declaration of my original idea, no matter how sketchily it was originally noted.

"I prefer the suggestive rather than the literal representation, although it might appear at first that this is a contradiction to the 'bold commitment' attitude I spoke of. To me, bold commitment is an emotional involvement with what you're drawing rather than how you're drawing it. You cannot be totally objective when you have the ability to pick

and choose your subject. It stands to reason that a particular need from within precipitated your choice and you're drawing is going to show it."

The significance of a drawing

It is this "emotional involvement" that gives a drawing more significance than a photo of the same subject. Whether it registers in the viewer's mind consciously or unconsciously doesn't particularly matter —the result is the same. He's aware that he is looking at the effort of someone with a special kind of talent who felt involved enough with what was happening to take the time and effort to record it in his own special way. Unlike the men behind the camera, an artist lends his own importance to the importance of the situation.

This is not meant to negate the efforts of creative photographers whose work and approach are so personal that you can identify their photos at a glance. (The work of Henri Cartier-Bresson fits into this category, for example). But like it or not, the fact remains that nearly anyone can take a picture. It's essentially a mechanical process and a rather simple one at that. Most children have experienced tripping a shutter before they're ten years old. Because our advanced manufacturing capabilities have afforded us rather sophisticated devices at moderate cost, the results of some of their attempts are surprisingly good—very often sharply contrasted and so clearly focused that they're acceptable for reproduction in most publishing situations.

With this in mind, is it any wonder that the photo is no longer thought of as having mystic or impossible properties—that we're no longer impressed with it as being something beyond our reach? Can the same be said of a good drawing? The layman can recognize that a competent, professional drawing is not the work of a ten year old, but he's not sure about a photo.

We're also aware that in a minute's time at least one photo can be taken. You needn't have a thimbleful of art knowledge to look at the average drawing and know that it could not have been executed in the same amount of time. This assumption can't help but add to the significance that a drawing possesses.

A value beyond the artistic

It's rare that the artist in today's world can assume the role of historian. Camera coverage is so widespread—the usual method of recording events—that the artist's work seems just *another* point of view, rather than the *only* point of view, as was the case before the advent of photography, when the artist was the only available recorder. With saturation coverage of all news events through television, movies, and newspapers, the public has learned to accept the photographic medium as the factual, objective point of view; it is now the artist's special function to supply the very necessary emotional point of view. Sugarman is such an artist, as the following will attest:

"To me the essence of successful reportage is capturing the fact and the *meaning* of a moment in time. For anyone who has found himself in the pressured position of struggling to fix that instant on paper when the situation is fugitive—sometimes hostile—it is an ideal only sometimes achieved. But it is in the *attempt* that I have found the joy of reportorial work.

"The facility necessary to translate the visual image, sometimes on flight or in transition, to the hand and the pen is an acquired skill that has grown with the years. But it's never a simple chore!

"The false starts for the artist-recorder, the nervous broken line, the drops of sweat that blot a passage of the drawing, all echo the immediacy of the search. In the reaching, the trying to pin down the touching heroism of black Americans braving hostile mobs in the attempt to vote in Mississippi, or the terrible hopelessness of poor whites whose lives have been stunted in the forgotten corners of Appalachia, the drawing becomes almost the incidental result of an emotional meeting. The intense thrust of the artist to understand; to winnow from the mass the true, single note; takes more than agility and the capacity to draw rapidly. It demands an honesty of purpose, a relating to the subject that is less clinical than human. If the moment is worth capturing, then the artist has the responsibility of endowing the drawing with the compassion that comes from understanding. It is in this fragile dimension that the artist's gift to the viewer is made."

The drawings selected for this chapter were drawn at a time and in a place where camera coverage was not permitted by law. And they were drawn by a man whose feeling for the equality of all the peoples of the world is so strong that he has devoted a major part of his life to "telling it like it is." At such a time, a drawing has an importance above and beyond the artistic—when it transcends the world of art for the world *itself* and becomes a part of history.

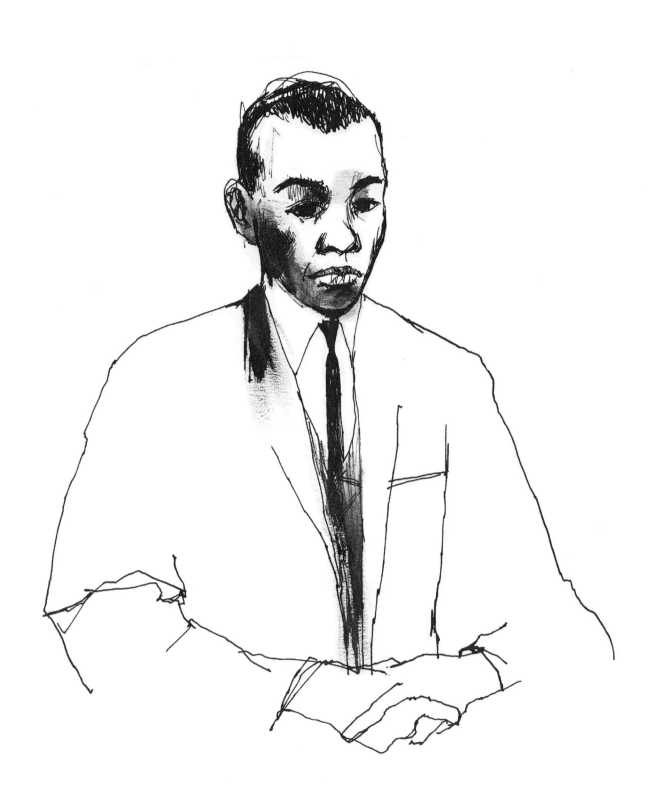

(Left) *Norman Butler, one of the three men convicted of assassinating Malcolm X. It would appear that the subject posed for the artist, assuming a relaxed portrait position, which, of course, was not the case. Sugarman sketched rapidly and with one concern—to capture the likeness. This was* reportage, *one of the more demanding facets of on-the-spot drawing, made even more difficult by the artist's prefer-ence in materials, pen and ink. This medium is direct, delib-erate, and permanent—every line shows! Sugarman's line is sensitive in its directness, picking up folds and forms rather than details, and used to explain rather than impress. The tones were achieved by scumbling the wet ink line with the finger and dragging it over the paper before it's allowed to dry. Once set, India ink is permanent and will not smear even when brushed over with water or other moist mediums.*

(Above) *Defense counsel cross-examining State's witness. Here the artist relies on his pen outline only to delineate the forms with the intention of adding wash later to bring the elements of the composition together interestingly and with pictorial impact. The darks in the foreground figure immed-iately set the illusion of distance and space, separating the planes in a way that might be accomplished with varying thicknesses of line and overlapping of forms, but not as well nor as fast. With time always an important consideration in situations such as this, the artist must concern himself only with reporting—now is not the time to experiment with new techniques. Sugarman never knew how much time he would have to work in. Many pages of his sketchbook contain fragments of drawings, some barely started, that were interrupted by the unpredictable proceedings.*

135

Courtroom spectators. There was much drama in the court-room, aside from the trial itself. The people that attended were not typical, casual on-lookers, but people either committed to the ideology that Malcolm X represented or completely opposed to it. The color of skin was not necessarily the dividing line—each faction included both black and white supporters. During recesses, Sugarman would mingle outside the courtroom doors with the spectators, listening to their opinions and thoughts about the proceedings. Some who had noticed his frequent stares in their direction and the frenzied pen movement that followed actually approached him with warnings not to draw them—which the artist ignored completely. It was also during recess times that Sugarman would fill a cup from a water fountain or washroom and apply his washes, resting the large sketchbook flat on a bench or stairway landing.

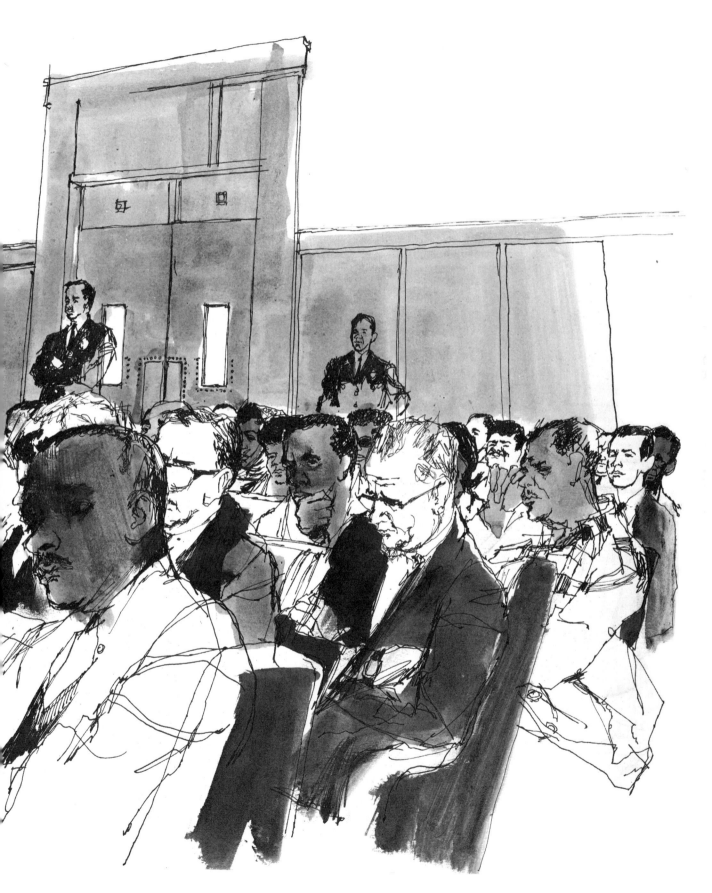

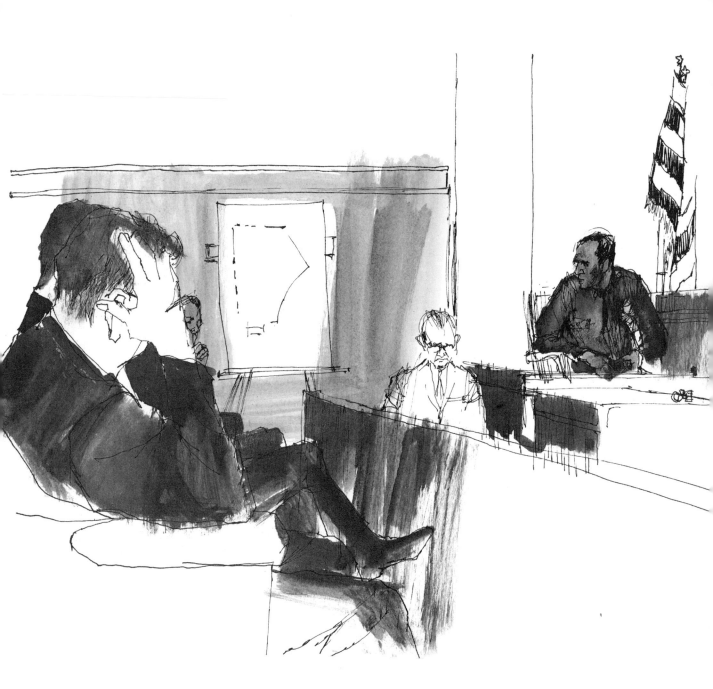

The testimony of this State's witness, a Negro policeman who
was on duty at the Audubon Ballroom in Harlem the night
Malcolm was killed, was, needless to say, very important to
the trial. Sugarman sketched him as he described the layout
of the hall to the court, referring to the floor plan which
hangs on the wall between the jury box and court stenogra-
pher. Here, again, the artist uses tone to denote color as in
the suit of the first juror, trousers and shoes of others, the
policeman, and stripes of the flag, but he also uses tone as
shadow on the left-sided plane of the jury box enclosure,
witness stand, and judge's booth. To soften the high con-
trasts, the artist used a middle tone brushed on loosely to
suggest the wood paneling of the courtroom walls.

The defense counsel was an articulate and dynamic speaker who wore cowboy boots beneath his conservative suit trousers. There were five defense counsels in all, three black, two white, and each day after the regular session they would 'hold court' for members of the press to explain what had transpired, court proceedings, and answer all questions put to them by the reporters. This sketch was made by the press-card carrying artist at one of these get-togethers. As Sugarman recalls: "I used soda or water, I forget which, for the wash in this drawing—as these meetings were voluntary and informal in nature, coffee, cigarettes and the like were allowed." Wash is a versatile and effective medium that reproduces faithfully in the halftone process. It can be mixed to any desired value according to the amount of ink (soluble and non-soluble work equally well) or lampblack (watercolor, usually in tube form) that is diluted in the water. A pocket-sized metal palette on the same order as those used in art classes in secondary schools is both inexpensive and convenient for mixing washes on-the-spot. Wash techniques are limitless: wash can be brushed on precisely or loosely; with line or without line; within the outlines accurately, or discounting the outlines completely; with pencil or pen; as color or shadow, or both, etc. Sugarman prefers a #5 or #6 Winsor-Newton red sable watercolor brush for wash, the fullness of the grade capable of holding a large supply of the mixture making its application easy and swift, while the tapered end offers a fine point for indicating details or working up tone in smaller areas.

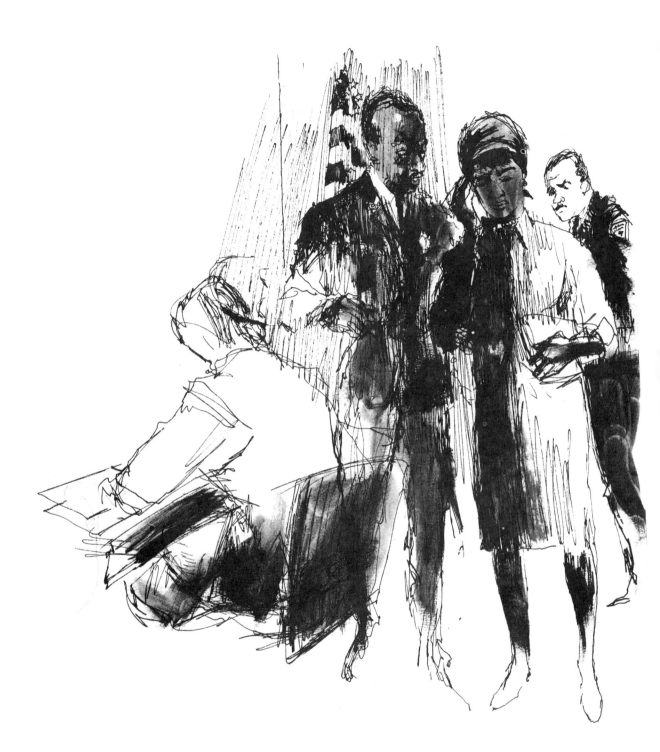

(Above) *Malcom's widow, Betty Shabazz, being helped from the stand by a court guard, emotionally upset following her first confrontation with the purported killers of her husband. Sugarman sketched this dramatic moment rapidly, concentrating primarily on the woman, but "snapping a mental picture of the people involved and their placement so that I could finish the scene from subsequent on-the-spot work." The see-through quality of the guard's head and the clerk's chair adds to the spontaneous effect.*

(Right) *Another "see-through" study. This time the defense counsel is the subject as he cross-examines a witness, leaning on the jury box as he speaks. Finding he had a few more moments to work after the initial sketch, Sugarman continued drawing the foreground figures through the jury-box rail and the original subject. In most rapid pen work, like this example, the line tends to be constant, time permitting little attempt at the thick-thin line or the other technique variations of a more finished drawing.*

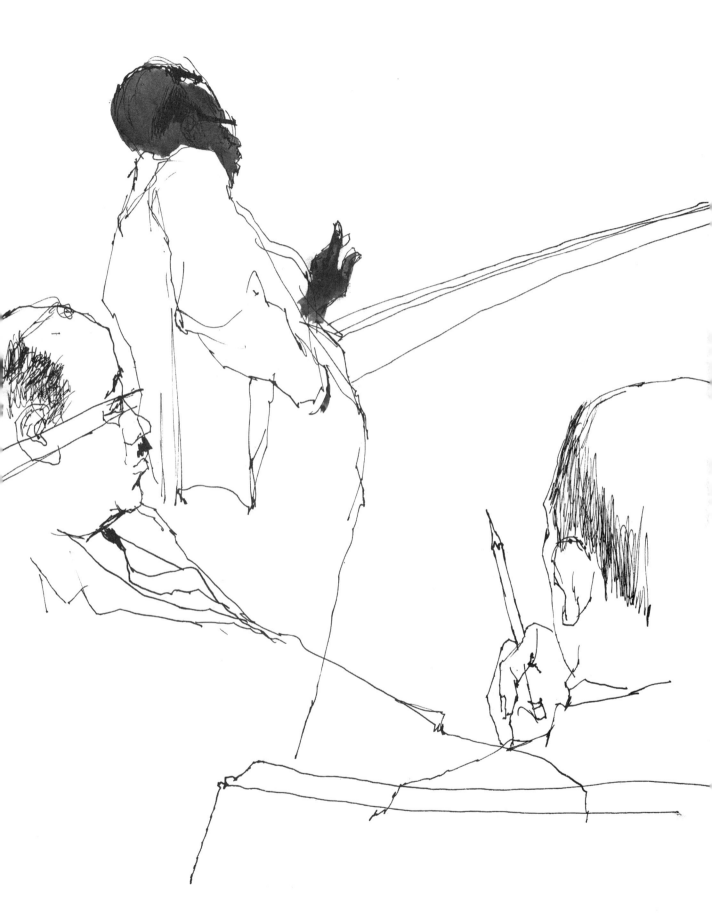

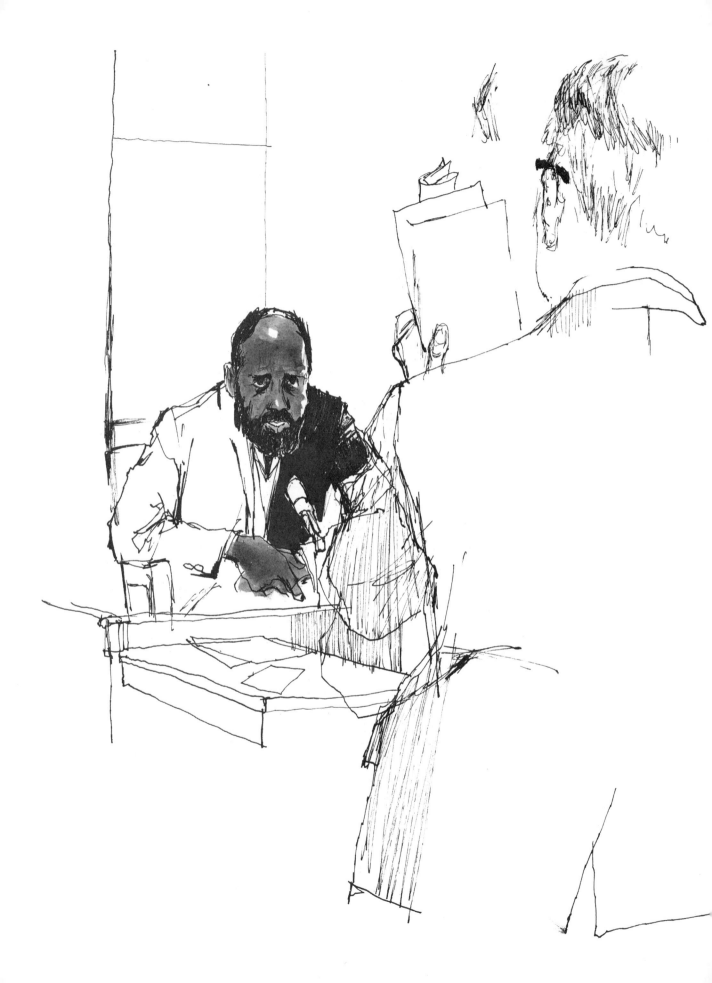

On these pages, we have the opportunity to see two separate drawings made of a single subject. The sketch on the left was made as the witness was being questioned by the document-waving counsel in the foreground whose changes of position brought about several false starts by the artist (as the floating pen lines to the left of the head and the "two left arms" would indicate). Finding that the witness' testimony brought forth many questions and subsequent cross-examination, Sugarman realized he would have more time, and thus began a more careful study which resulted in the portrait appearing on the right. All the drawings in this chapter were executed with an Ultra-flex pen, a special instrument designed specifically for India ink. The point retracts into the barrel which is also the reservoir for the ink, therefore always keeping the nib wet. It's the drying out of the ink on the point and in the feed lines that causes clogging, and the design of this pen (provided it is filled frequently) prevents drying out from occurring.

The drawings in this chapter were all done in a single afternoon for a self-imposed book project Weaver is doing on juvenile delinquency. This group constituted a chapter in his book, but Weaver graciously offered it for use here instead, having more than enough chapters for his own use. They appear in the sequence in which they were drawn, except for the drawing below which was extracted from the sketchbook and reproduced here the same size as the orig-inal. Weaver did these drawings with a 6B pencil on a lightweight, rather smooth-finish, 8'' x 10-1/2' sketch pad.

12. ROBERT WEAVER

THE
JOURNALISTIC
APPROACH

"The journalistic approach in art," maintains Bob Weaver, "is nothing more complicated than a desire to tell a story, describe an event, or illustrate a mood. The illustrator has experienced something and he desires to reproduce it. Many painters simply don't have this desire, but an illustrator who doesn't have it cannot very well serve the cause of journalism.

"I think almost anyone can train himself to be sensitive to the special character, spirit, or mood of a particular place or time. If one cannot be physically present at the scene to collect eye-witness data, (and sometimes it's not only impossible but preferable *not* to be there), the artist projects himself imaginatively into it, always being careful to respect, not destroy or supress, what information is available to him."

The role of the journalist

Bob Weaver doesn't set out to "do an illustration" *per se,* nor does he aspire to produce a timeless piece of art. His goal is basically to report; his approach—journalistic, his method—visual notations. His drawings waste no time; the quick and sure quality of his line is evident by the economy with which it's applied. His subjects are depicted in the middle of an action, captured as if in a suspended state convenient for Weaver to record.

His approach to these drawings is subdued. He's not a master technician, nor does he display any pencil razzle-dazzle. His materials are, as a matter of fact, reduced to a bare minimum. As Weaver himself says:

"I go out with a brace of 5B or 6B pencils, a pink eraser, a pad of smooth, white paper, a pocket pencil-sharpener, and a can of spray fixative."

What he also brings along is an extraordinary ability to see and to record, and he does this with an integrity that is—if one had to choose—the single most important factor of Weaver's work. Certainly it's a primary quality which has enabled him to achieve the success he has. These are his own words on the subject:

"I think it's absolutely essential, so far as is humanly possible, to remove all biases and preconceptions before starting a journalistic assignment. We need more good reporting, fewer editorial positions. It's far more effective to *show* the villain clearly than to denounce him. I'm not talking about some moral imperative to 'be fair,' but what makes for the maximum impact."

The quality of line

The quality of line can tell us much about an artist's concepts and approach. For instance, Rodin's line was that of a man so confident of form that he rarely indicated it in his drawings. Being a master sculptor, his quick notations concerned themselves with body action, grace, and rhythm. The "roundness" would come later, three dimensionally. Modigliani worked with love for the beauty of the line itself, sacrificing proportion if need be in order to emphasise it. Van Gogh used line in quick, passionate strokes, much like the dabs of color in his painting, until the image was formed. We each come to our individual line by way of our personality.

Out of context with the rest of the drawing, Weaver's line is impatient, blunt, insensitive. It's not the kind of line you admire for its intrinsic beauty—it has little. Weaver works for the sum total, the completed drawing; and that drawing is both sensi-

tive and beautiful, an interesting contradiction pointing out the fact that a beautiful drawing isn't necessarily made with beautiful lines.

Weaver draws with exceptional speed. He's intense and involved not only with capturing his subject's physical appearance, but with mood and attitude as well. There's no time to stop and fix "mistakes," nor is there room for refinement and finesse. It's this urgency, this white heat feeling, which gives Weaver's line its flavor of unpredictability. He stresses design rather than three dimensional form. He expresses the contour rather than following it with precision-like accuracy. He'll draw folds with quick slashes, indicating rather than depicting.

Weaver will use darks mostly to suggest light and shade, or, by selective finishing, to emphasize certain parts of the drawing, to control the eye's attention. The darks are drawn quickly also, "scribbled in" with short, deft strokes. No smudging or subtle gradations are attempted.

On-the-spot and journalism

"Any on-the-spot sketch would provide a welcome sparkle to the printed page—lighten it," Weaver asserts. "There is no doubt there are too many photos cluttering up magazines and newspapers, e.g. the public figure with a lot of out-of-focus bric-a-brac behind his left ear, or the full color photo 'essay' which is all design and no content.

"A second advantage would be the element of immediacy and spontaneity—rapidly disappearing from the newsphoto. More and more, it seems to me, the photographer and the subject are in some sort of cahoots; that is, a public figure 'performs' for the camera.

"Which leads into the third and most important virtue of the sketch report, which has to do with candor and truth. I think that the manipulative techniques of advertising (which sometimes are indistinguishable from the editorial elements of the printed media), the ballyhooing and self-promotion which magazines are indulging in more and more, all tend to create a credibility gap. I believe, then, that the artist could restore to the journals a visual excitement, a more personal view of events, and, finally, a more honest one."

Drawing from life

The human form has been the favorite subject for artists throughout history. To a journalist the interest is more than just artistic, for, except through natural **phenomena,** events are precipitated by people, and it is the job of the journalist to observe and record those responsible or involved. Weaver has this to say:

"While I think it essential that the artist see the subject in the flesh, it's conceivable that in the case of a very public figure, the illustrator might see the quintessential man in the printed or televised image rather than in the private confrontation.

"While there's a certain raw force in the unaltered on-the-spot sketch, I believe that the artist should not edit his work while in the presence of the subject he's illustrating, as that presence can sometimes overwhelm one's judgment.

"When you have to do a sketch of someone you don't know or who's a well-known figure, chances are that his spirit of cooperation, as well as the amount of time he can give, are limited. There's a certain tension—a sense of urgency—which puts the artist on his mettle. Any prolonged viewing of a thing is bound to deaden the ability to see clearly—thus the deadline works to the *benefit* of the artist. You can see the unfamiliar more clearly than the familiar. This is really an argument ·against the deplorable practice of commissioning artists to do portraits from photographs.

"As to any psychic waves that might be passing between artist and sitter, I personally have never been aware of any, being too busy with jawlines."

Visual language

Like Robert Andrew Parker, Ben Shawn, and very few others, Weaver crosses that indescribable line separating fine art from applied art· The context in which a drawing is used seems to decide the difference today, which is unfortunate for the art world in general. Many pieces of work, if matted, framed, and hung in a gallery show entitled "Twentieth Century Drawings" or "Graphics by Modern Masters" would be accepted as such, even though (if the fact were well hidden) the same work appeared as an illustration for a mass circulation magazine.

If only a few illustrations attain this level of artistry, it is the illustrator himself who is to blame, for his approach is more often to produce something pleasing or novel, or middle-of-the-roadish. He is often more involved with developing a style than an idea. Weaver adds:

"There are too few illustrators who have the skill to communicate anything except very simple ideas. Magazine illustration for me is too decorative, too superficial. The challenge to the illustrator is to use art forms to reveal, to convey the gravity of, and to delve into the issues of this particular time in history.

"Perhaps it's the fault of the art schools, but there does seem to be a confusion of roles which leads the

young illustrator to think he's expected to produce works of art which are incidentally reproduced in a magazine. Nothing is more boring than this attempt to marry off the story-telling obligations of illustration with the latest school of painting. First-rate writing is having something to say—and saying it clearly. Illustration is, or should be, *visual language*."

The drawn documentary

The drawings included in this chapter were done during a single day in 1960 for a book project concerning juvenile delinquency in America. It was to be a look into gangs in a personal way. In this group, Weaver accompanied a former 'bopping' or fighting gang that decided to give up their gang feuds and go social. This was their first social outing. After

gaining their confidence, Weaver boarded the bus with the gang and headed for a Bear Mountain picnic on the grass. They were a confident, inter-racial group ("We like ourselves" was their slogan.) that very quickly accepted this soft-spoken intruder in their midst and did the best thing possible for a probing artist—they ignored him completely. Thus, Weaver was able to go about his work of making pictures with little or no interruption. They appear in the sequence in which they were drawn and the result is rather like a documentary film unfolding before us.

Artistically, the drawings speak for themselves. Weaver draws beautifully, composes intelligently, designs naturally, and most of all, records faithfully, for he's a "journalist." And the art world is in dire need of "journalists" of Weaver's capabilities!

For his own book, Weaver had titled this chapter "A Trip to the Country," denoting this fighting gang's first social engagement—a picnic at Bear Mountain, an upstate New York recreational park. Upon arriving, members spread out to various athletic areas, from ballfields to an archery range as pictured above. With no time for extraneous details, Weaver gets to the heart of the subject with quick, bold strokes, drawing over (rather than erasing) to correct.

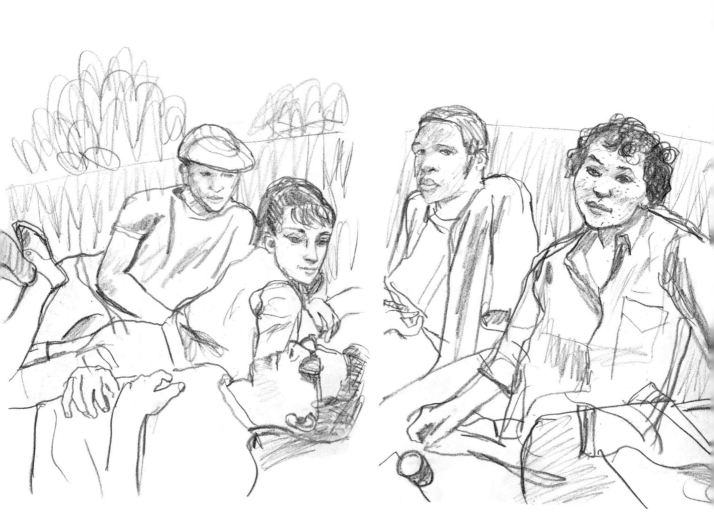

Drawn across two pages, Weaver's angle of vision was at the spine of the sketch pad; his subject's eyes focused directly at him, resulting in a drawing that gives the impression that the viewer is on the scene too. The drawing is composed in a way that either side holds up as an entity in itself as well as being a part of the picture as a whole. One interesting aspect of Weaver's work is what he decides (or what he decides not) to emphasize in his figures, as well as how far he'll carry one particular element. In the above sketch, the faces get his greatest attention—they are shaded, hair clearly indicated, and show more detail than elsewhere in the drawing (the artist even suggests the freckles on the girl at the right). As we move further from the heads, the lines become mere suggestions of form and the background landscape dissolves into impatient indications of mass and tone.

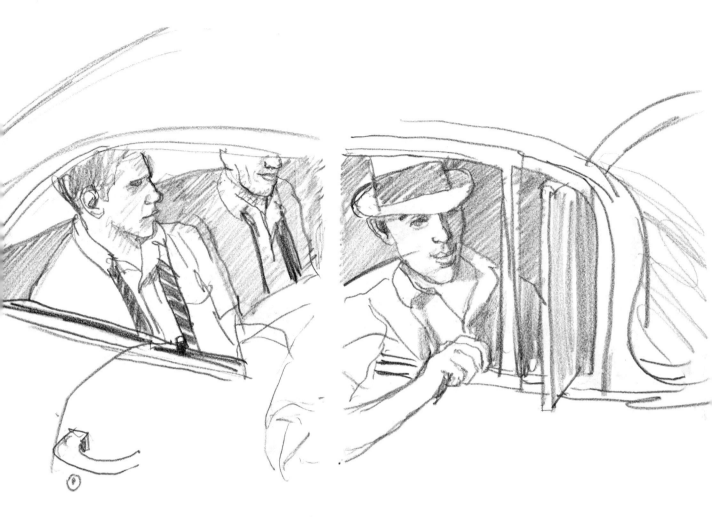

By indicating a minimum of detail and no tone outside the perimeter, Weaver has built a composition that is a frame within a frame. This drawing also extended over a two-page spread in Weaver's 8-1/2'' x 11'' sketch pad (as the vertical break in the drawing at center, caused by the pad's binding channel might indicate). These members didn't accompany the others in the bus, but provided their own transportation—this vehicle—and did not leave its interior for the entire afternoon. The face of the foreground subject is, once again, the most clearly defined portion of the work, and yet his arm is as vague as the two subjects seated in the rear of the car. The figures are silhouetted by a tone made up of quickly-drawn parallel lines, the same tone appearing in the foreground subject's face, with only a thicker, darker outline preventing the one from blending entirely into the other.

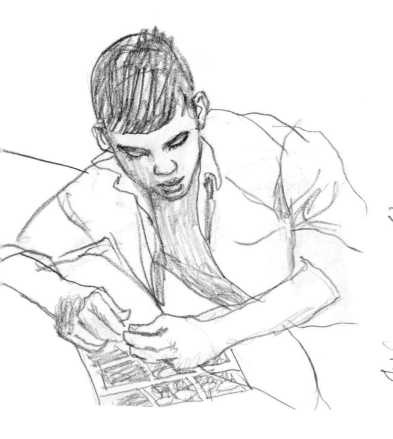

Weaver is no "formula" artist. His subjects are real because they're drawn as individuals—people do not have the same noses, lips, eyes, or ears, and though any of these features may be indicated by a simple line, it is never the same line, therefore it is never the same nose. Weaver's portraits, despite the speed in which they are drawn, are accurate likenesses. He doesn't render folds, they're simply lines expressing the gesture of the fold, their direction suggesting the form underneath. This subject's attention is focused on a magazine. The artist accents this downward flow by paying more attention to the lapels, T-shirt beneath, hands, and the magazine itself, each more completely realized than the peripheral segments of the drawing which remain outlines with no tonation. Weaver's figures "melt" naturally into their movement; you can feel their weight on the ground.

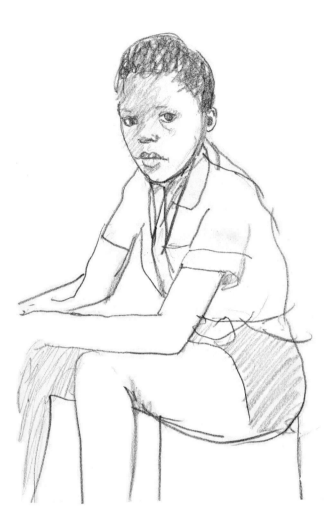

When is a drawing finished? An artist answers this question
anew each time he draws. Detail is extraneous if it distracts,
necessary if it helps clarify the composition or theme of the
drawing. Some artists draw everything, their philosophy akin
to that of the mountain climber, "because it's there." Others
have a more selective approach, including only that which
spurs their interest. Because there can be no rules when it
comes to individual choice, no approach can be deemed cor-
rect or incorrect. Weaver, it would appear, wastes no time
with labels— he takes each thing as it comes, his drawings
evolve as if they are in command of the artist rather than he
of them. In this drawing, the girl's head is delicately handled,
with minimal tonation softening her gentle features. The
foreground arm and leg show direction of the form only and
not their respective volumes.

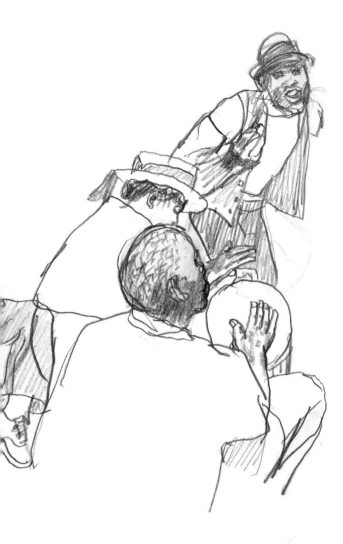

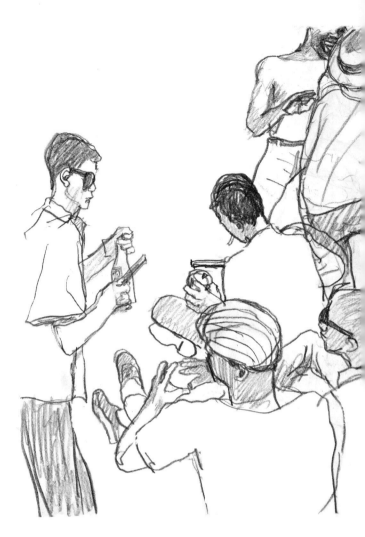

Weaver uses white space authoritively, whether as a compositional factor or as form. The latter holds true in the sketch above where the foreground figure's shirt, because it's expressed only by an outline (and an incomplete one at that), appears as a two dimensional form—flat against the rounded three dimensional form of the head. The artist draws to the edge of the paper, the drawing ending where the page ends on all four sides. Figures are more than "cut off"—they're "cut on"—as in the case of the leg at the left, which obviously belongs to a subject outside of the page's perimeter. The result is reminiscent of a Degas' painting, which, like the above, is cropped with seemingly little concern as to what is cut or where the cutting takes place. Here, a few of the gang members play their bongo drums as they gather around in a grass meadow after lunch.

Here again figures are cropped by the page edges; Weaver doesn't compromise or change what he sees just to fit it all in. Perhaps it is this very quality that adds an even greater sense of realism and authenticity to his work; the viewer feels "that's the way it must have been" when there are no compositional contrivances or obvious design effects employed. This is due to our unconscious acceptance of photographs as fact; the photograph, of course, always crops indiscriminately. As those who brought their drums with them started to play, others created their own instruments, improvising on sticks, soda cans, and bottles to supplement the drum beat. Against this rhythm section, a few voices sang the popular songs of the day, and soon others who had drifted closer began to dance. It is said that music is the universal language—groups like this appear to prove it so.

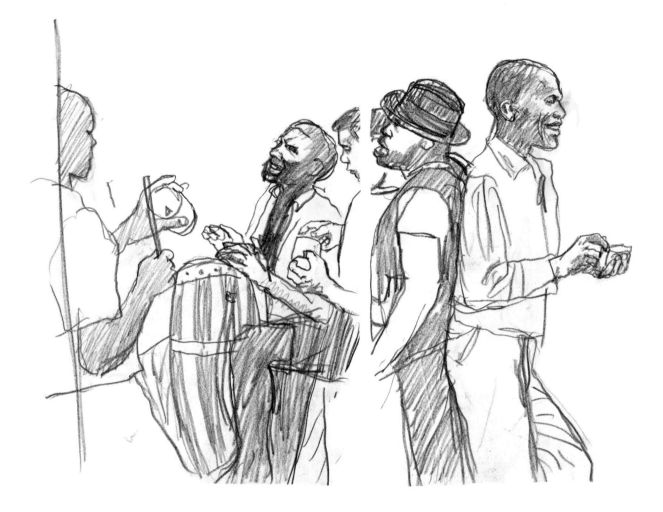

In this double-page sketch, the action once again dictates the drawing. Weaver takes advantage of the "accidents" of life that exist but are rarely drawn. The flow of the composition to the left is created by the grouping around a void—a white space that forces the eye to focus on the stick as it taps against the empty can. This action is counterbalanced by the figure at the right whose back is turned away from the focal point and whose attention is actually out of the picture. An incident, then, is not necessarily limited by the information offered within the drawing. Here Weaver has supplied us with a broader look; he has told us that others around this piecemeal "orchestra" had become effected by them, and the figure at the right responds to that effect. An artist with Weaver's capabilities can make his statement without feeling restricted by the area in which he has to work.

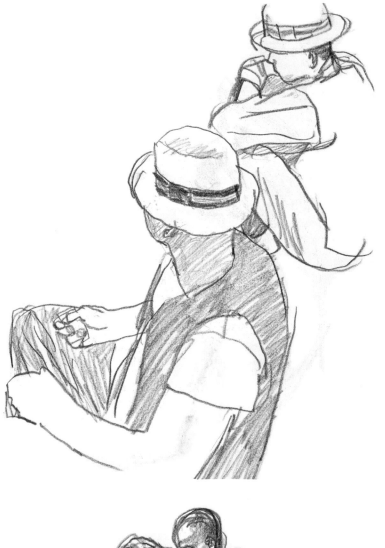

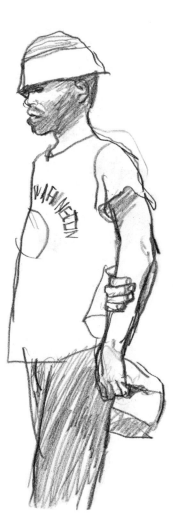

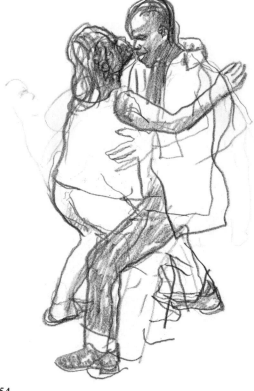

These three single-page studies depict the onlookers (upper left and right) and dancing participants (left). While Weaver often draws people whose characters are expressed through their facial features, he can also say a lot about a person from a back view or in profile with very little of the face actually showing. He does this by means of careful observation, proper proportion, gesture, and figure nuances. Tone is used as color in vest, trousers, and hatbands of the seated figures above, as shadow under the hat, chin, and shirt of the figure directly above, and as both in the drawing at the left. In Weaver's handling of the latter work, the emphasis is on the intertwining limbs of the dancing figures. In a highly selective process, the girl's right arm and the man's left leg are more carefully defined than the others, creating a single unit of two distinct subjects.

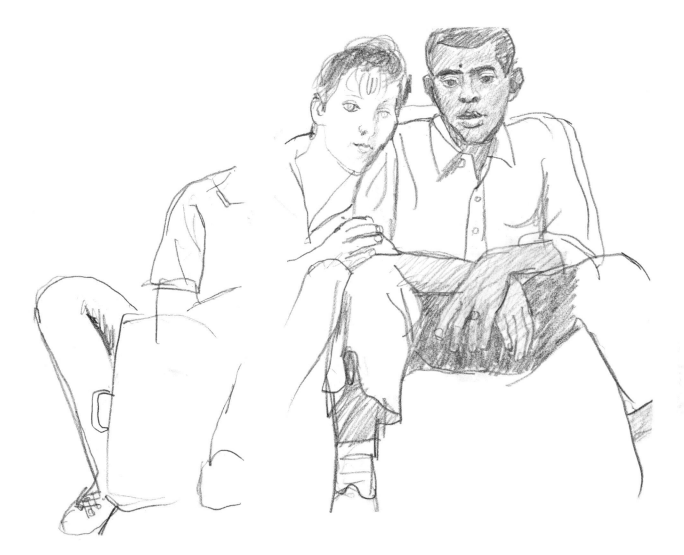

At dusk, much of the energy had been danced out. Small groups formed within the whole; voices were lower and the atmosphere more subdued. Couples, like the one pictured above in this tender drawing, huddled together, perhaps a little sad that this fun-filled day was rapidly drawing to a close, and soon they'd all have to file into the bus, taking leave of the green grass and clean-smelling air to return to their crowded tenement neighborhood. Despite the space the two-page spread provided the artist, he "squashed" his subjects to the right side, cutting them off at top, left, and bottom in the process, perhaps to further emphasize their intimacy and dependence. The result is that they are pulled together emotionally in a way that transcends their actual physical placement. The dark outline of the girl's cheek pushes into "her guy's" shoulder in a way that blends them.

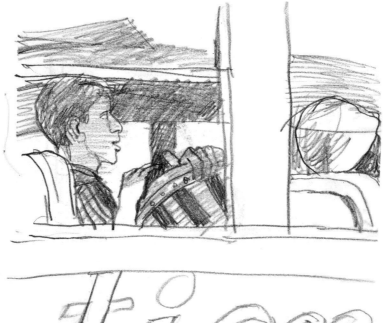

BACKWORD

We have heard from those who work on-the-spot professionally and those who do it as a form of relaxation. We've looked at drawings that were fragments, notes, details, or preparation for other work, followed by others that were complete entities, start-to-finish location drawings. Some emphasized action, others mood; some pencil, others pen.

Contradictions? I certainly hope so! There are too many books today that are written and illustrated by one man. Their value, I believe, is limited. If you like the man's work you run the risk of seeing too much of it and learning soon gives way to imitation, conciously or unconciously. If you dislike the work, chances are you'll reject *everything* about the book, thoughts and ideas included, however valid and helpful they may be.

This book was purposely designed as a potpourri —the emphasis was on diversity—different people with different points of view, varied subject matter with varied drawing approaches; anything and everything that would create interest and hopefully elicit reader involvement. An emphatic rejection of an idea can sometimes be as important as complete acceptance; you find yourself taking sides, leaning one way or another, and that in itself helps to clear up in your own mind where *you* stand, your directions and goals, beliefs and values.

There is one point, however, that remains constant throughout, and that is the value of on-the-spot drawing. Whether you draw on location occasionally or as a steady diet is up to you. The main thing is to leave behind the comfort and convenience, influences and references, gimmicks and gadgets, and, most important, the styles and techniques, and go out for a fresh look.

I emphasize 'style and technique' because that is the most common mistake made by students today— putting the cart before the horse. Style develops *through* drawing, *by* drawing. It evolves from it and should never precede it. As for technique, I can only repeat what others have said in the preceding chapters: the drawing suffers when the 'how' becomes more important than the 'why.' Technique is only the means to an end and not the end in itself. Right now, at this moment, there are art students doing the same thing they did last month, and probably not knowing it. Somewhere along the line they have picked up an impressive shading technique, for instance. Fine. That's part of the discovery process. But all too often, having tucked away his discovery in a little bag, the student will rely on this magical device every time a leg needs volume or a breast needs form. If he is not made aware of this dependence, his growth will end right there. Observation will then become secondary—every knee cap will be the *same* knee cap, not the model's knee cap. Instead, a formula for drawing knee caps has emerged, and unless the aim is to write a book *Drawing Knee Caps for Fun and Profit,* he has gained nothing. The search for new formulas is the only search that will take place, and the result will be a drawing with little difference from the one before it, and much worse, not very different from the one *after* it.

They say "One picture is worth a thousand words." Well, I've supplied the thousand words. I hope they will inspire you to supply the picture. One drawn on-the-spot, of course. . .

INDEX

Edited by Susan E. Meyer and Margit Malmstrom
Designed by James Craig
Composed in 10 point Times Roman by Phototype Systems, Inc.
Printed and bound by Interstate Book Manufacturing